THE LIFE OF THE MADONNA IN ART

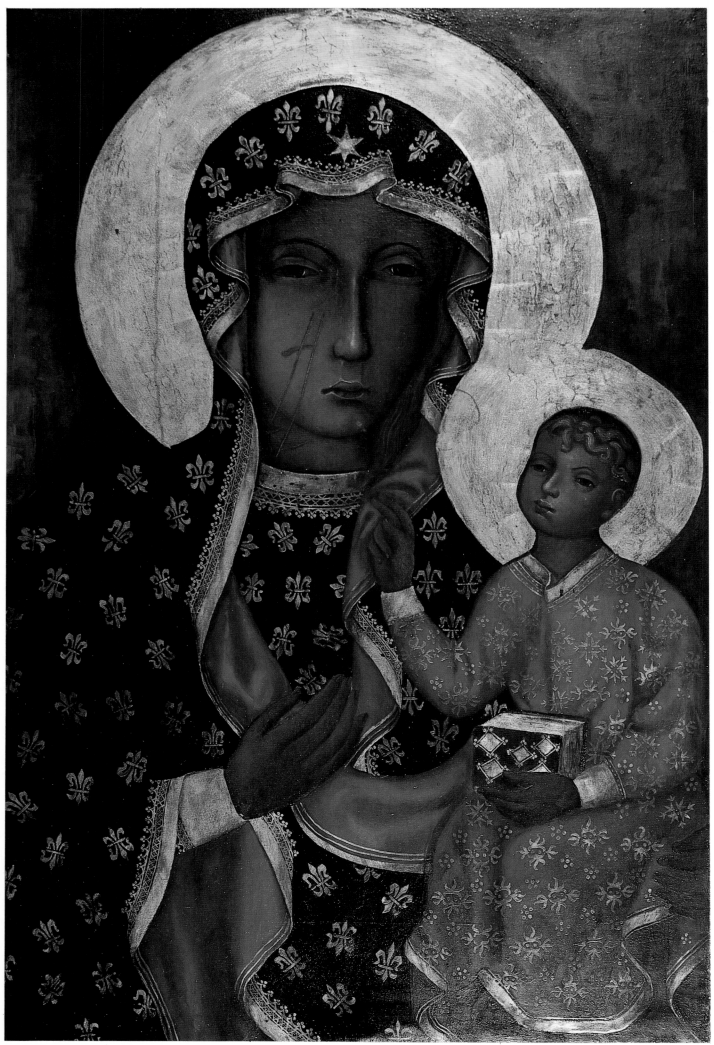

OUR LADY OF CZESTOCHOWA

THE LORD HIMSELF WILL GIVE YOU THIS SIGN:

THE VIRGIN SHALL BE WITH CHILD,

AND BEAR A SON,

AND SHALL NAME HIM IMMANUEL.

*(Isaiah 7:14)**

THE LIFE OF THE

ANDREA BONAIUTI
BENOZZO GOZZOLI
BOTTICELLI
BRUEGEL
CARAVAGGIO
DONATELLO
DUCCIO
FILIPPO LIPPI
FRA ANGELICO
GENTILE DA FABRIANO
GHIRLANDAIO
GIORGIONE
GIOTTO
GIOVANNI BELLINI
GIOVANNI DA MILANO
GIOVANNI DI PAOLO
GUERCINO
LEONARDO DA VINCI
LORENZO LOTTO
MANTEGNA
MASACCIO
MICHELANGELO
MOSTAERT
MURILLO
PACINO DI BONAGUIDA
PIERO DELLA FRANCESCA
PONTORMO
RAPHAEL
SIMONE MARTINI
SPINELLO ARETINO
TADDEO GADDI
TITIAN
VAN DER GOES
VAN DER WEYDEN

MADONNA IN ART

CONTENTS

THE LIFE OF THE MADONNA IN ART

Foreword by
His Excellency, Most Rev. Pio Laghi
Apostolic Nuncio

Presentation by
His Excellency, Most Rev. Achille Silvestrini
Titular Archbishop of Novaliciana

Introduction by
Fabrizio Mancinelli
Director of the Pontifical Museums and Galleries

Texts chosen by
Samuele Olivieri, O.F.M.

Texts from the writings of the Fathers and Doctors of the Church
chosen by the Daughters of St. Paul
from *A Voice Said Ave*, by Charles Dollen, St. Paul Editions, Boston

Iconographic information by
Ornella Casazza

Biography of the Blessed Virgin Mary by
Rev. James Alberione, S.S.P., S.T.D.
from *Mary, Hope of the World*, St. Paul Editions, Boston.

Editorial Coordination: Claudio Nardini

Graphic layout: Lorenzo Crinelli
with the photographic collaboration of Antonio Badalucco

Coordination of production: Paola Bianchi

Chromatic plant: Fotolito Toscana
Printing: Arti Grafiche Parigi e Maggiorelli

ISBN 0-8198-4440-3

For *Italian Edition:*
© 1984—Nardini Editore—Centro Internazionale del Libro—Firenze

For *English Edition:*
Copyright © 1985, by the Daughters of St. Paul
50 St. Paul's Ave., Boston, MA 02130

The Daughters of St. Paul are an international congregation of women religious serving the Church with the communications media.

In addition to the iconography of the Madonna in Art, this volume presents the life of the Blessed Mother, Mary, Hope of the World, *by Rev. James Alberione, S.S.P., S.T.D., illustrated and enriched with the reflections of the Fathers and Doctors of the Church. It concludes with the theology of Mary as given by the document of Vatican II, the Dogmatic Constitution on the Church* (Lumen Gentium, *Chapter 8).*

FOREWORD

For me it is both a privilege and a pleasure to present this magnificent volume to the American public. This book is worthwhile for many reasons, and I recommend highly its circulation in this country. The work describes in a marvelous manner, through the exquisite reproduction of artistic masterpieces, the life of Mary from the time of her Immaculate Conception up to her Assumption into heaven. It is a veritable treasure of some of the more well-known examples of European painting. Through its concise, sober text, the book also serves to provide its readers with clear meditations on the Gospel texts that pertain to the events depicted artistically.

In order to meditate on this volume and derive from it solid enrichment, one has to do more than simply flip through its pages admiring the lavish colors and the sharpness of the artistic reproductions. Art, of course, does have its own peculiar language. For these images to convey their true message to the reader, it is necessary to keep in mind some basic keys to their interpretation. I limit myself to mention but two of these. We cannot expect to find in this volume a complete biography of Mary because the Gospel itself was not intended to furnish us with one. It is evident that the Gospels were written to inform us about Mary's Son and His salvific work on earth. Mary's life must always be viewed in subordination to that of her Son. We read about her in the Gospels because we need to know how Jesus was conceived, how He was born, how He was raised from infancy, how He performed His first miracle because of Mary's pleading, how she stood at His side throughout His moment of suffering and death, and how Mary waited with the disciples in the Upper Room for the Spirit to give birth to the Church Jesus founded. Thus, Mary must always be seen in relation to her Son and to His work. Her iconography is intimately bound to that of Christ and His Church.

Through Mary, God became flesh, entered a people, and became the center of human history. She is the bond of interconnection between heaven and earth. Without Mary, the Gospel is stripped of flesh and blood and is distorted into an ideology, into a spiritualistic rationalism.

The Daughters of Saint Paul are to be commended for providing in an English edition this most attractive volume which, I hope, will serve to encourage its readers to attain an ever deeper understanding of the vital role played by Mary in the life of her Incarnate Son.

February 9, 1985

Archbishop Pio Laghi
Apostolic Pro-Nuncio

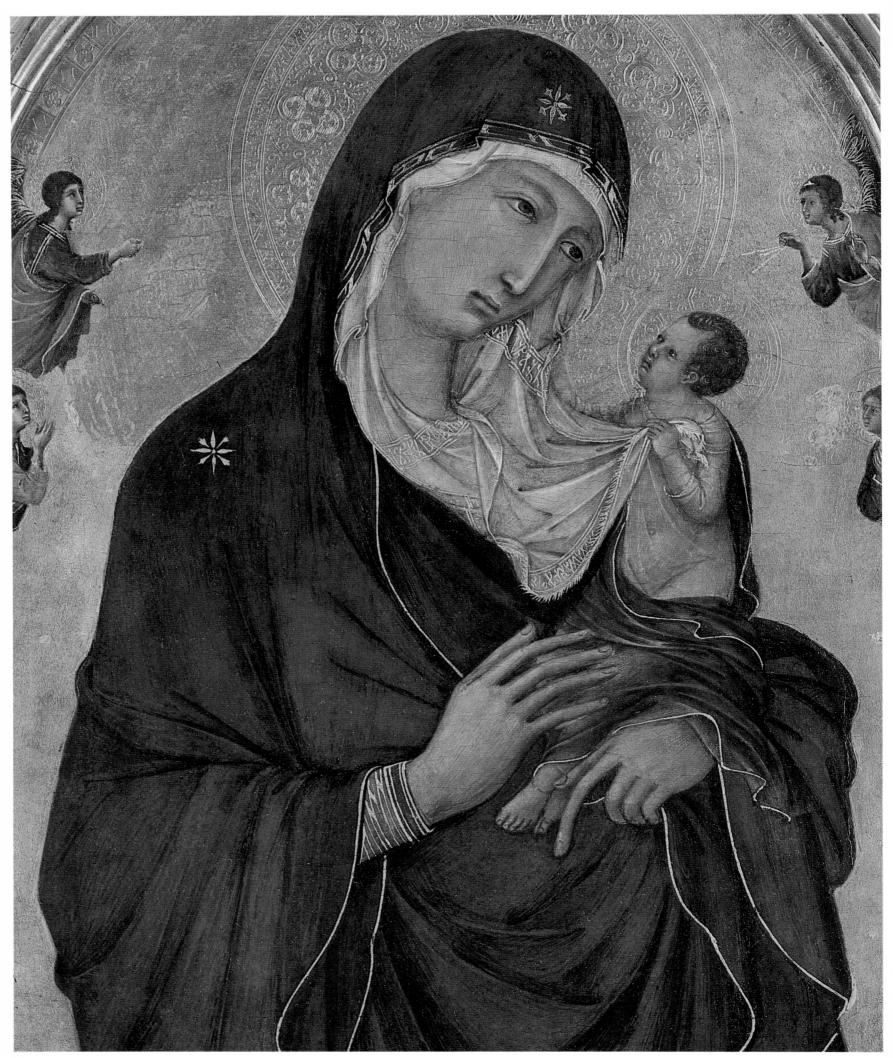

DUCCIO

PRESENTATION

"With the Assumption of the Mother of God—her birth into heaven—we want to honor the blessed moment of her birth upon the earth.

"Many ask themselves: when was she born? When did she come into the world? It is a question which they ask themselves especially now that the second millennium of the birth of Christ approaches. The birth of the Mother obviously had to precede in time the birth of her Son. Therefore, should we not also celebrate the second millennium of the birth of Mary?"

(John Paul II, in the Homily of the Mass of August 15, 1983, at the Grotto of Lourdes)

What do we know of the origins of Mary?

The canonical texts of the New Testament have extremely brief references to her: she belonged to the house of David, was a relative of the priest Zechariah and his wife, Elizabeth, and lived in Nazareth. To that small village God sent the angel Gabriel to salute her as "full of grace" (Luke 1:28), and to give her the unthinkable announcement: "You will conceive in your womb and bear a son, and you shall call his name Jesus.... The Holy Spirit will come upon you, and the power of the Most High will overshadow you" (Luke 1:31, 35). And the young girl, in the freedom of her heart, answered with a humble assent: "I am the handmaid of the Lord; let it be to me according to your word" (Luke 1:38).

Since everyone born of a Hebrew woman became a member of the people of Israel, Mary offered to the Son of the Most High what made Him belong to the human race, together with an Israelite identity. The Apostle Paul says that it is precisely the fact that He was born of Mary which is our guarantee that Jesus was not an apparition, but a man of flesh and blood as we are, who entered history to bring about man's passage from subjection to the Old Law to the universal sonship of God (cf. Galatians 4:4-6).

From the cross, in the hour of His supreme offering, Jesus saw His Mother and beside her the disciple whom He loved. He turned to Mary and said, "'Woman, behold, your son!' Then he said to the disciple, 'Behold, your Mother!'" (John 19:26-27).

These are the two moments—the Fiat, *making her the* Theotókos *or Mother of God, and the confiding of man to her protection—from which springs the twofold mission of Mary: to give human flesh to the Christ, and to bring Christ to men: Mother of Jesus; Mother of the Church.*

"All generations will call me blessed" (Luke 1:48). From the very beginning, fascinated humanity directed its attention to discovering the origins of Mary, to grasping her human and psychological physiognomy, to penetrating her marvelous place in the sublime plan of God. The silence of the canonical sources about her parents, the place and time of her birth, and her childhood, found a complement in the apocryphal narratives. The same holds true for her dormition, *a premise to her Assumption into heaven. The canonical and apocryphal sources compete in offering to Marian iconography rich points for an abundant harvest of images and picture stories, in the East as well as in the West, in antiquity as well as in modern times.*

Of iconographic biographies of Mary we could, therefore, assemble thousands. In this selection, using the masterpieces of the major artists between the 14th and 16th centuries, the editors desired to compose an ideal biography, which synthesizes the "classical" or more familiar faces of Mary.

It is their hope, I would almost say, their ambition, that visual enjoyment will stimulate affection and devotion—just as a family picture album satisfies the needs of the heart—and that from contemplation prayer may spring up spontaneously.

"I entrust all to you, O Mary," is the invocation repeated by Pope John Paul II. May there be prayer to ask Mary's help against the threats facing the Church and mankind in the finale of the closing millennium, and in the one whose dawn already paints the sky.

Rome, September 1984, feast of the Nativity of the Virgin Mary.

✠ ACHILLE SILVESTRINI

(Titular Archbishop of Novaliciana)

INTRODUCTION

The iconography of the Virgin is among the most intricate and rich of all portrayals: whether artistic—with the figure alone or accompanied by the Child and other personages such as St. Joseph, St. Anne, St. John the Baptizer as a child and St. Catherine—or literary, with narratives sometimes drawn from the apocryphal Gospels.

It is not well known that, for a purpose similar to ours in this volume, some examples of the most significant iconical compositions with the Virgin were gathered together during the eighteenth and nineteenth centuries in a collection for the Sacred Museum of the Apostolic Library. These are now displayed in the rooms of the Vatican Art Gallery dedicated to the so-called "Primitives." Among others is a rare picture of the Madonna of Birth, dating from the end of the 14th century, and another which is considered one of the first representations of the Immaculate, dating from the second half of the third century.

This volume, the only one of its kind, is a collection of works chosen as especially meaningful for illustrating "The Life of the Madonna in Art."

Clearly a selection had to be made, because for every episode there obviously exist tens of possible alternatives. Ornella Casazza, to whom we also owe the able and clear drafting of the related information, has concentrated, with a few important exceptions, on the period from the fourteenth to the sixteenth centuries documenting above all the pre-Tridentine iconography on this subject.

The choice of episodes follows step by step the events in Mary's life, from the Virgin's birth to her assumption and coronation. As in one ancient miniatured manuscript, every picture is accompanied by the corresponding citation from Scripture, from the writings of the Church Fathers and Doctors, or from the apocryphal texts, which extend the narration to the childhood of Mary, not found in the evangelical texts. The prose-and-picture narrative is significantly concluded with the very beautiful prayer to the Virgin found in the thirty-third canto of Dante's "Paradise" and with the Majesty of Duccio—the painting which perhaps exemplifies Marian iconography more completely than any other. The events between the childhood of Christ and His passion—in which the figure of the Virgin does not appear—are to be found in the unedited illustration of the Tree of the Cross by Pacino di Bonaguida.

This volume is destined to both the person who simply loves Mary and to the studious person. Both can avail themselves of this rich collection of significant masterpieces.

FABRIZIO MANCINELLI
(Director of Byzantine, Medieval and Modern Art
at the Pontifical Monuments, Museums and Galleries)

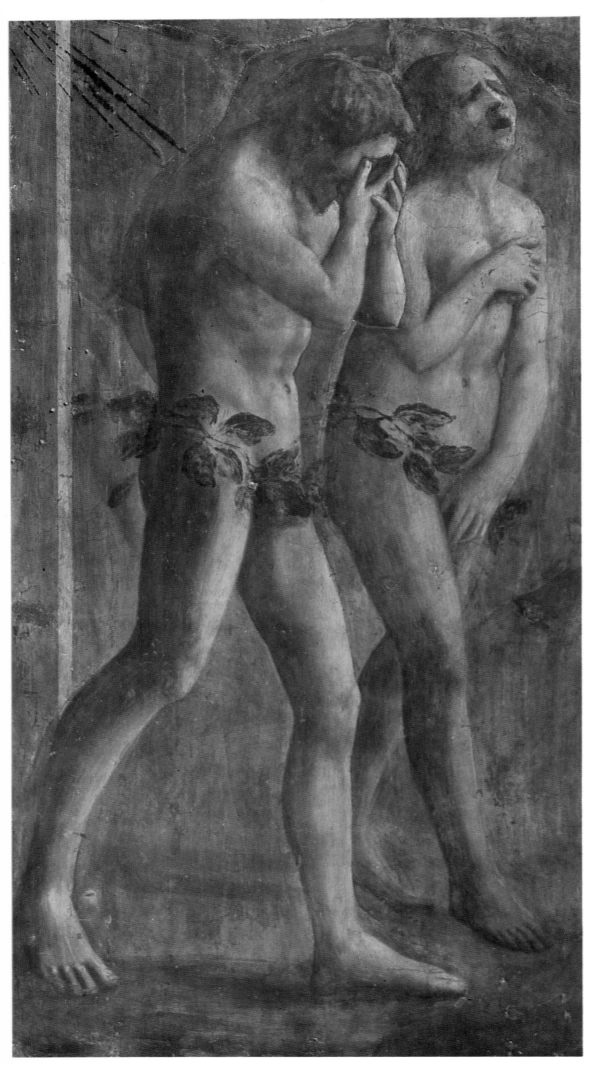

"I WILL PUT ENMITY BETWEEN
YOU AND THE WOMAN,
AND BETWEEN YOUR SEED
AND HER SEED;
HE SHALL BRUISE YOUR HEAD,
AND YOU SHALL BRUISE HIS
HEEL."

(Genesis 3:15)

MASACCIO

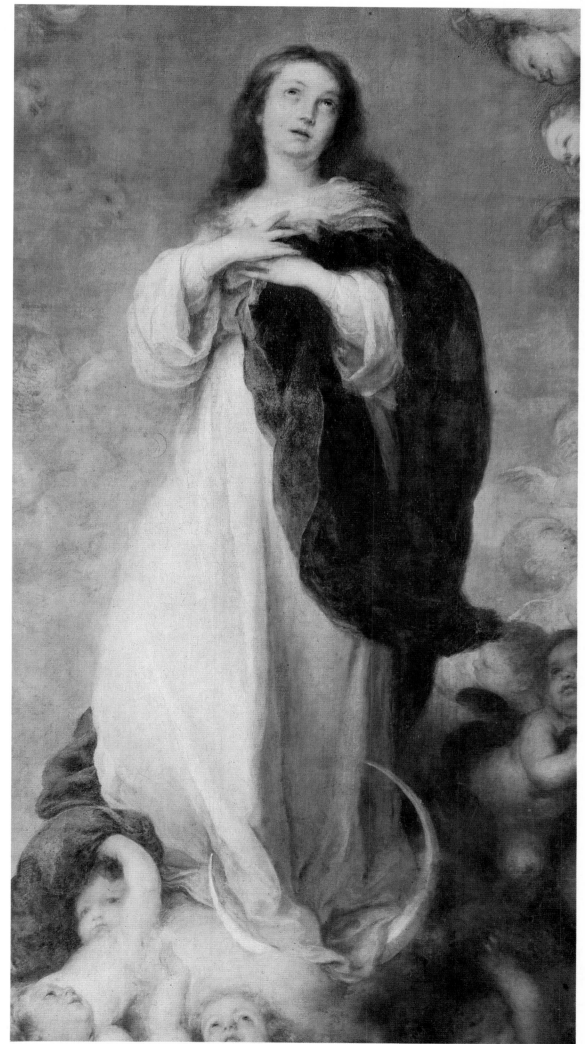

A GREAT SIGN APPEARED IN THE SKY, A WOMAN CLOTHED WITH THE SUN, WITH THE MOON UNDER HER FEET, AND ON HER HEAD A CROWN OF TWELVE STARS.

*(Revelation 12:1)**

MURILLO

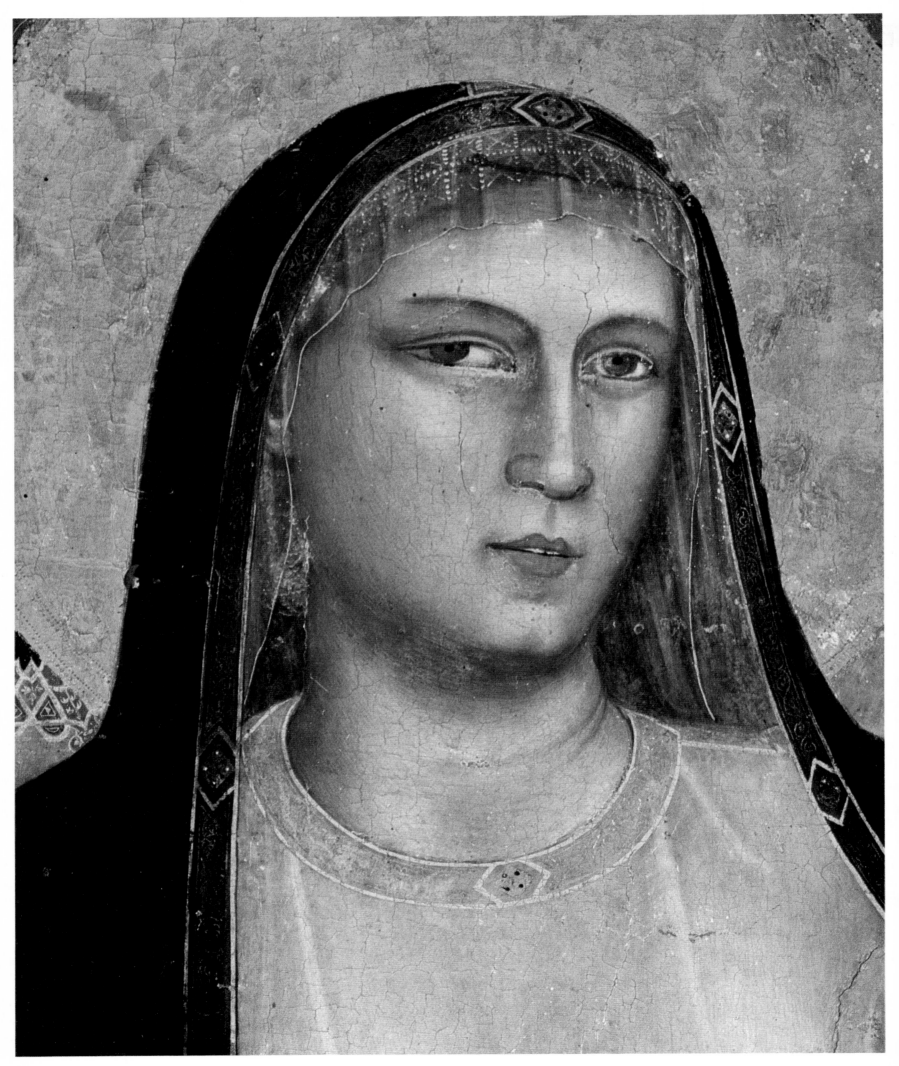

GIOTTO

THE LIFE OF THE MADONNA IN ART

THE BIRTH OF MARY

JOACHIM WAS A RICH AND DEVOUT MAN. AND WITH
HIS RICHES "HE MADE A DOUBLE OFFERING TO THE
TEMPLE, SAYING: 'WHAT I GIVE OF MY EXCESS WEALTH

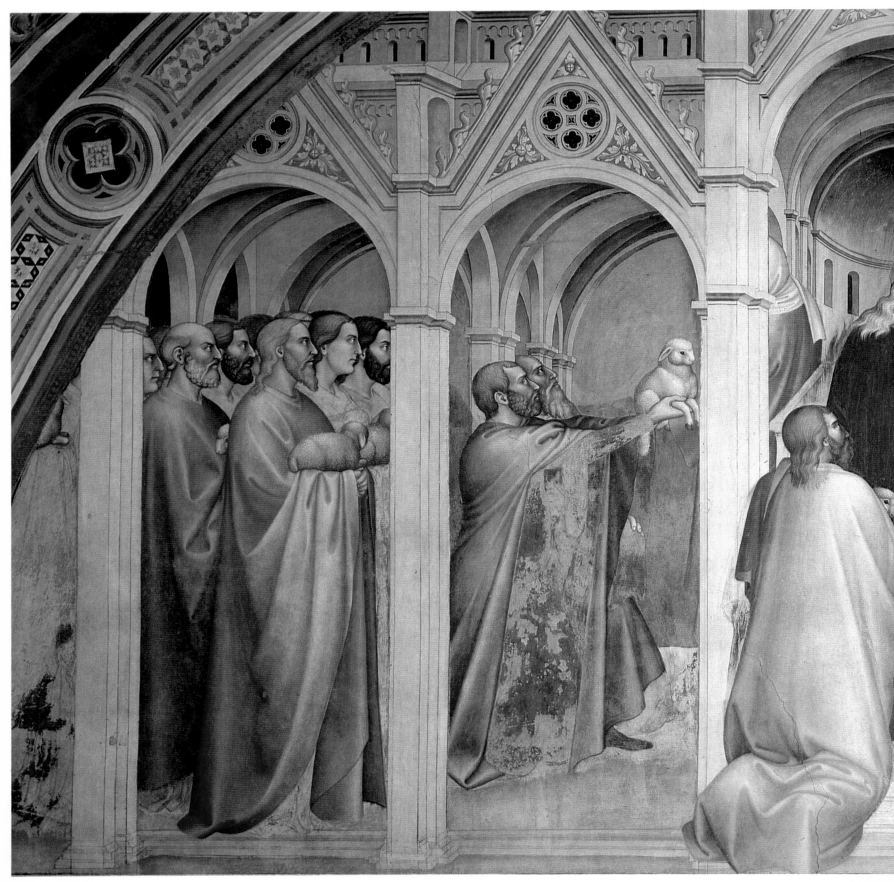

GIOVANNI DA MILANO

SHALL BE FOR EVERYONE: I OFFER IT IN EXPIATION
FOR MY SINS.'"

(Protoevangelium of James 1:1)

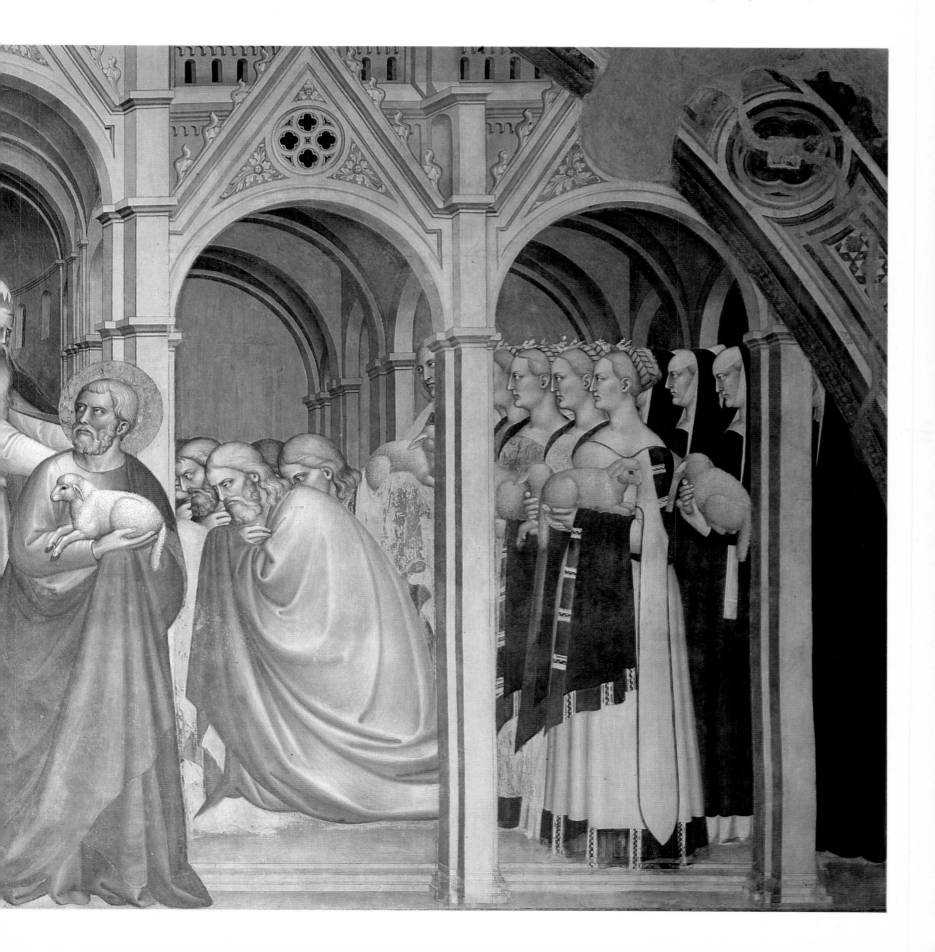

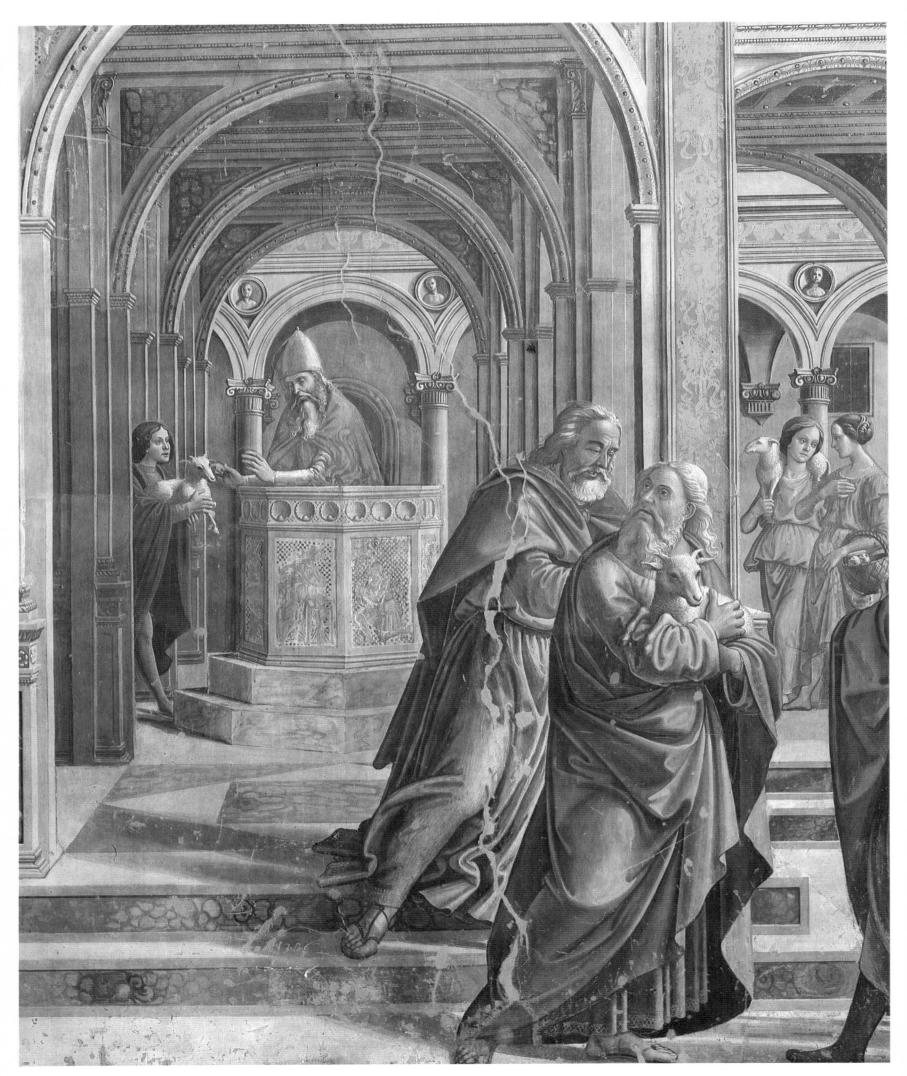

GHIRLANDAIO

ONE DAY WHEN JOACHIM HAD
COME TO MAKE A GENEROUS
OFFERING AT THE ALTAR AS
WAS HIS CUSTOM, HE WAS
REBUKED:

"IT IS NOT RIGHT
FOR YOU
TO OFFER GIFTS FIRST,
FOR YOU HAVE BEGOTTEN
NO OFFSPRING IN ISRAEL."

JOACHIM WAS OVERCOME
WITH SORROW AND AT THE
ADVICE OF HIS RELATIVES
CONSULTED THE TRIBAL REC-
ORDS OF HIS PEOPLE. HE
DID INDEED FIND THAT ALL
THE JUST ONES OF ISRAEL
HAD RAISED UP CHILDREN.
BUT IN HIS DEEP HUMILIA-
TION "HE REMEMBERED THE
PATRIARCH ABRAHAM, HOW
GOD HAD GIVEN HIM IN HIS
LAST DAYS A SON, ISAAC."

LEAVING HIS WIFE, THE
DEVOUT ISRAELITE WENT
INTO THE DESERT TO FAST
AND PRAY.

(Protoevangelium of James 1:2-4)

THERE WAS CERTAINLY NO GREATER MISFORTUNE FOR A JEWISH PERSON THAN TO BE CHILDLESS, FOR HAD NOT GOD PROMISED TO HIS PEOPLE DESCENDANTS LIKE THE SANDS OF THE SEA? EVERY WOMAN WAS DEEPLY IMPRESSED BY THESE PROMISES, AND IF SHE WERE BARREN SHE BELIEVED HERSELF AN OBJECT OF GOD'S DISPLEASURE. ANNE POURED FORTH HER SOUL IN BITTER COMPLAINT: "WHO FATHERED ME, AND WHAT WOMB BROUGHT ME FORTH, THAT I SHOULD BE A REPROACH IN ISRAEL?"

BUT ANNE REMEMBERED THE FAITH OF HER ANCESTORS, AND WITH RENEWED COURAGE MADE THIS PRAYER: "GOD OF MY FATHERS, BLESS ME: HEAR MY PRAYER, AS YOU BLESSED THE WOMB OF SARA, AND GAVE HER A SON, ISAAC!" AND, AGAINST ALL HOPE, HER PRAYER WAS HEARD: "BEHOLD, AN ANGEL OF THE LORD APPEARED TO HER AND SAID:

'ANNE, ANNE,

THE LORD HAS HEARD

YOUR PRAYER:

YOU SHALL CONCEIVE AND BEAR,

AND YOUR OFFSPRING

SHALL BE SPOKEN OF

IN THE WHOLE WORLD.'"

THIS WONDERFUL MESSAGE FOUND AN ECHO IN THE SOUL OF THE AFFLICTED ANNE. AND IN AN OUTPOURING OF FAITH SHE WHO WAS TO BE MARY'S MOTHER IMMEDIATELY CONSECRATED HER FUTURE OFFSPRING. SHE VOWED: "AS THE LORD LIVES, IF I BRING FORTH EITHER A MALE OR FEMALE CHILD, IT SHALL MINISTER TO GOD ALL THE DAYS OF ITS LIFE."

(Protoevangelium of James 1:3; 3:1; 2:4; 4:1)

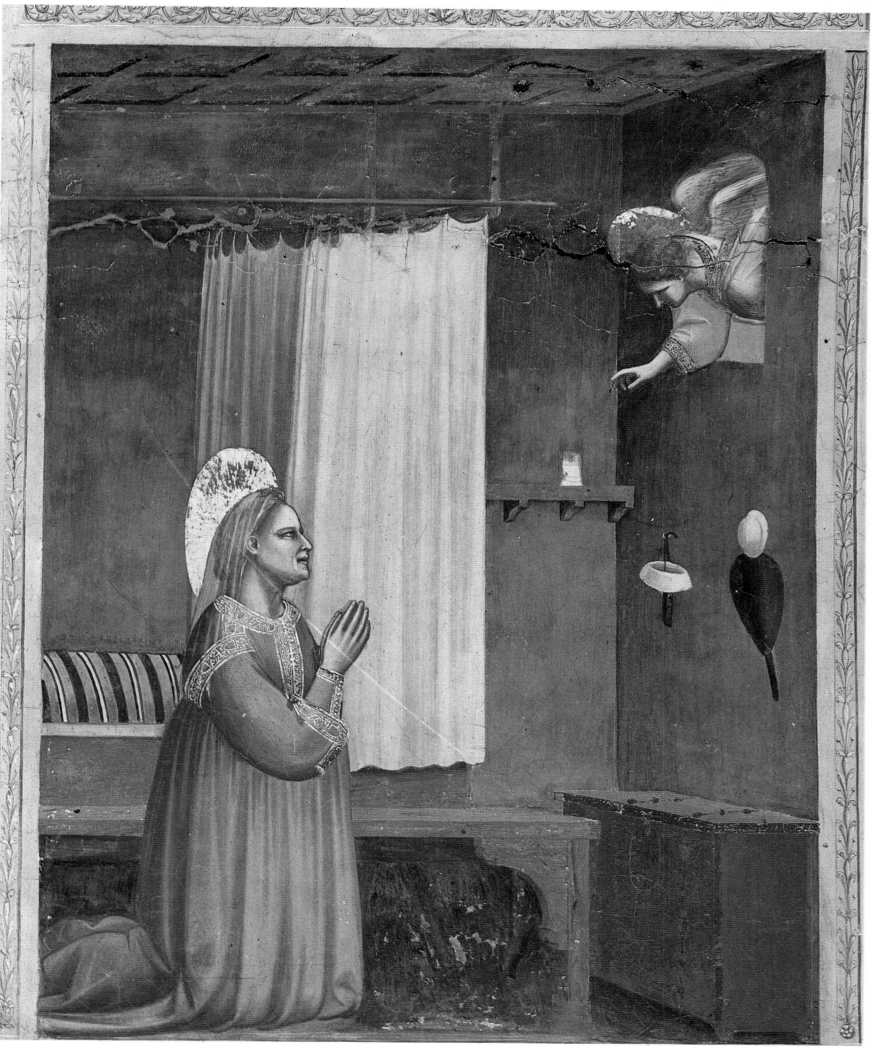

GIOTTO

AN ANGEL OF THE LORD AP-
PEARED TO JOACHIM, SAYING:

"JOACHIM, JOACHIM,
GOD HAS HEARD
YOUR PRAYER.
GO ON YOUR WAY,
FOR YOUR WIFE
WILL CONCEIVE."

(Protoevangelium of James 4:2)

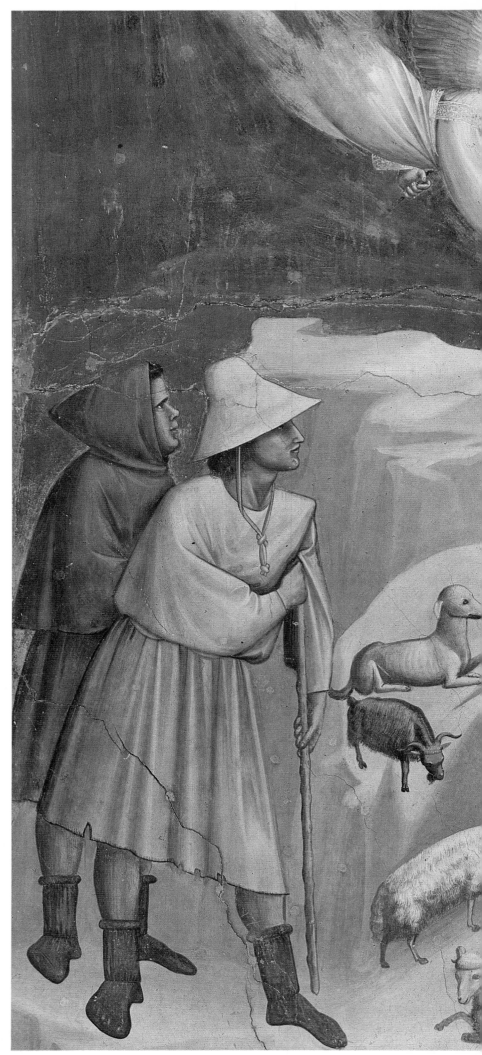

GIOTTO

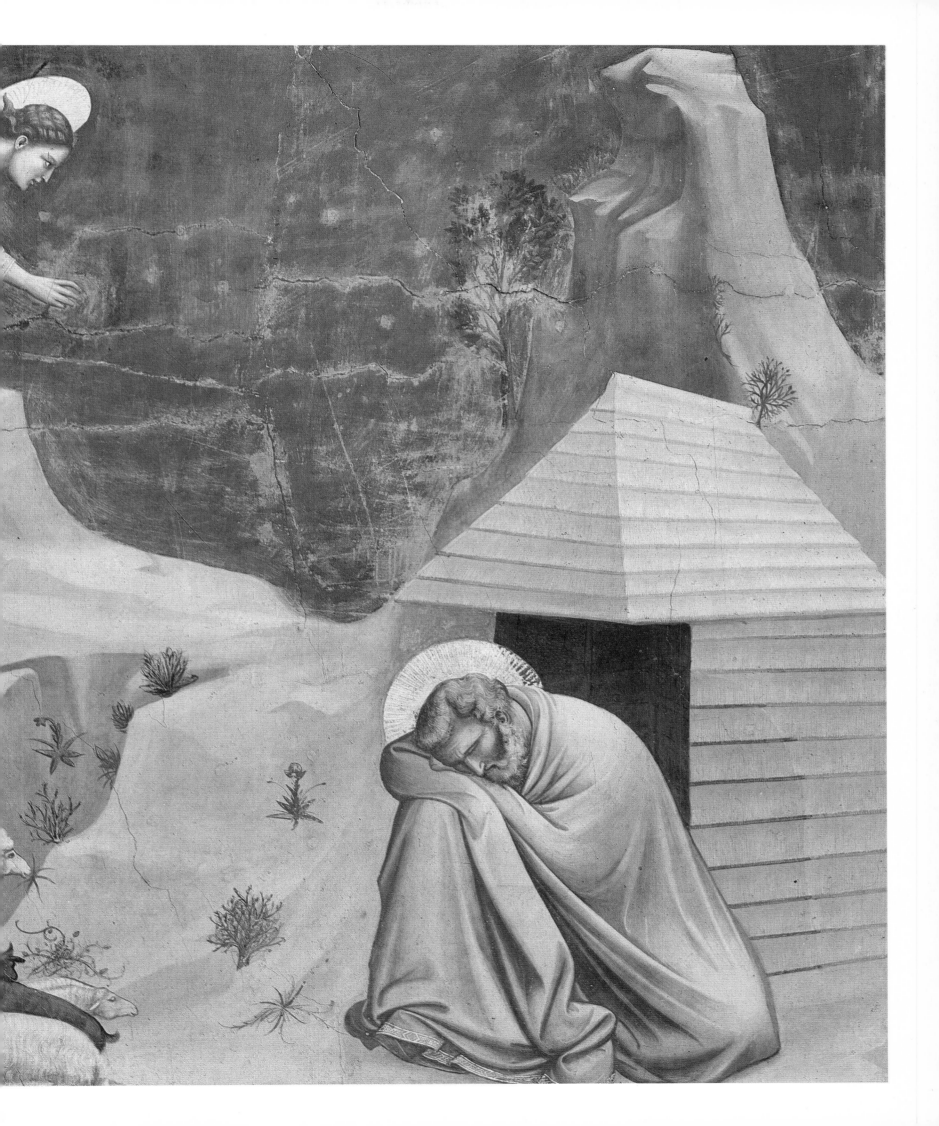

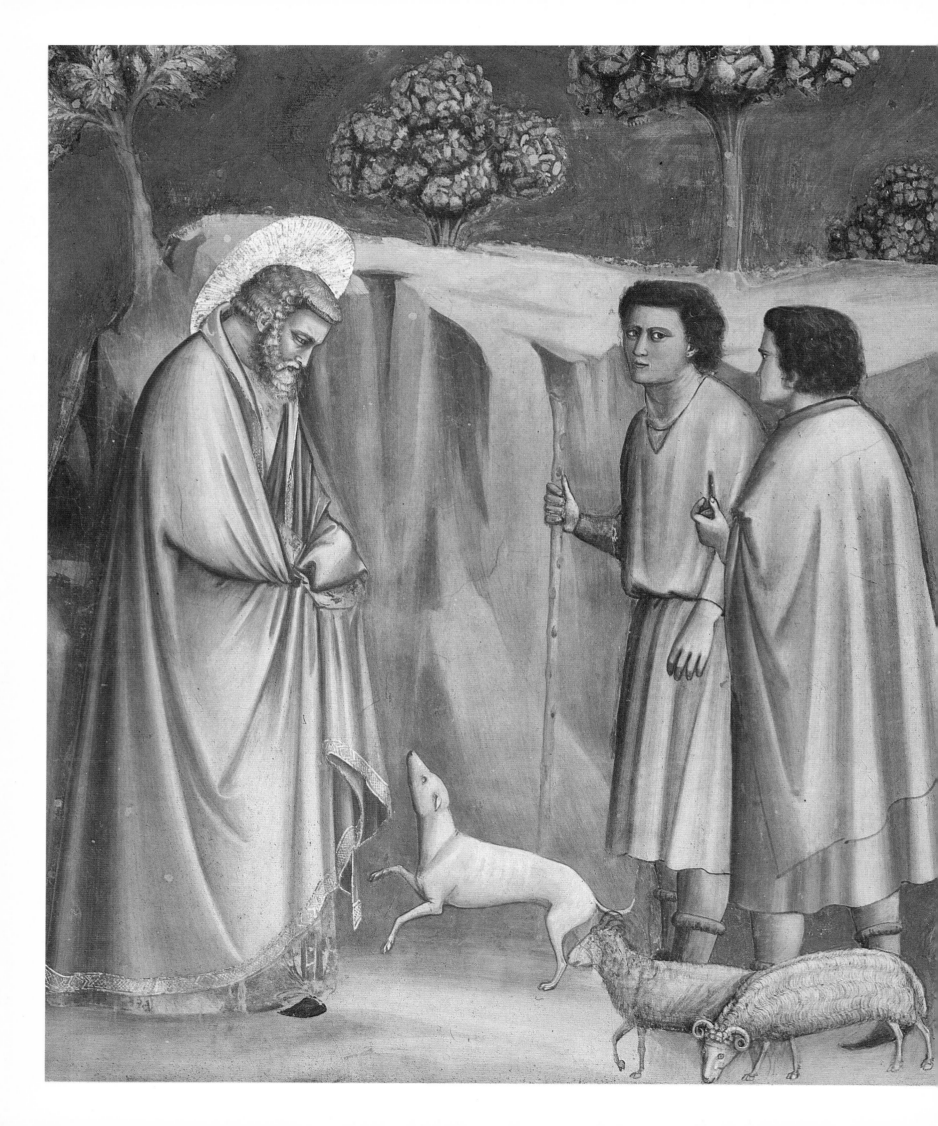

DIVINELY WARNED TO LEAVE HIS SOLITUDE, JOACHIM HURRIED TO REJOIN HIS WIFE. HE GAVE HIS SHEPHERDS THIS ORDER: "BRING TO ME TEN LAMBS WITHOUT BLEMISH AND WITHOUT DEFECT: THEY WILL BE FOR THE LORD MY GOD. BRING ME ALSO TWELVE TENDER CALVES: THEY WILL BE FOR THE PRIESTS AND THE SANHEDRIN. AND ALSO ONE HUNDRED KID GOATS FOR ALL THE PEOPLE."

(Protoevangelium of James 4:3)

GIOTTO

JOACHIM CAME WITH HIS FLOCKS, AND ANNE STOOD AT THE GATE. WHEN SHE SAW HIM SHE RAN AND HUNG ON HIS NECK, SAYING TO HIM:

"NOW I KNOW THAT THE LORD GOD HAS BLESSED ME EXCEEDINGLY, FOR I WAS A WIDOW, BUT NOT ANY LONGER; I WAS CHILDLESS AND I SHALL CONCEIVE."

AND JOACHIM RESTED THE FIRST DAY IN HIS HOUSE.

(Protoevangelium of James 4:4)

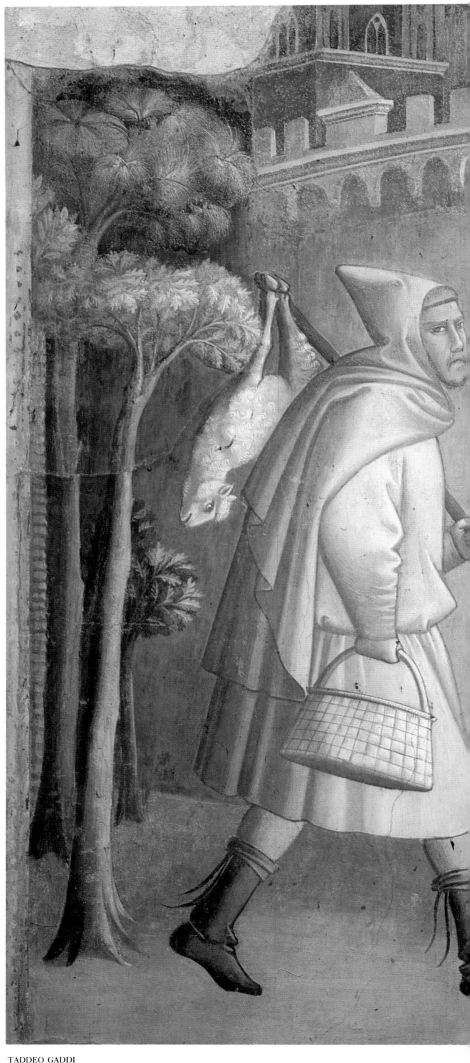

TADDEO GADDI

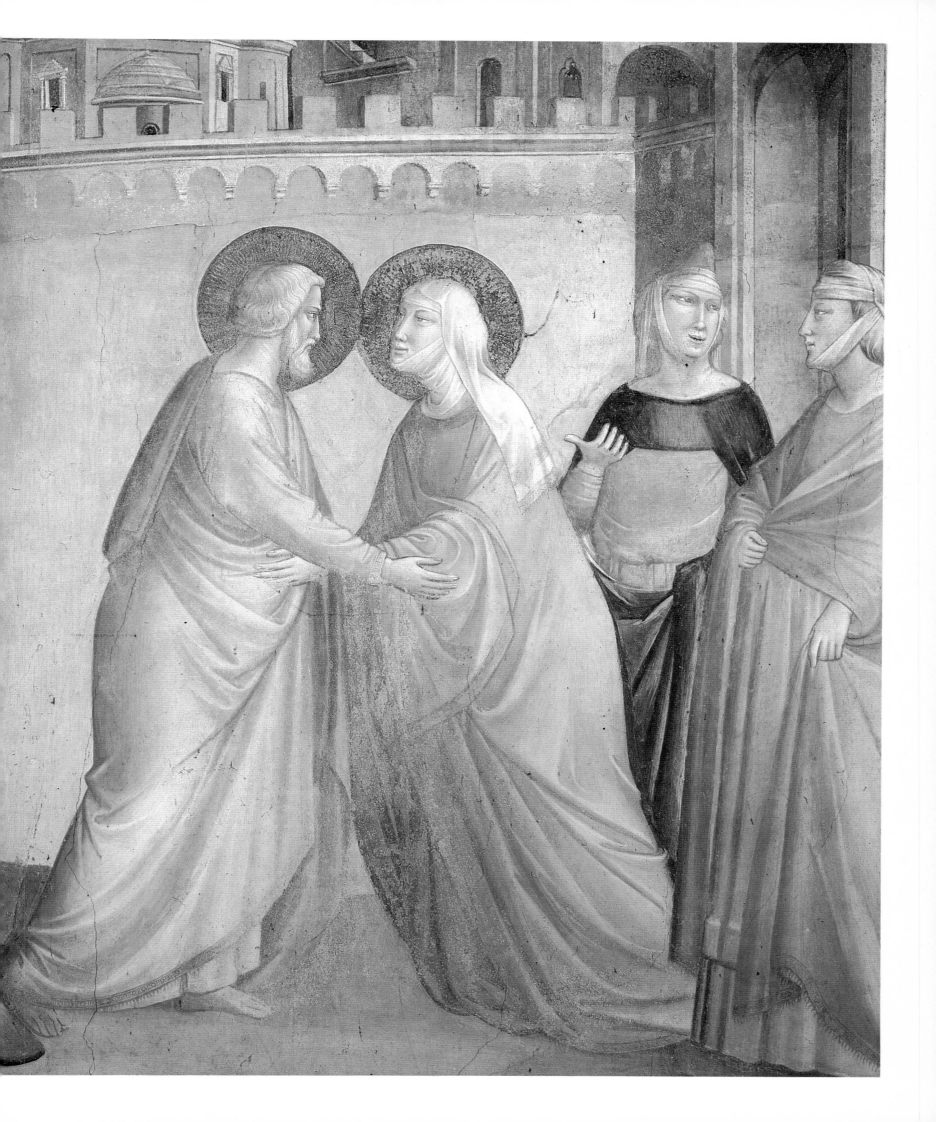

AND HER MONTHS WERE FULFILLED, AND IN THE NINTH MONTH ANNE GAVE BIRTH. AND SHE ASKED THE MIDWIFE: "WHAT HAVE I BROUGHT FORTH?" AND SHE SAID, "A GIRL." AND ANNE SAID:

"MY SOUL IS GLORIFIED THIS DAY,"

AND SHE LAY DOWN. AND WHEN THE DAYS WERE FULFILLED, ANNE PURIFIED HERSELF AND NURSED THE CHILD AND CALLED HER NAME MARY.

(Protoevangelium of James 5:2)

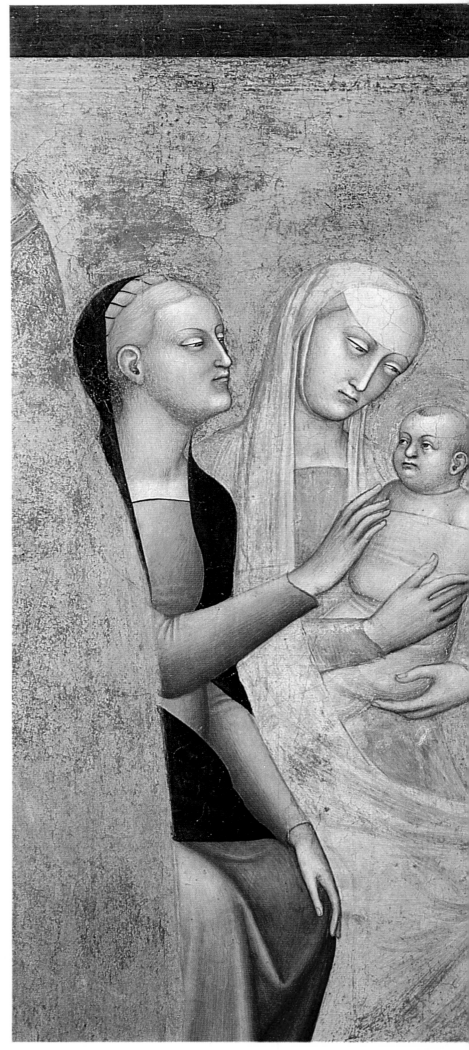

GIOVANNI DA MILANO

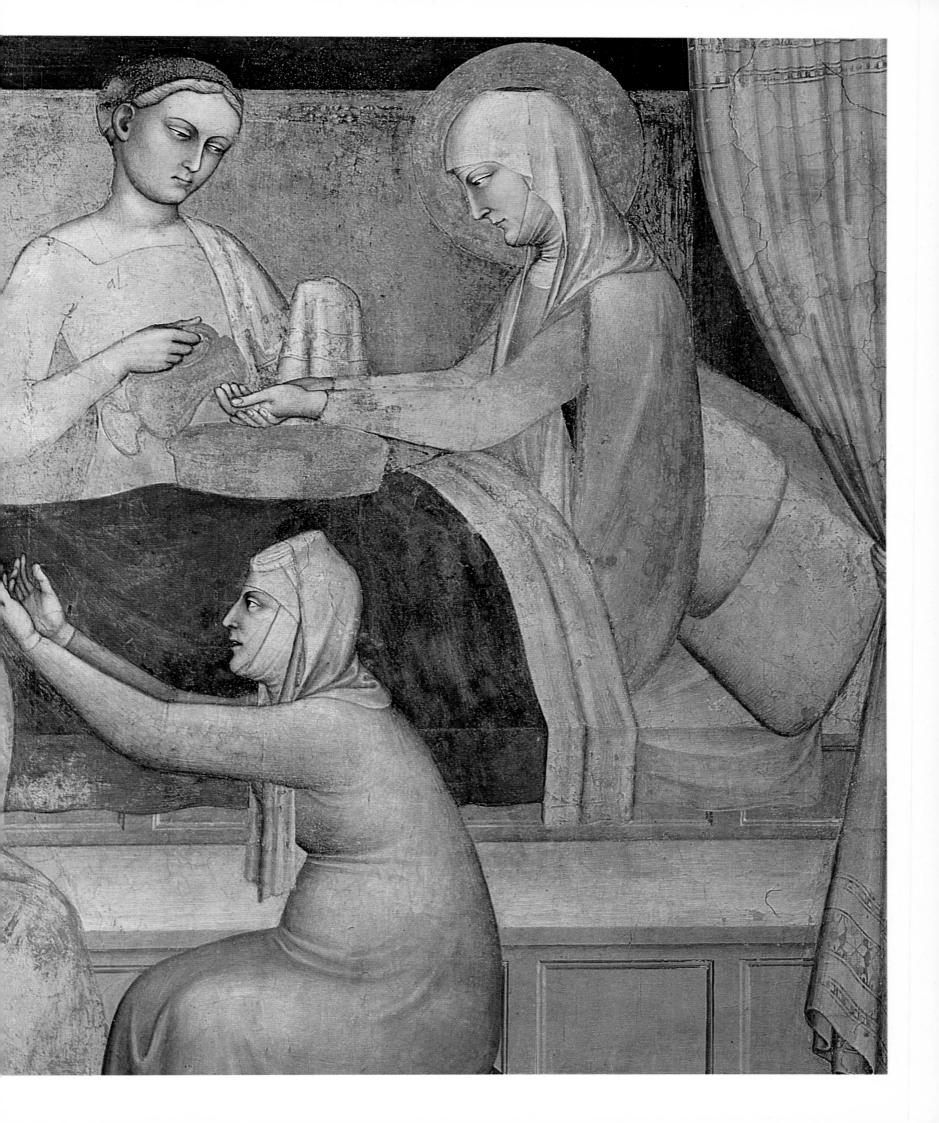

ANNE, BLESSED ABOVE ALL OTHERS, WE, TOO, BRING OUR REVER-
ENCE, FOR YOU HAVE GIVEN BIRTH TO THE GIRL FROM WHOM HE
WILL COME WHO IS THE BASIS OF ALL OUR HOPE. BLESSED,
INDEED, ABOVE ALL OTHERS, AND BLESSED IN YOUR OFFSPRING!

THE TONGUES OF ALL BELIEVERS SING THE PRAISES OF YOUR
CHILD. EVERY VOICE IS RAISED IN JOY AT HER BIRTH. HOW WORTHY
ANNE IS OF PRAISE, MOST WORTHY, FOR SHE RECEIVED THE
MESSAGE OF GOD'S GOODNESS, AND BROUGHT FORTH SUCH FRUIT
THAT FROM IT WOULD COME OUR LORD, JESUS.

(St. John Damascene)

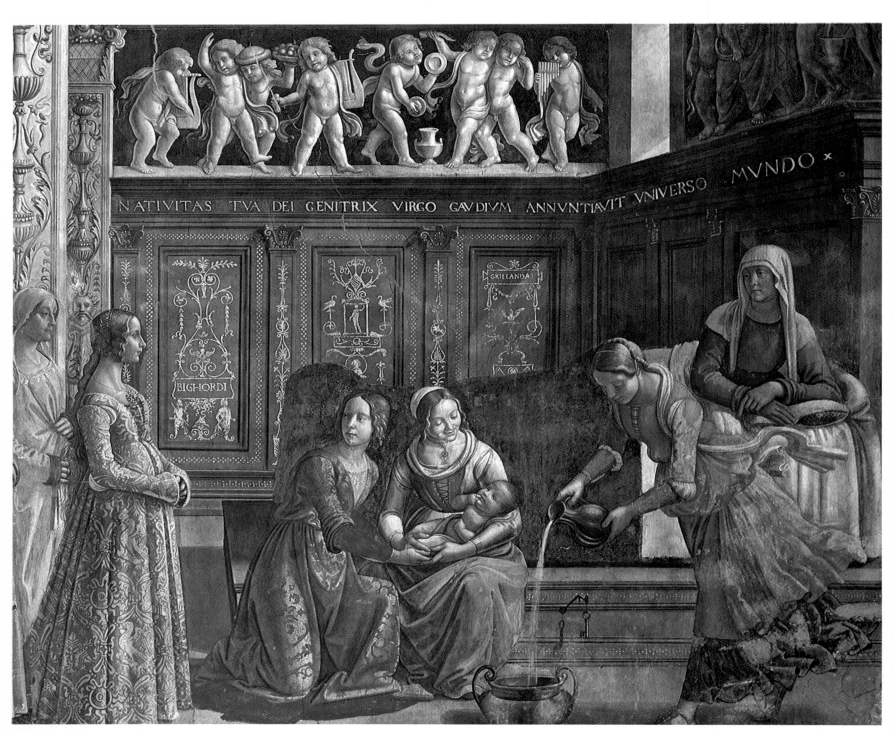

GHIRLANDAIO

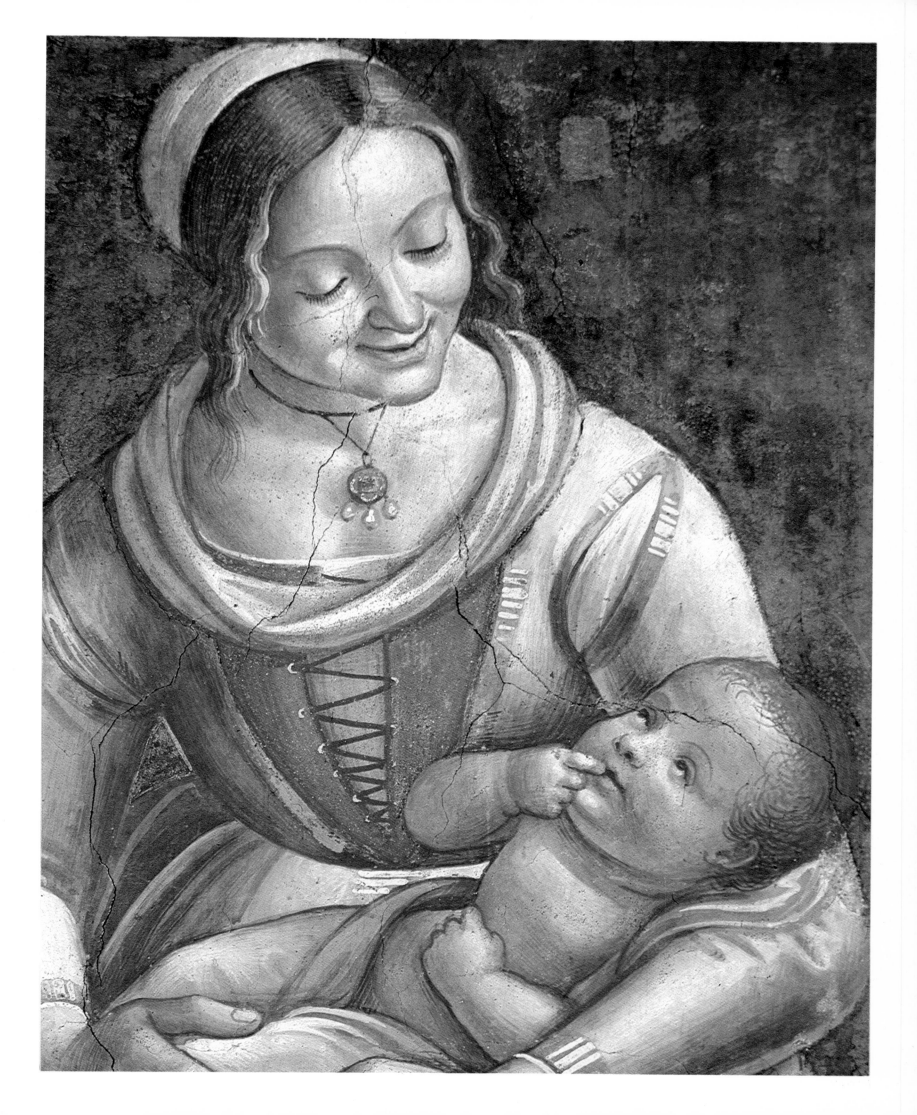

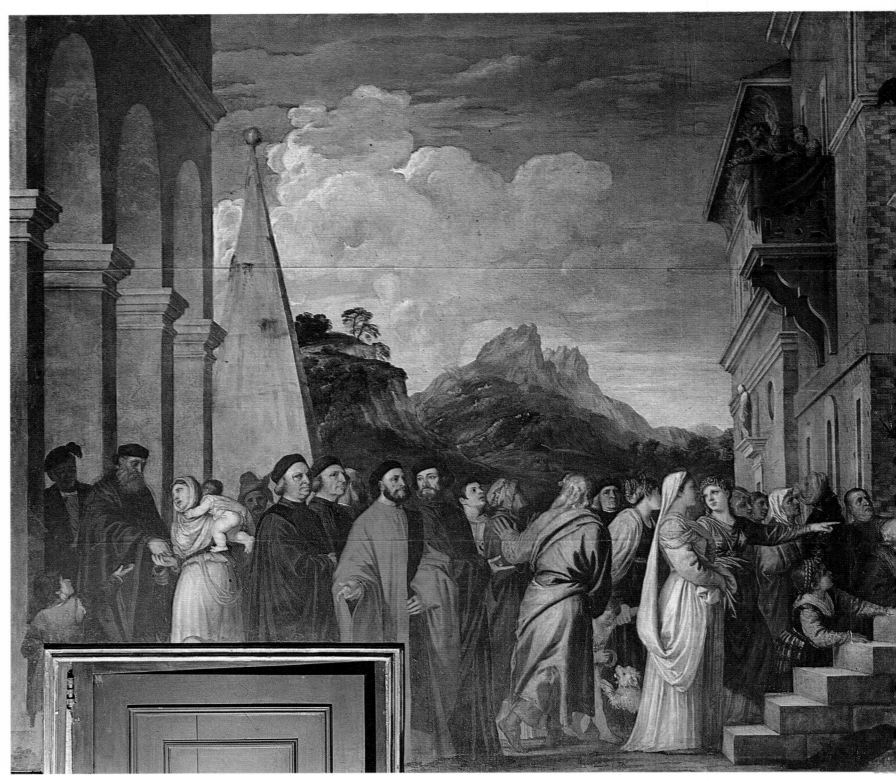

TRADITION NARRATES THAT IN GRATITUDE TO THE LORD FOR THE BLESSING OF A DAUGHTER, JOACHIM AND ANNE VOWED TO CONSECRATE HER TO HIM IN THE TEMPLE AS SOON AS HER AGE PERMITTED IT. AND THEY WERE FAITHFUL TO THEIR PROMISE.

MARY WAS SCARCELY THREE YEARS OLD WHEN, ACCOMPANIED BY HER PARENTS, SHE FIRST SET FOOT IN THE TEMPLE. HERE THE NOBLE CHILD WAS ADMITTED TO THE ELECT GROUP OF VIRGINS CONSECRATED TO GOD. THE EXACT TIME OF MARY'S PRESENTATION IN

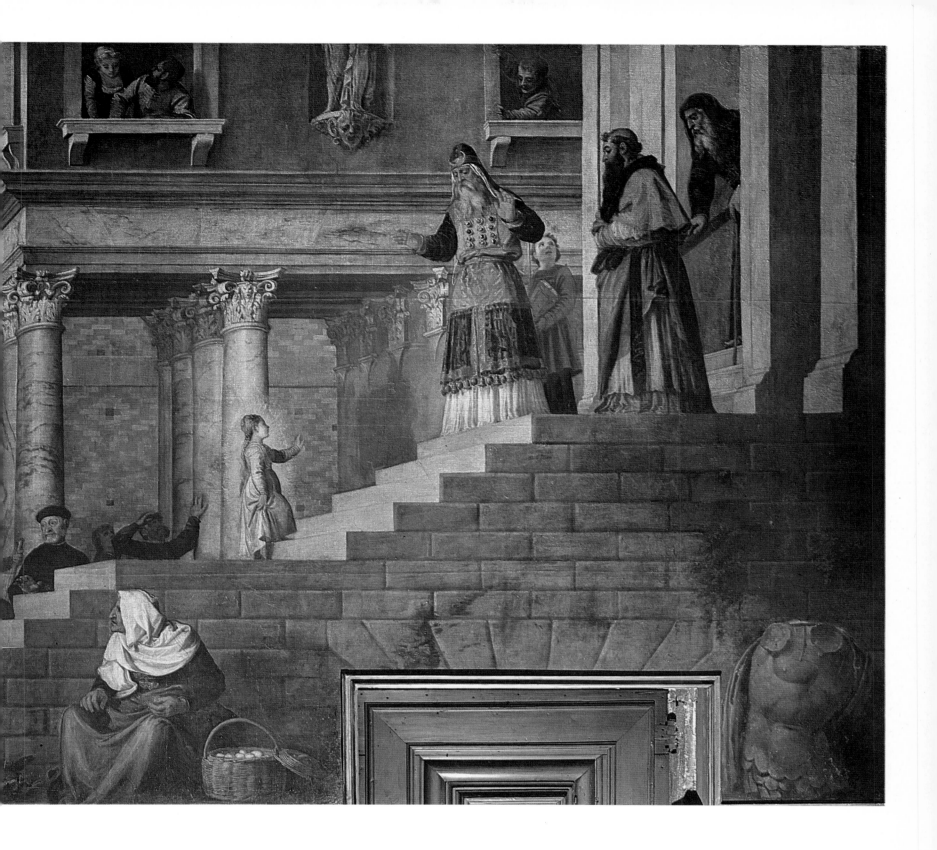

THE TEMPLE IS UNKNOWN. THE CHURCH CELEBRATES THE FEAST OF THE PRESENTATION ON NOVEMBER TWENTY-FIRST.

THE PURPOSE OF MARY'S PRESENTATION IN THE TEMPLE WAS TWOFOLD: THAT SHE MIGHT CONSECRATE HERSELF TO THE LORD AND RECEIVE A SUITABLE SPIRITUAL FORMATION.

(Rev. James Alberione, S.S.P., S.T.D.)

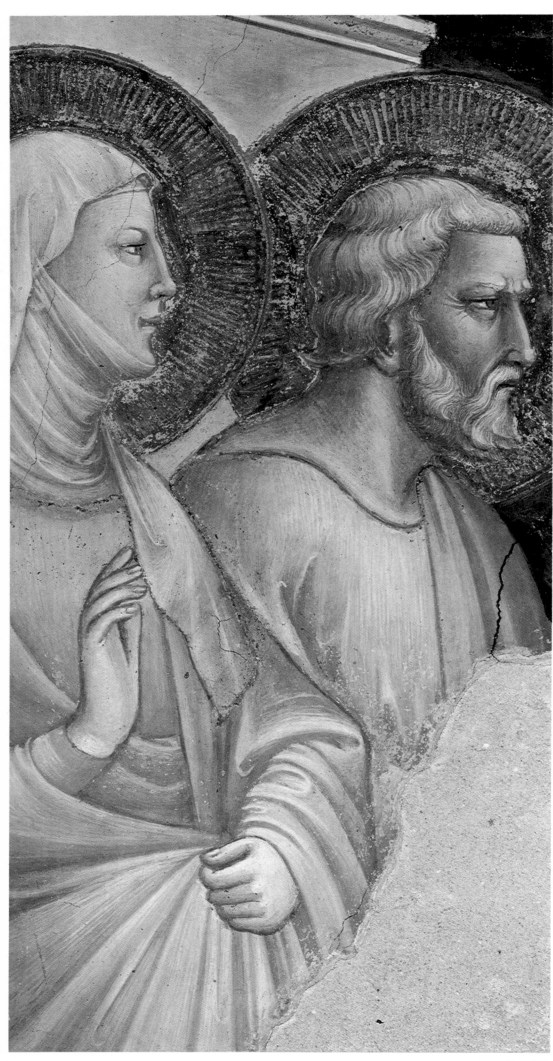

THE DESIRES OF THE WORLD AND THE CONCUPISCENCE OF THE FLESH NEVER TOUCHED HER PURE SOUL. SHE WAS PRESERVED VIRGINAL, BODY AND SOUL, AS BECAME ONE WHO WOULD SOMEDAY RECEIVE HER GOD INTO HER BOSOM.

(St. John Damascene)

TADDEO GADDI

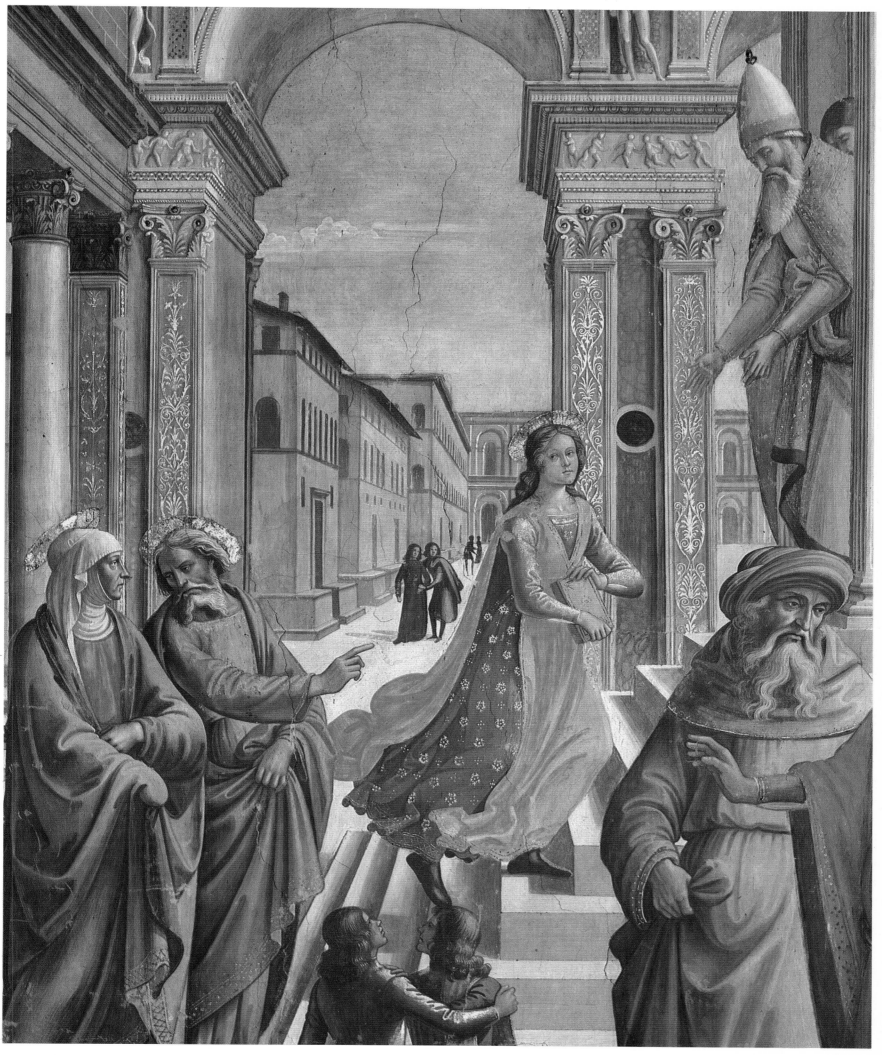

GHIRLANDAIO

MARY WAS BETROTHED TO A MAN

WHOSE NAME WAS JOSEPH,

OF THE HOUSE OF DAVID.

(cf. Luke 1:27)

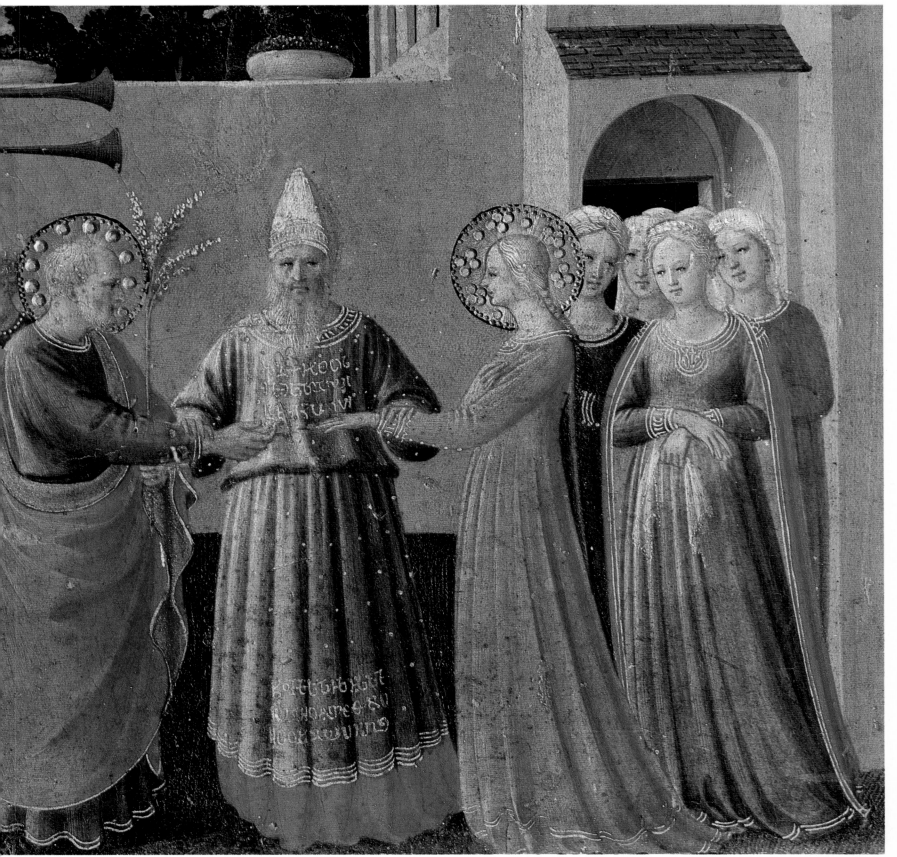

FRA ANGELICO

I WILL GREATLY REJOICE IN
 THE LORD,
 MY SOUL SHALL EXULT IN
 MY GOD;
FOR HE HAS CLOTHED ME
 WITH THE GARMENTS
 OF SALVATION,
 HE HAS COVERED ME WITH
 THE ROBE OF
 RIGHTEOUSNESS,
AS A BRIDEGROOM DECKS
 HIMSELF WITH A GARLAND,
 AND AS A BRIDE ADORNS
 HERSELF WITH HER JEWELS.

(Isaiah 61:10)

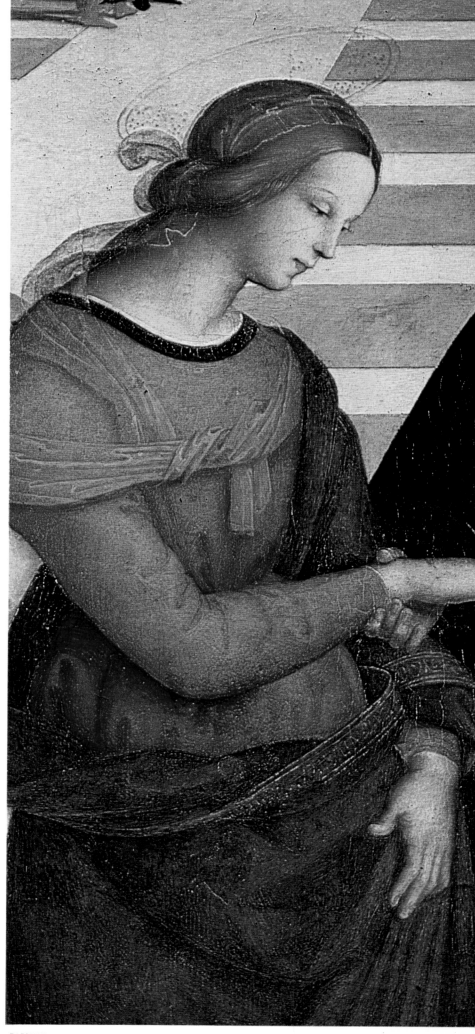

RAPHAEL

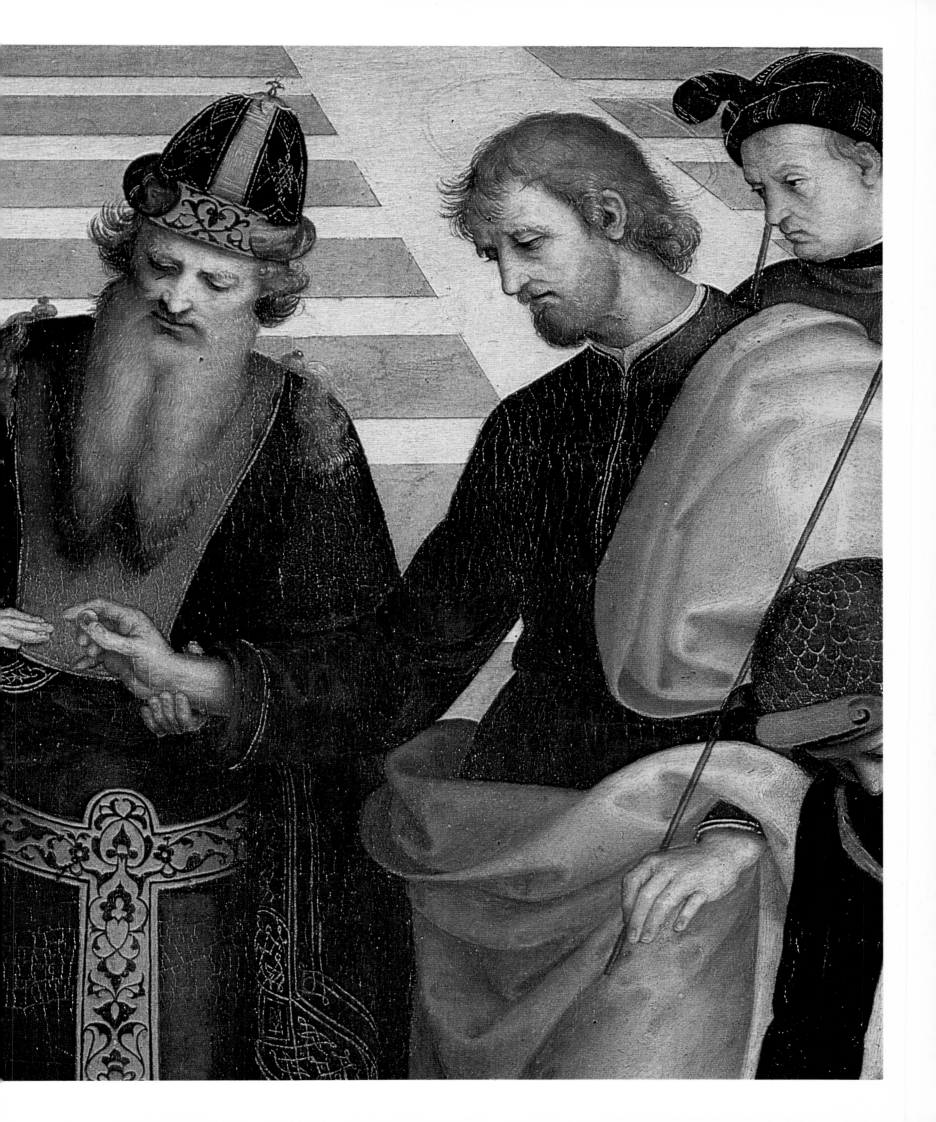

HAIL, FULL

OF GRACE

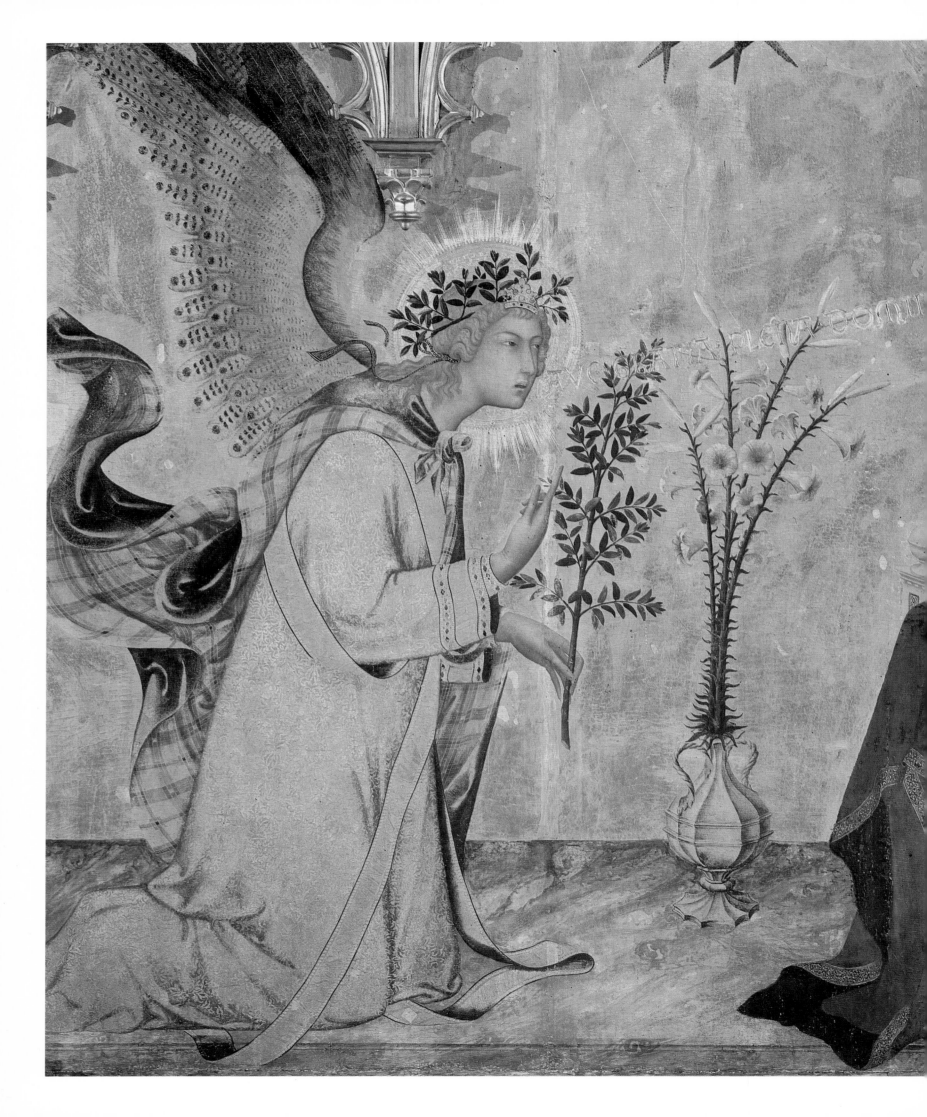

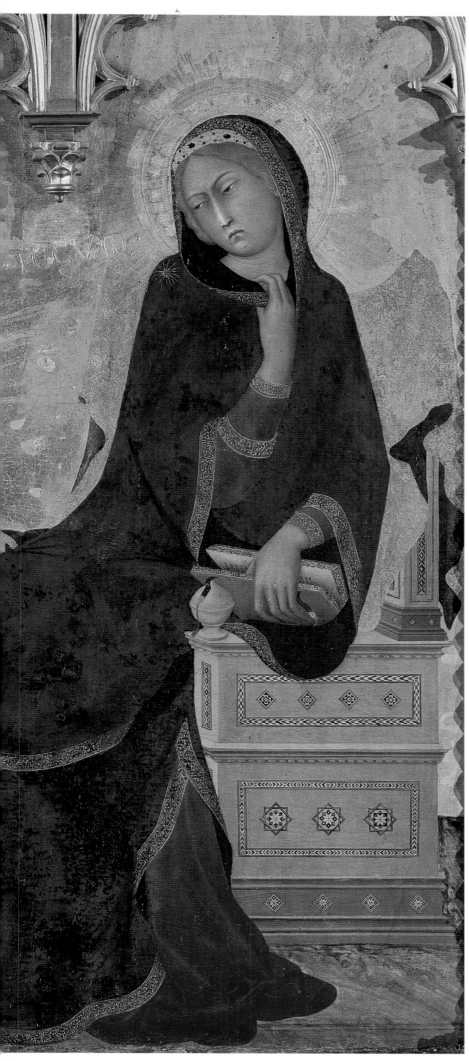

IN THE SIXTH MONTH THE
ANGEL GABRIEL WAS SENT
FROM GOD TO A CITY OF
GALILEE NAMED NAZARETH,
TO A VIRGIN BETROTHED TO
A MAN WHOSE NAME WAS
JOSEPH, OF THE HOUSE OF
DAVID; AND THE VIRGIN'S
NAME WAS MARY.

(Luke 1:26-27)

SIMONE MARTINI

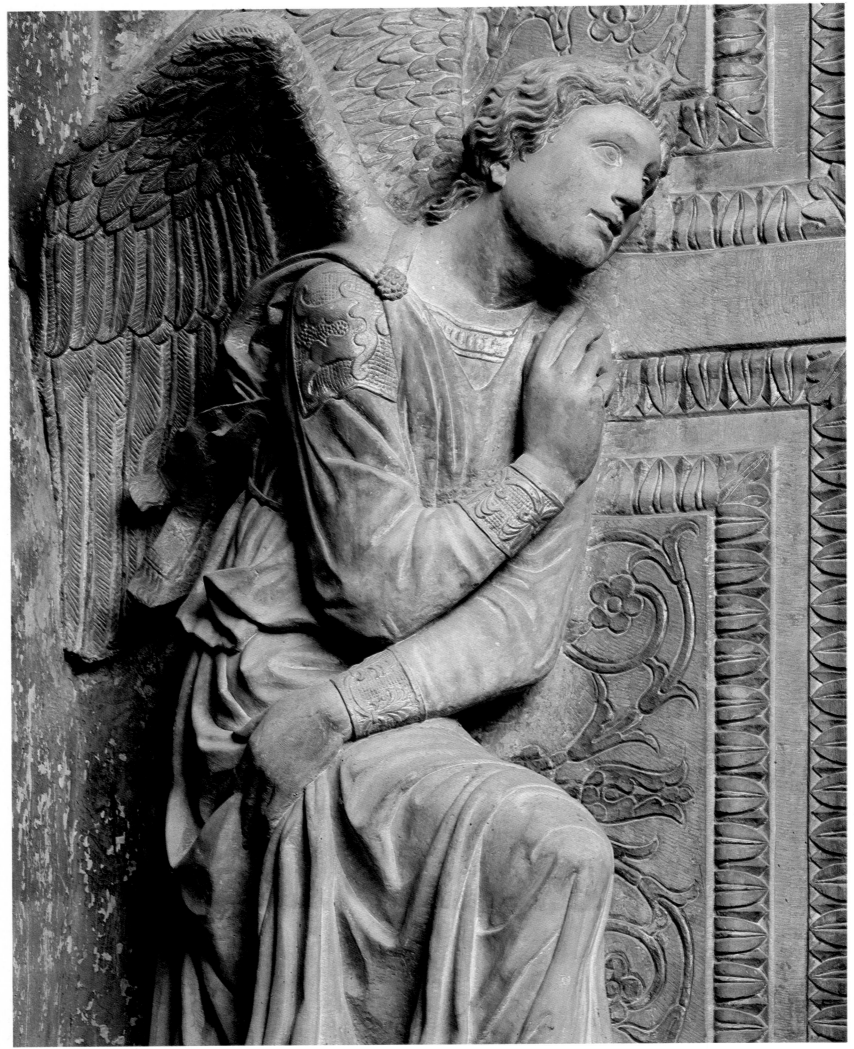

DONATELLO

AND HE CAME TO HER AND SAID,

"HAIL, FULL OF GRACE, THE LORD IS WITH YOU!"

BUT SHE WAS GREATLY TROUBLED AT THE SAYING, AND CONSIDERED IN HER MIND WHAT SORT OF GREETING THIS MIGHT BE. AND THE ANGEL SAID TO HER, "DO NOT BE AFRAID, MARY, FOR YOU HAVE FOUND FAVOR WITH GOD. AND BEHOLD, YOU WILL CONCEIVE IN YOUR WOMB AND BEAR A SON, AND YOU SHALL CALL HIS NAME JESUS.

HE WILL BE GREAT, AND WILL BE CALLED THE SON OF THE MOST HIGH;

AND THE LORD GOD WILL GIVE TO HIM THE THRONE OF HIS FATHER DAVID, AND HE WILL REIGN OVER THE HOUSE OF JACOB FOR EVER;

AND OF HIS KINGDOM THERE WILL BE NO END."

AND MARY SAID TO THE ANGEL, "HOW CAN THIS BE, SINCE I HAVE NO HUSBAND?"

AND THE ANGEL SAID TO HER,

"THE HOLY SPIRIT WILL COME UPON YOU, AND THE POWER OF THE MOST HIGH WILL OVERSHADOW YOU;

THEREFORE THE CHILD TO BE BORN WILL BE CALLED HOLY,

THE SON OF GOD.

AND BEHOLD, YOUR KINSWOMAN ELIZABETH IN HER OLD AGE HAS ALSO CONCEIVED A SON; AND THIS IS THE SIXTH MONTH WITH HER WHO WAS CALLED BARREN. FOR WITH GOD NOTHING WILL BE IMPOSSIBLE."

(Luke 1:28-37)

"BEHOLD, I AM THE HANDMAID
OF THE LORD;
LET IT BE TO ME
ACCORDING TO YOUR WORD."

(Luke 1:38)

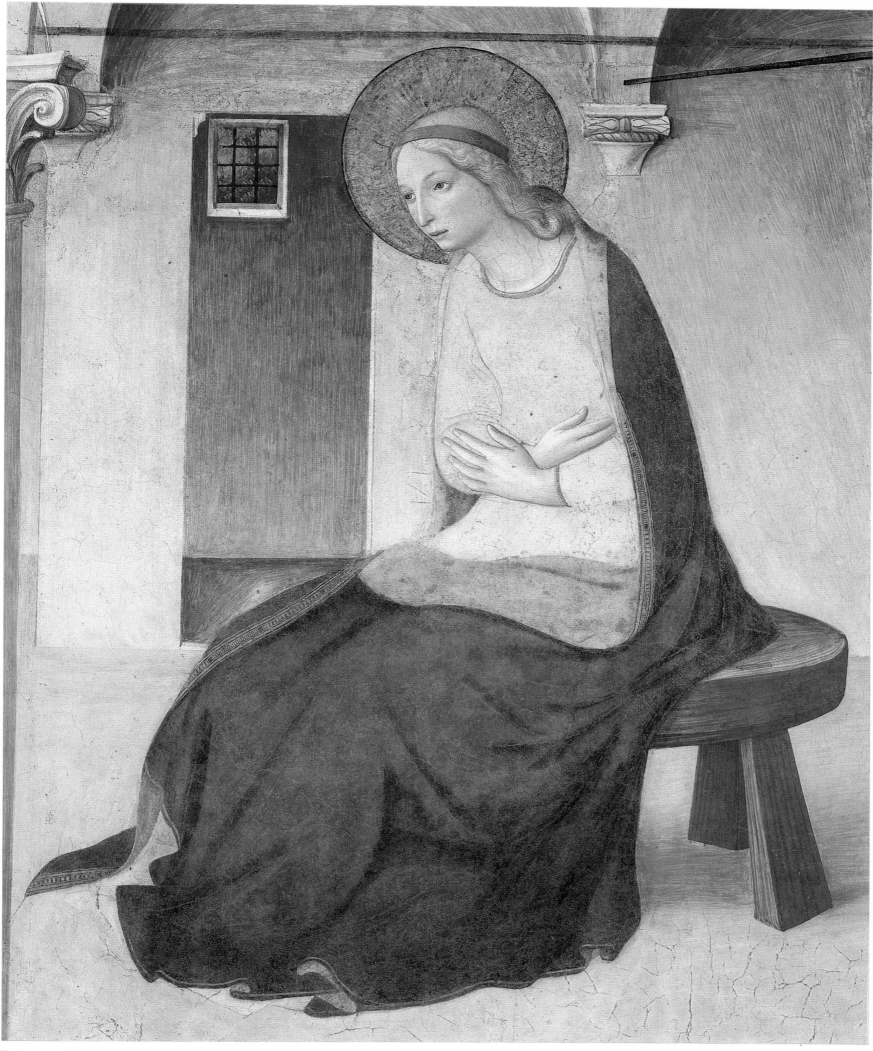

FRA ANGELICO

IN THOSE DAYS MARY AROSE
AND WENT WITH HASTE INTO
THE HILL COUNTRY, TO A
CITY OF JUDAH, AND SHE
ENTERED THE HOUSE OF
ZECHARIAH AND GREETED
ELIZABETH.

AND WHEN ELIZABETH
HEARD THE GREETING
OF MARY,
THE BABE LEAPED
IN HER WOMB.

(Luke 1:39-41)

GHIRLANDAIO

ELIZABETH WAS FILLED WITH THE HOLY SPIRIT AND SHE EXCLAIMED WITH A LOUD CRY,

"BLESSED ARE YOU AMONG WOMEN, AND BLESSED IS THE FRUIT OF YOUR WOMB!

AND WHY IS THIS GRANTED ME, THAT THE MOTHER OF MY LORD SHOULD COME TO ME? FOR BEHOLD, WHEN THE VOICE OF YOUR GREETING CAME TO MY EARS, THE BABE IN MY WOMB LEAPED FOR JOY. AND BLESSED IS SHE WHO BELIEVED THAT THERE WOULD BE A FULFILLMENT OF WHAT WAS SPOKEN TO HER FROM THE LORD."

(Luke 1:41-45)

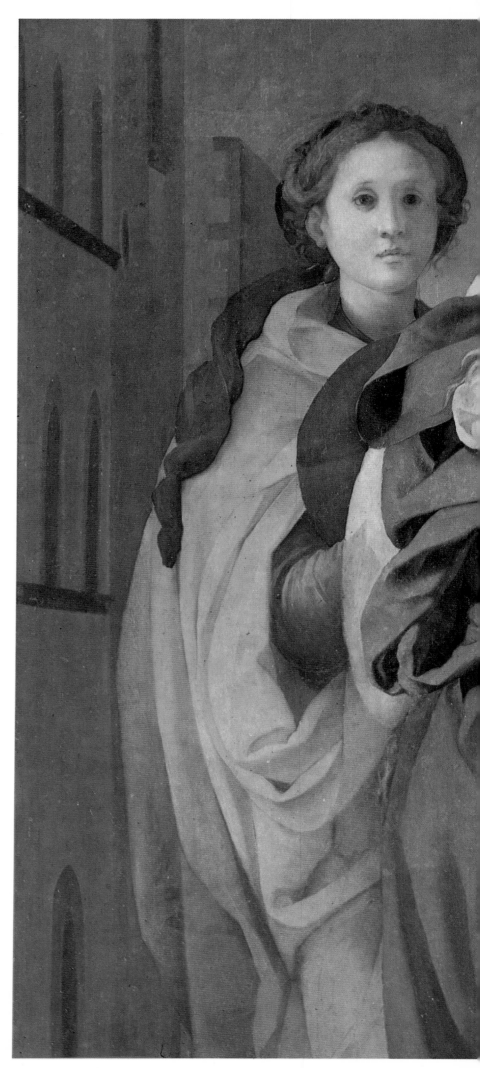

54

PONTORMO

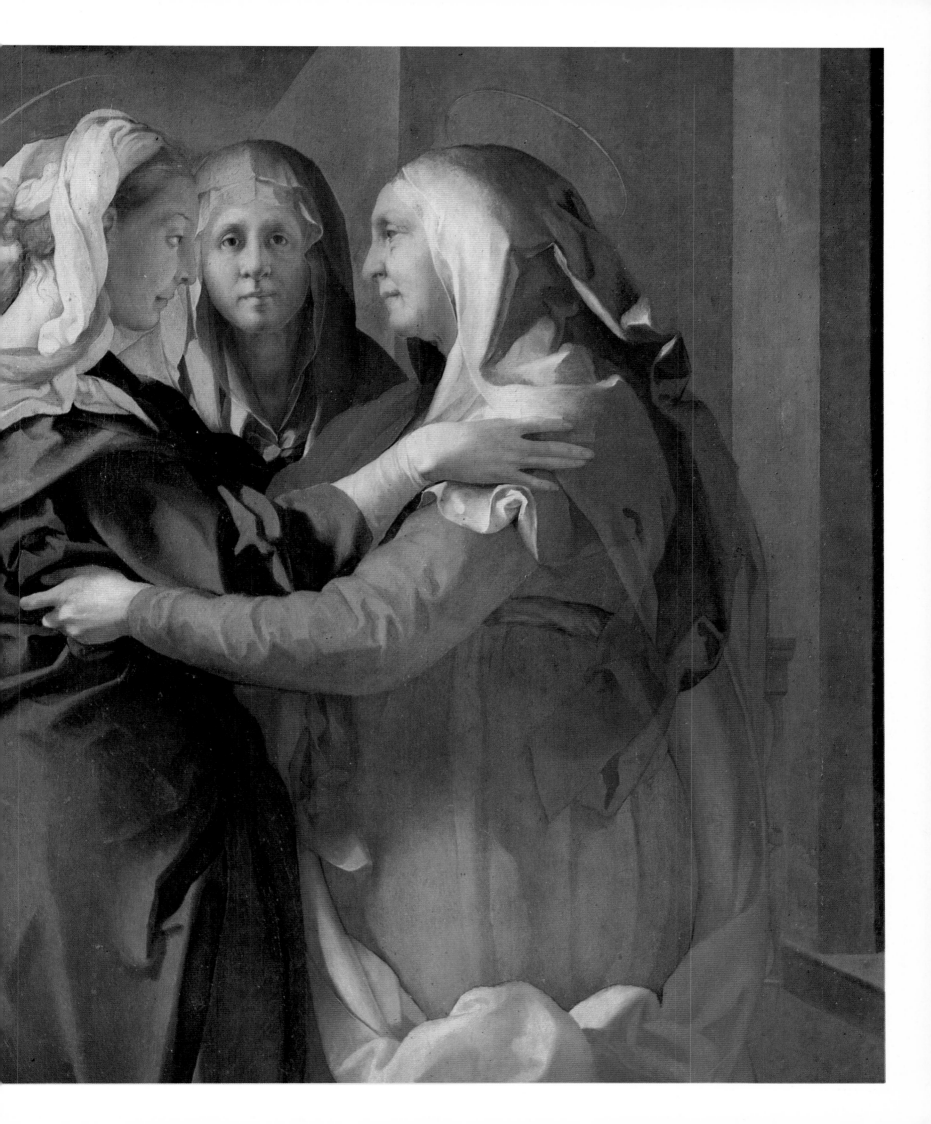

AND MARY SAID,

"MY SOUL MAGNIFIES THE LORD,

AND MY SPIRIT REJOICES IN GOD MY SAVIOR,

FOR HE HAS REGARDED THE LOW ESTATE OF HIS

HANDMAIDEN.

FOR BEHOLD, HENCEFORTH ALL GENERATIONS WILL

CALL ME BLESSED."

(Luke 1:46-48)

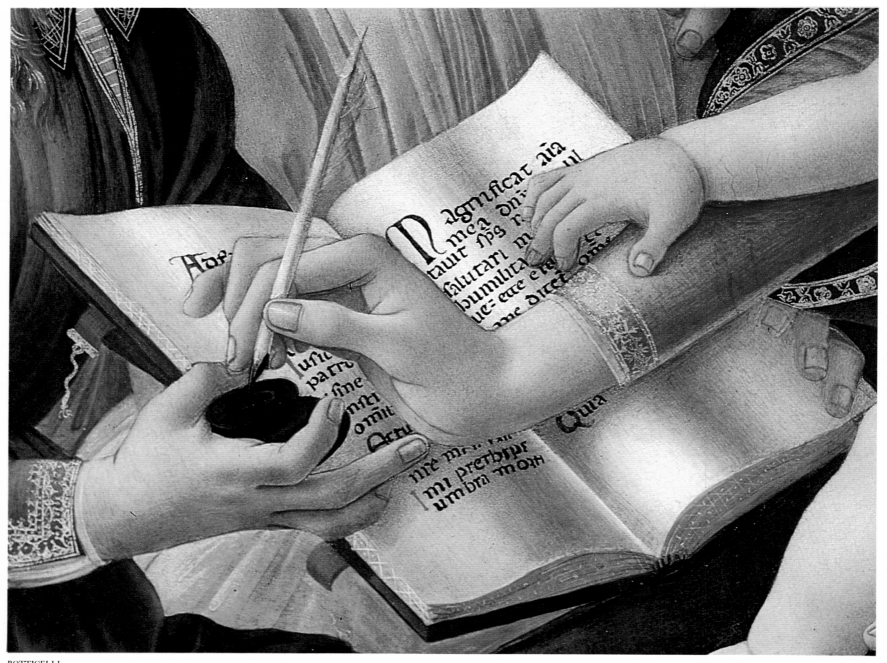

BOTTICELLI

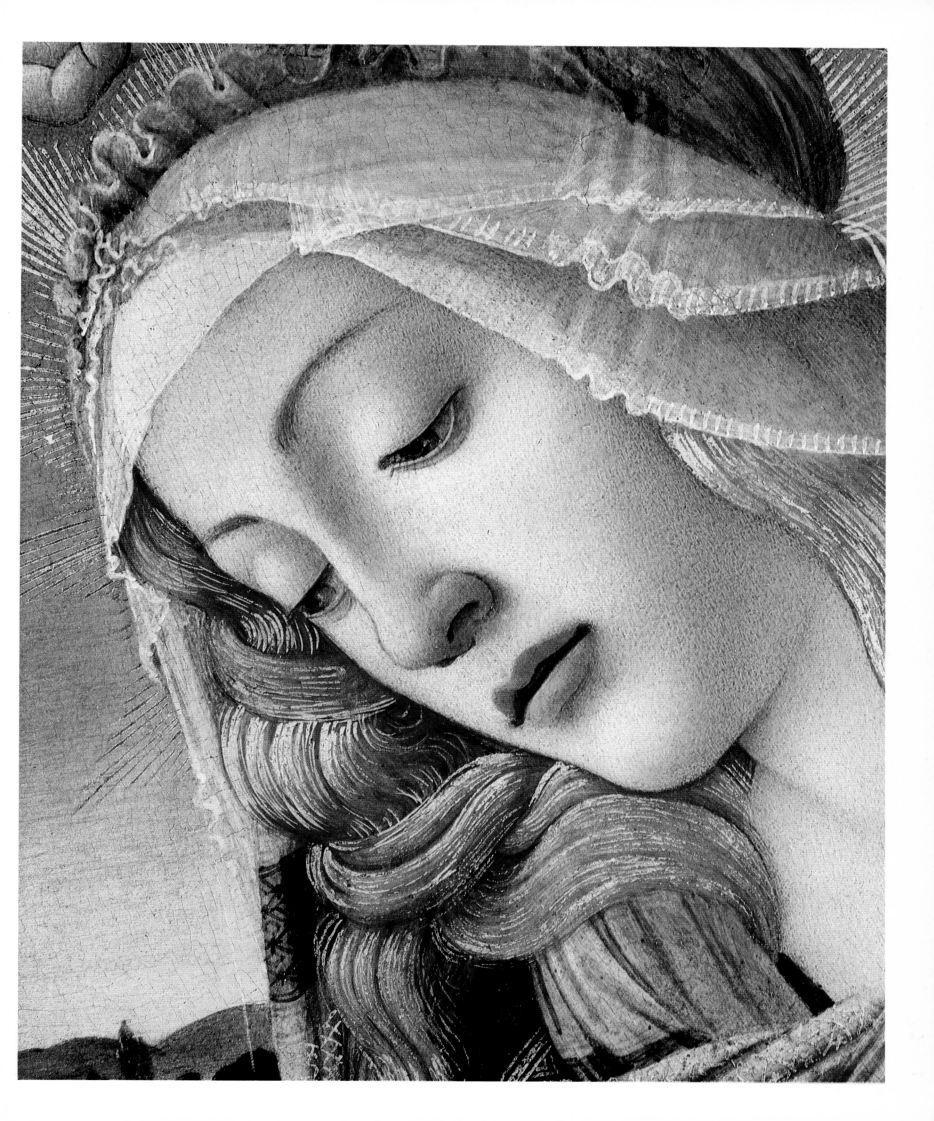

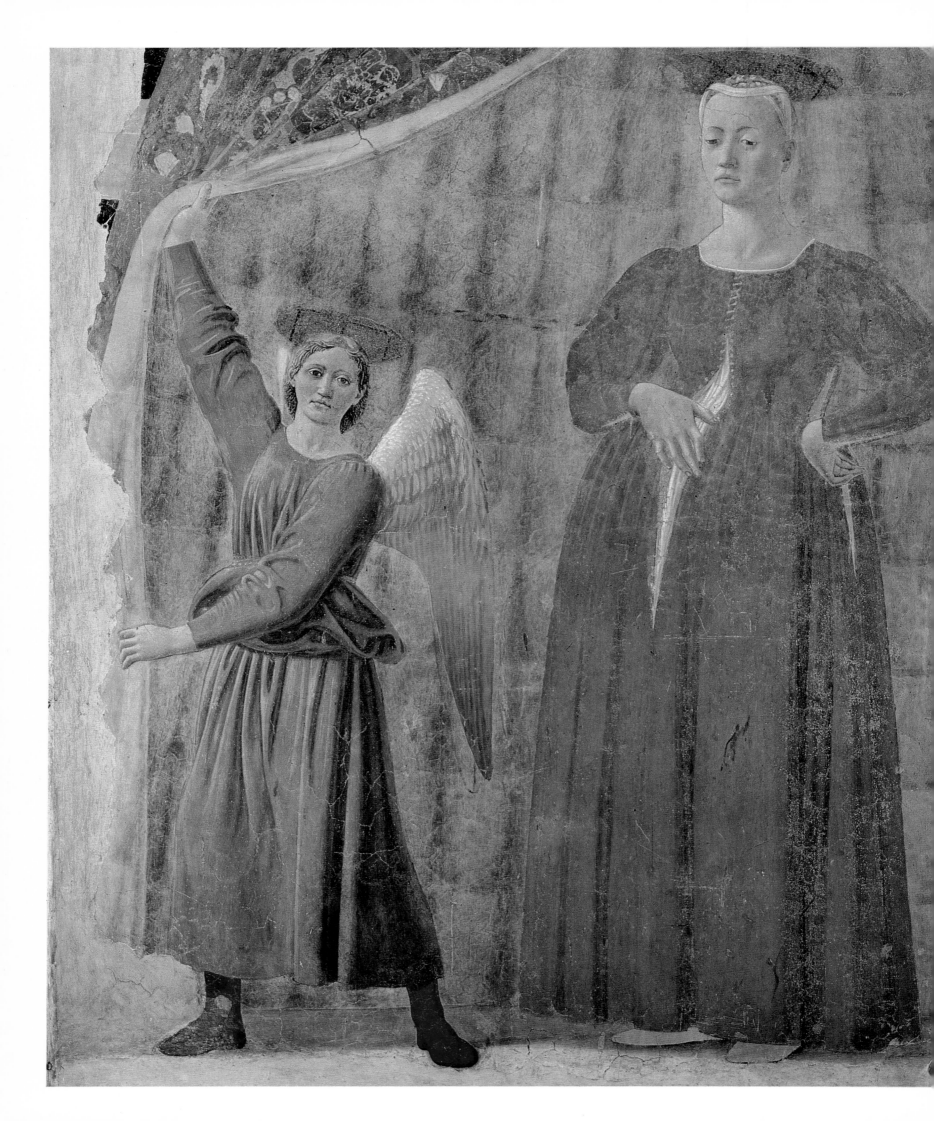

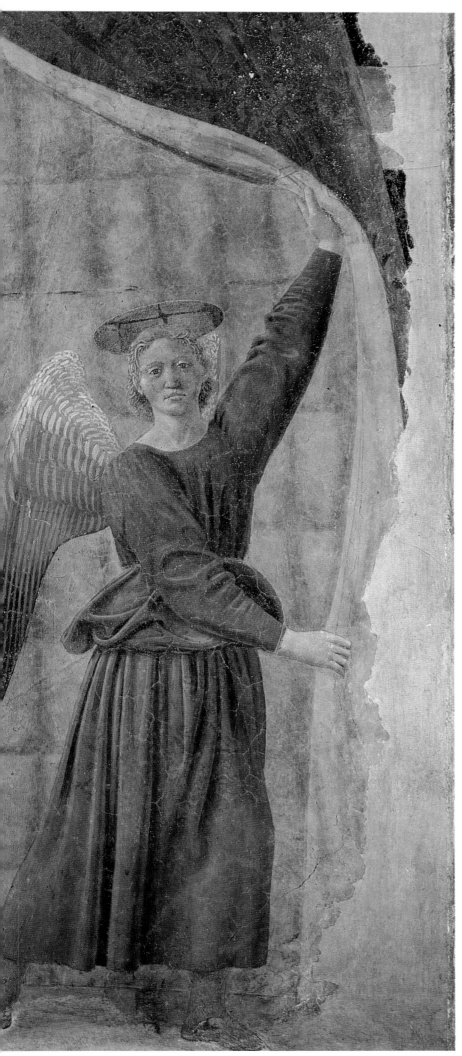

O MARY, YOU HAVE BEEN RAISED ABOVE EVERY CREATURE. YOU HAVE SURPASSED ALL IN PURITY. ONLY YOU HAVE BEEN CHOSEN TO BEAR THE CREATOR OF ALL CREATURES IN YOUR WOMB, GIVEN HIM TO THE WORLD, PRESSED HIM TO YOUR BOSOM.

ONLY YOU, FROM AMONG ALL CREATION, HAVE BEEN MADE THE MOTHER OF GOD.

(St. Sophronius)

WHEN HIS MOTHER MARY HAD BEEN BETROTHED TO JOSEPH, BEFORE THEY CAME TOGETHER SHE WAS FOUND TO BE WITH CHILD OF THE HOLY SPIRIT; AND HER HUSBAND JOSEPH, BEING A JUST MAN AND UNWILLING TO PUT HER TO SHAME, RESOLVED TO SEND HER AWAY QUIETLY. BUT AS HE CONSIDERED THIS, BEHOLD, AN ANGEL OF THE LORD APPEARED TO HIM IN A DREAM, SAYING,

"JOSEPH, SON OF DAVID, DO NOT FEAR TO TAKE MARY YOUR WIFE, FOR THAT WHICH IS CONCEIVED IN HER IS OF THE HOLY SPIRIT;

SHE WILL BEAR A SON AND YOU SHALL CALL HIS NAME JESUS, FOR HE WILL SAVE HIS PEOPLE FROM THEIR SINS." ALL THIS TOOK PLACE TO FULFIL WHAT THE LORD HAD SPOKEN BY THE PROPHET:

"BEHOLD, A VIRGIN SHALL CONCEIVE AND BEAR A SON, AND HIS NAME SHALL BE CALLED EMMANUEL"

(WHICH MEANS, GOD WITH US). WHEN JOSEPH WOKE FROM SLEEP, HE DID AS THE ANGEL OF THE LORD COMMANDED HIM; HE TOOK HIS WIFE, BUT KNEW HER NOT UNTIL SHE HAD BORNE A SON; AND HE CALLED HIS NAME JESUS.

(Matthew 1:18-25)

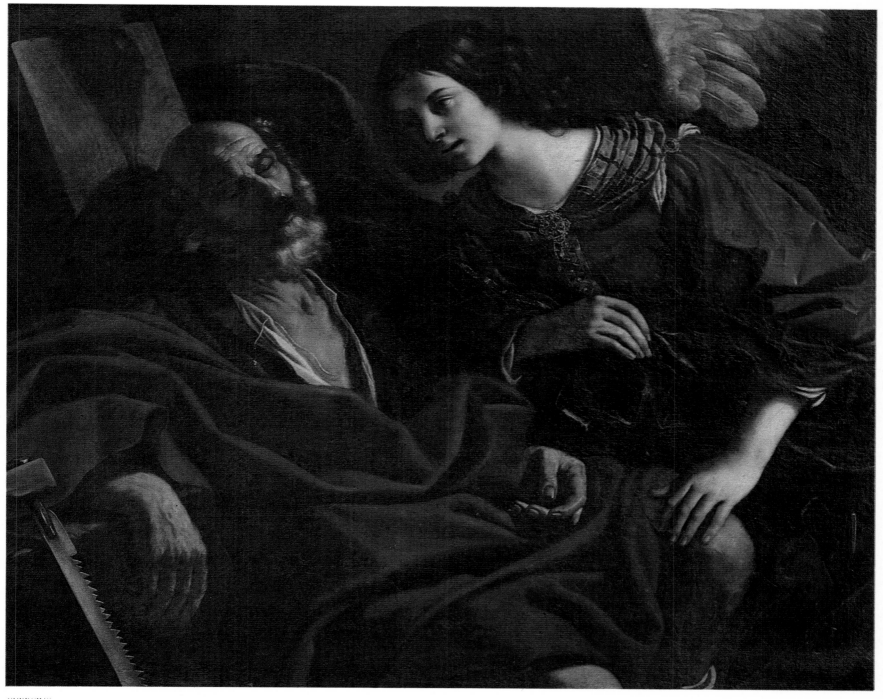

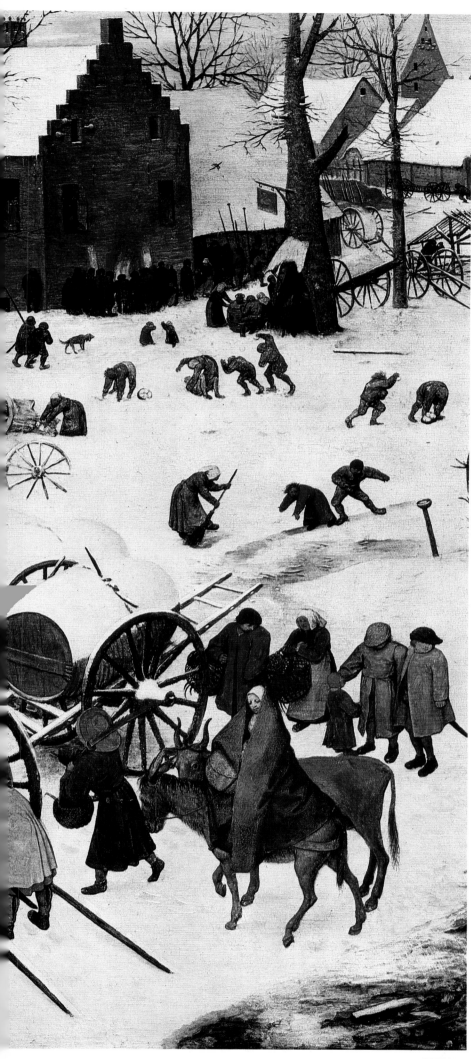

JOSEPH ALSO WENT UP FROM GALILEE, FROM THE CITY OF NAZARETH, TO JUDEA, TO THE CITY OF DAVID, WHICH IS CALLED BETHLEHEM, BECAUSE HE WAS OF THE HOUSE AND LINEAGE OF DAVID, TO BE ENROLLED WITH MARY HIS BETROTHED.

(Luke 2:4-5)

63

...AND THE WORD

AND DWELT

WAS MADE FLESH

AMONG US

WHILE THEY WERE THERE, THE TIME CAME FOR HER TO BE DELIVERED.

AND SHE GAVE BIRTH TO HER FIRST-BORN SON AND WRAPPED HIM IN SWADDLING CLOTHS, AND LAID HIM IN A MANGER, BECAUSE THERE WAS NO PLACE FOR THEM IN THE INN.

(Luke 2:6-7)

GENTILE DA FABRIANO

LORENZO LOTTO

IN THE SQUALOR OF THE
MANGER LIES THE POOR AND
HUMBLE CREATOR OF THE
WORLD.

(From a Christmas hymn)

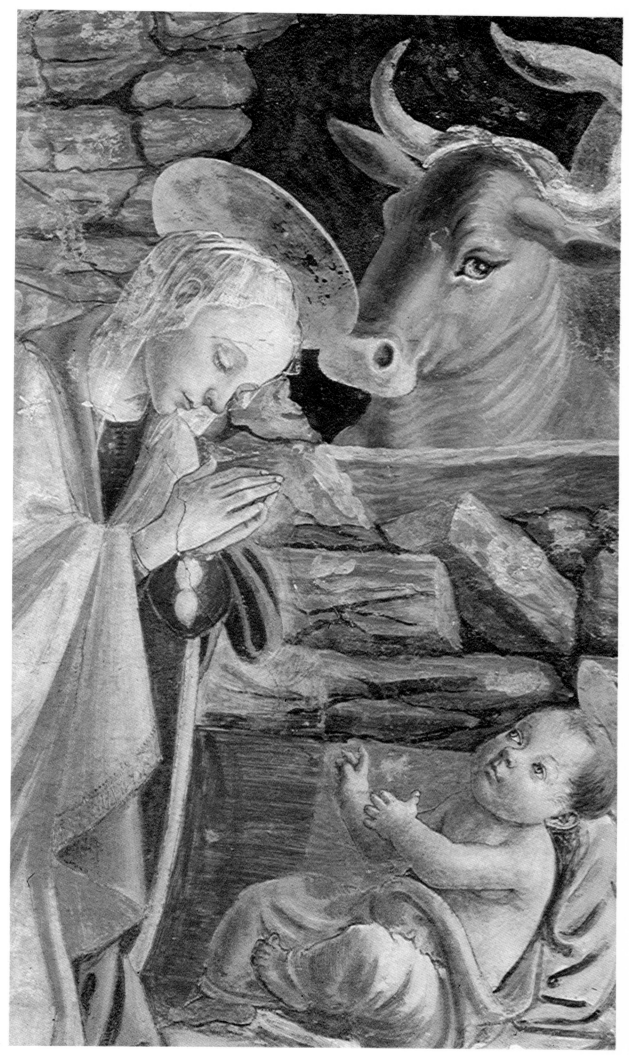

BOTTICELLI

IN THAT REGION THERE WERE SHEPHERDS OUT IN THE FIELD, KEEPING WATCH OVER THEIR FLOCK BY NIGHT. AND AN ANGEL OF THE LORD APPEARED TO THEM, AND THE GLORY OF THE LORD SHONE AROUND THEM, AND THEY WERE FILLED WITH FEAR. AND THE ANGEL SAID TO THEM, "BE NOT AFRAID; FOR BEHOLD, I BRING YOU GOOD NEWS OF A GREAT JOY WHICH WILL COME TO ALL THE PEOPLE; FOR TO YOU IS BORN THIS DAY IN THE CITY OF DAVID A SAVIOR, WHO IS CHRIST THE LORD. AND THIS WILL BE A SIGN FOR YOU: YOU WILL FIND A BABE WRAPPED IN SWADDLING CLOTHS AND LYING IN A MANGER." AND SUDDENLY THERE WAS WITH THE ANGEL A MULTITUDE OF THE HEAVENLY HOST PRAISING GOD AND SAYING,

"GLORY TO GOD IN THE HIGHEST, AND ON EARTH PEACE AMONG MEN WITH WHOM HE IS PLEASED!"

(Luke 2:8-14)

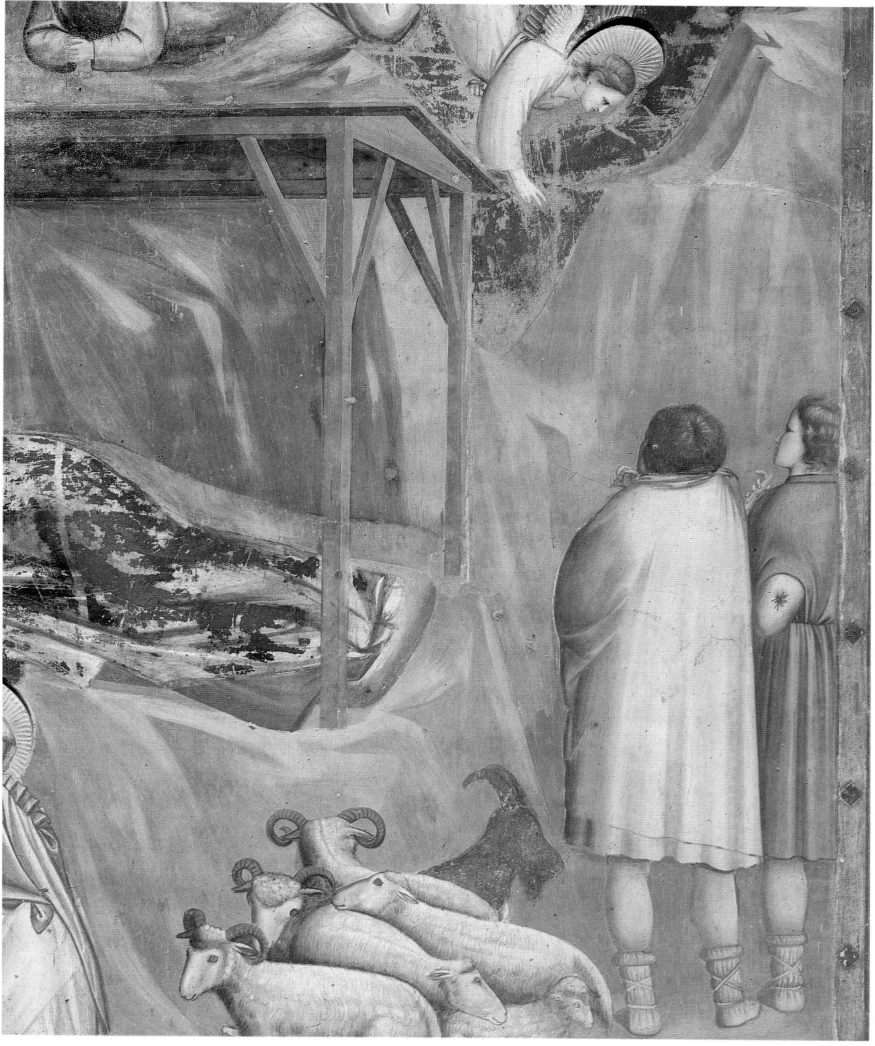

GIOTTO

WHEN THE ANGELS WENT AWAY FROM THEM INTO HEAVEN, THE SHEPHERDS SAID TO ONE ANOTHER, "LET US GO OVER TO BETHLEHEM AND SEE THIS THING THAT HAS HAPPENED, WHICH THE LORD HAS MADE KNOWN TO US." AND THEY WENT WITH HASTE, AND FOUND MARY AND JOSEPH, AND THE BABE LYING IN A MANGER. AND WHEN THEY SAW IT THEY MADE KNOWN THE SAYING WHICH HAD BEEN TOLD THEM CONCERNING THIS CHILD; AND ALL WHO HEARD IT WONDERED AT WHAT THE SHEPHERDS TOLD THEM.

(Luke 2:15-18)

MARY TREASURED
ALL THESE THINGS
AND REFLECTED ON THEM
IN HER HEART.

*(Luke 2:19)**

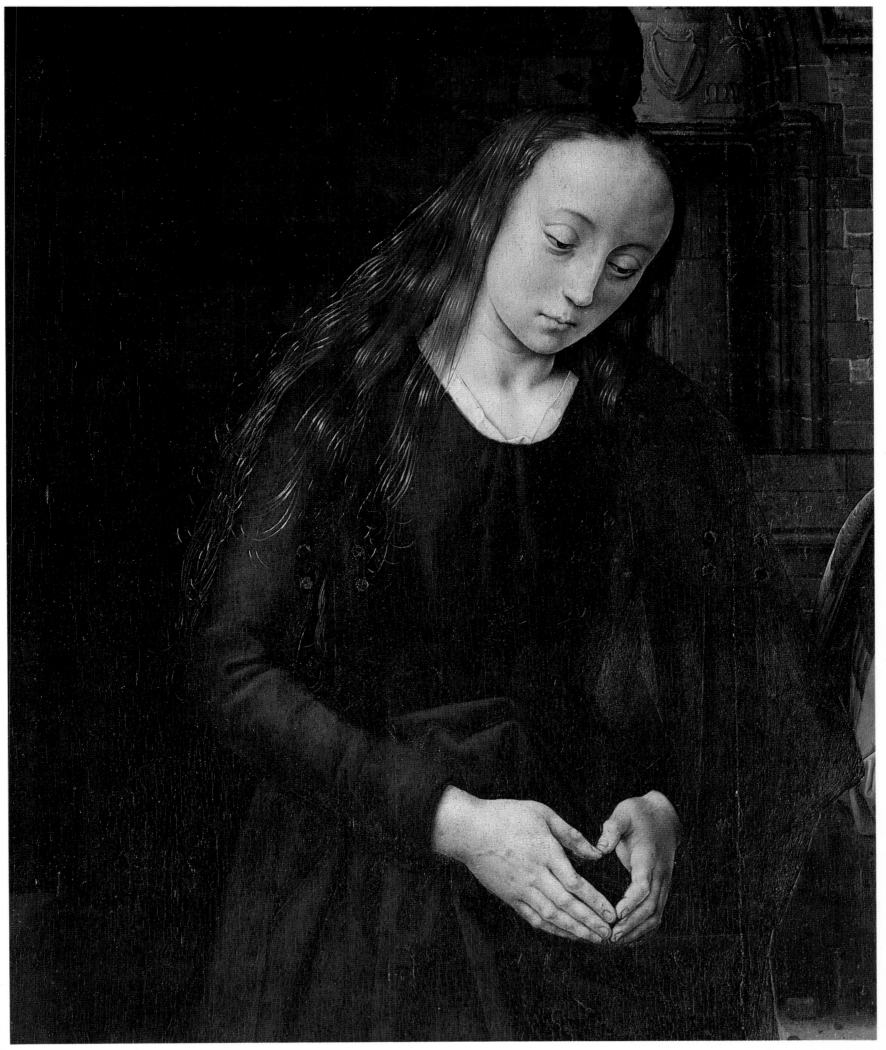

VAN DER GOES

WHEN THE EIGHTH DAY CAME
AND THE CHILD WAS TO BE CIRCUMCISED,
THEY GAVE HIM THE NAME JESUS,
THE NAME THE ANGEL HAD GIVEN HIM
BEFORE HIS CONCEPTION.

*(Luke 2:21)***

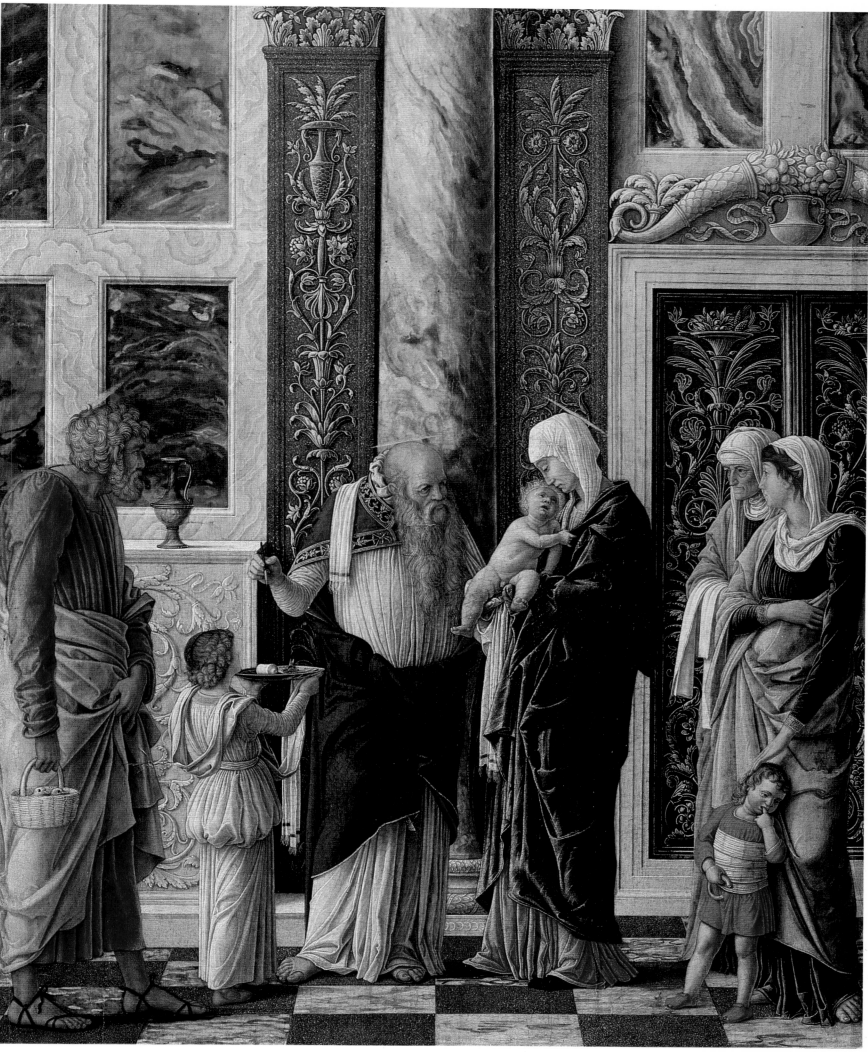

WHEN THE DAY CAME FOR THEM TO BE PURIFIED AS LAID DOWN BY THE LAW OF MOSES, THEY TOOK HIM UP TO JERUSALEM TO PRESENT HIM TO THE LORD— OBSERVING WHAT STANDS WRITTEN IN THE LAW OF THE LORD: *EVERY FIRST-BORN MALE MUST BE CONSE- CRATED TO THE LORD*—AND ALSO TO OFFER IN SACRIFICE, IN ACCORDANCE WITH WHAT IS SAID IN THE LAW OF THE LORD, *A PAIR OF TURTLEDOVES OR TWO YOUNG PIGEONS*.

(Luke 2:22-24)**

NOW THERE WAS A MAN IN JERUSALEM, WHOSE NAME WAS SIMEON, AND THIS MAN WAS RIGHTEOUS AND DEVOUT, LOOKING FOR THE CONSOLATION OF ISRAEL, AND THE HOLY SPIRIT WAS UPON HIM. AND IT HAD BEEN REVEALED TO HIM BY THE HOLY SPIRIT THAT HE SHOULD NOT SEE DEATH BEFORE HE HAD SEEN THE LORD'S CHRIST. AND INSPIRED BY THE SPIRIT HE CAME INTO THE TEMPLE; AND WHEN THE PARENTS BROUGHT IN THE CHILD JESUS, TO DO FOR HIM ACCORDING TO THE CUSTOM OF THE LAW, HE TOOK HIM UP IN HIS ARMS AND BLESSED GOD AND SAID,

"LORD, NOW LET YOUR SERVANT DEPART IN PEACE, ACCORDING TO YOUR WORD;

FOR MY EYES HAVE SEEN YOUR SALVATION
WHICH YOU HAVE PREPARED IN THE PRESENCE OF ALL
PEOPLES,
A LIGHT FOR REVELATION TO THE GENTILES,
AND FOR GLORY TO YOUR PEOPLE ISRAEL."

AND HIS FATHER AND HIS MOTHER MARVELED AT WHAT WAS SAID ABOUT HIM; AND SIMEON BLESSED THEM AND SAID TO MARY HIS MOTHER,

"BEHOLD, THIS CHILD IS SET FOR THE FALL AND
RISING OF MANY IN ISRAEL,
AND FOR A SIGN THAT IS SPOKEN AGAINST

(AND A SWORD WILL PIERCE THROUGH YOUR OWN SOUL ALSO), THAT THOUGHTS OUT OF MANY HEARTS MAY BE REVEALED."

(Luke 2:25-35)

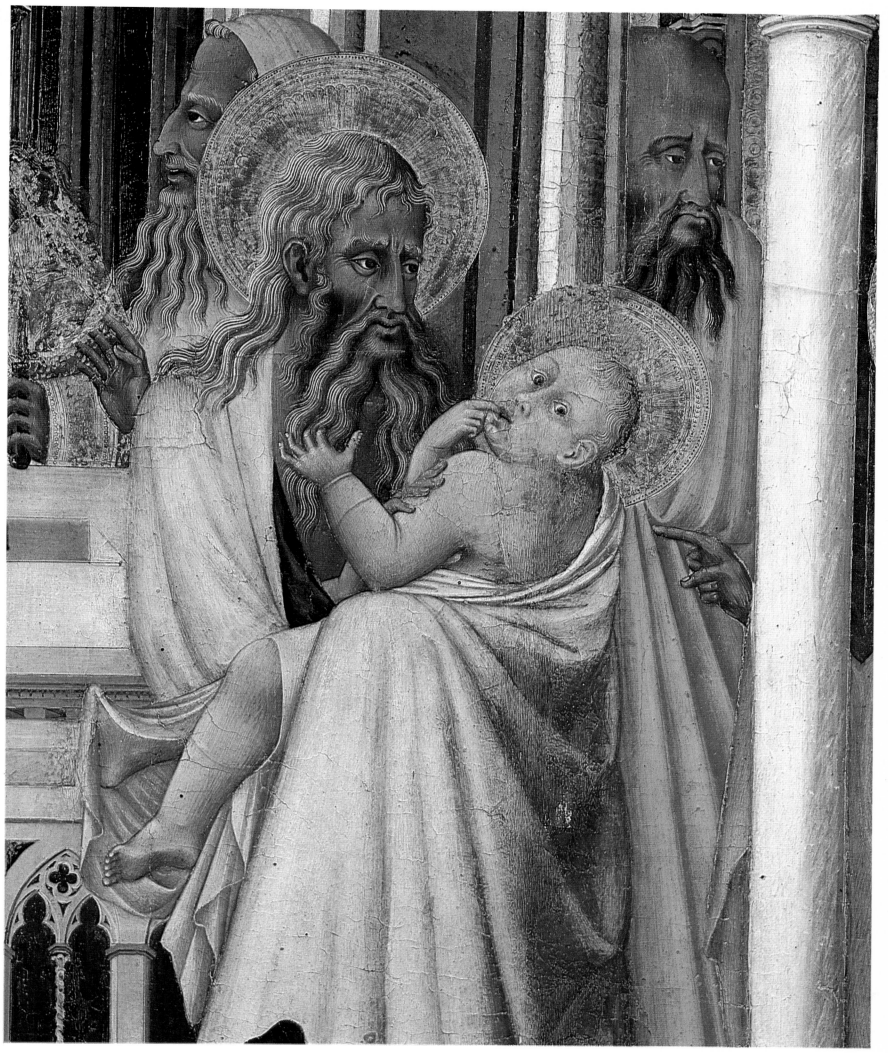

GIOVANNI DI PAOLO

WISE MEN FROM THE EAST CAME TO
JERUSALEM, SAYING,

"WHERE IS HE WHO HAS BEEN
BORN KING OF THE JEWS?
FOR WE HAVE SEEN HIS STAR
IN THE EAST, AND HAVE
COME TO WORSHIP HIM."

WHEN HEROD THE KING HEARD THIS,
HE WAS TROUBLED, AND ALL JERUSA-
LEM WITH HIM; AND ASSEMBLING ALL
THE CHIEF PRIESTS AND SCRIBES OF
THE PEOPLE, HE INQUIRED OF THEM
WHERE THE CHRIST WAS TO BE BORN.
THEY TOLD HIM, "IN BETHLEHEM OF
JUDEA; FOR SO IT IS WRITTEN BY THE
PROPHET:

'AND YOU, O BETHLEHEM, IN THE
LAND OF JUDAH,
ARE BY NO MEANS LEAST AMONG THE
RULERS OF JUDAH;
FOR FROM YOU SHALL COME A RULER
WHO WILL GOVERN MY PEOPLE
ISRAEL.'"

THEN HEROD SUMMONED THE WISE
MEN SECRETLY AND ASCERTAINED FROM
THEM WHAT TIME THE STAR APPEARED;
AND HE SENT THEM TO BETHLEHEM,
SAYING, "GO AND SEARCH DILIGENTLY
FOR THE CHILD, AND WHEN YOU HAVE
FOUND HIM BRING ME WORD, THAT I
TOO MAY COME AND WORSHIP HIM."

(Matthew 2:1-8)

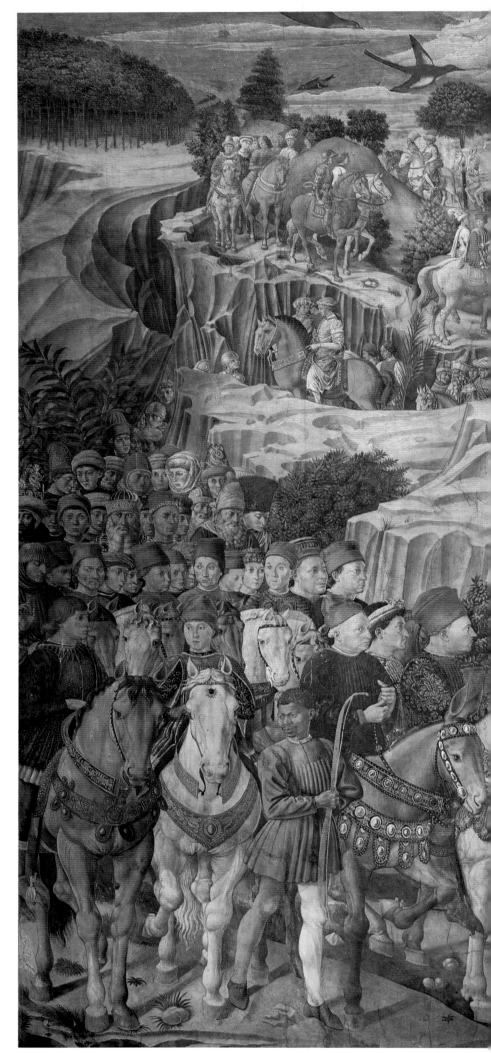

BENOZZO GOZZOLI

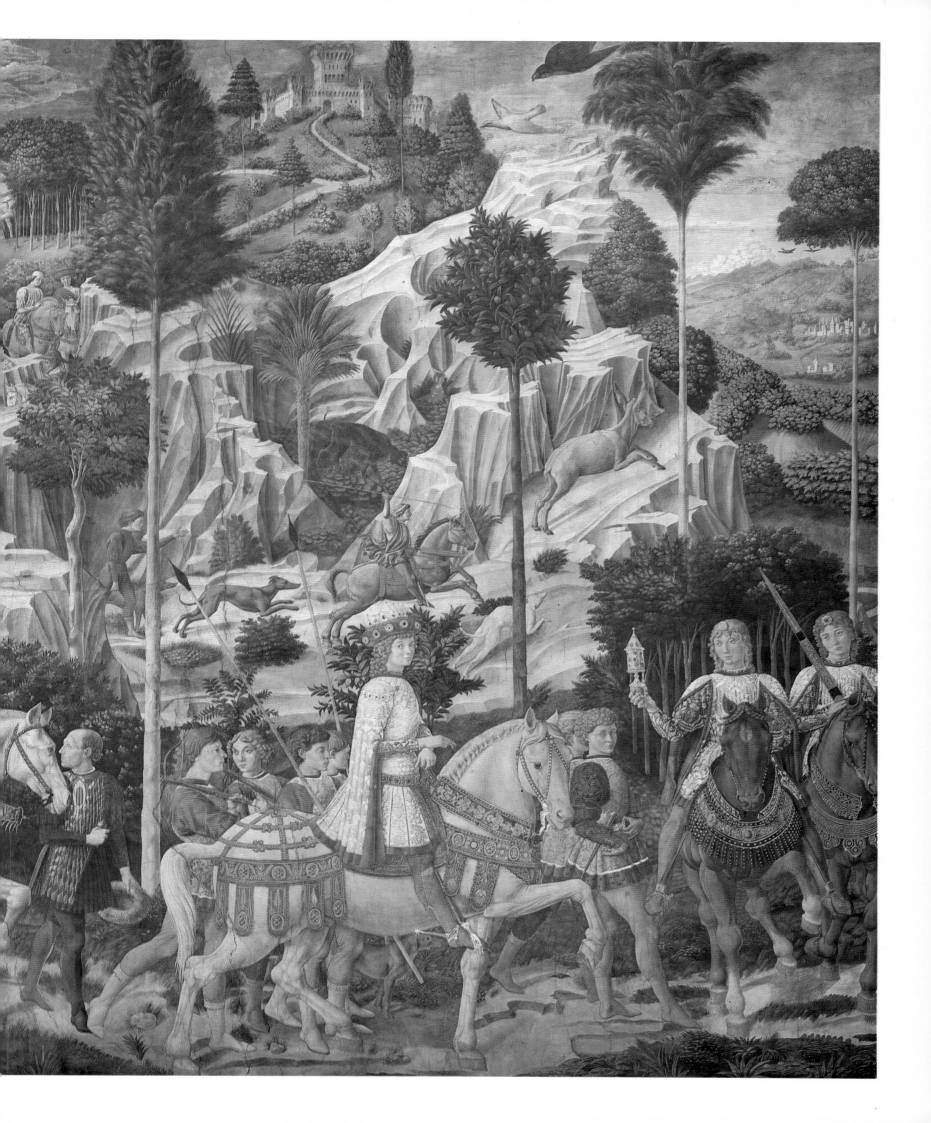

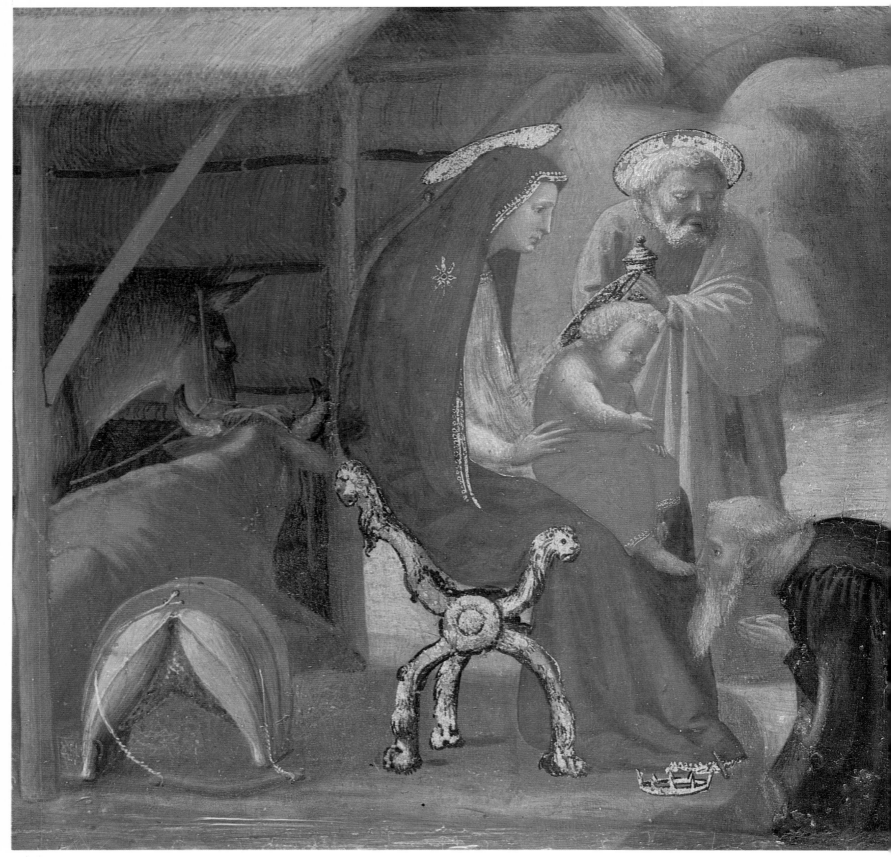

MASACCIO

WHEN THEY HAD HEARD THE KING THEY WENT THEIR WAY; AND

LO, THE STAR WHICH THEY HAD SEEN IN THE EAST WENT BEFORE

THEM, TILL IT CAME TO REST OVER THE PLACE WHERE THE CHILD

WAS. WHEN THEY SAW THE STAR, THEY REJOICED EXCEEDINGLY

WITH GREAT JOY; AND GOING INTO THE HOUSE THEY SAW THE

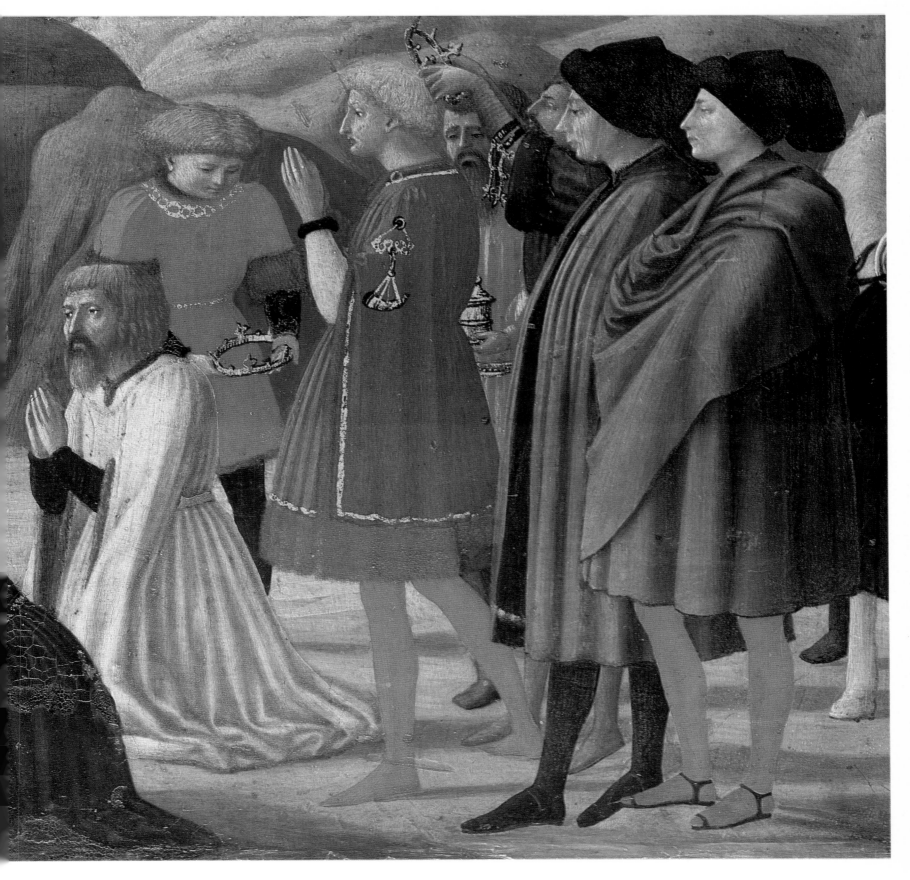

CHILD WITH MARY HIS MOTHER, AND THEY FELL DOWN AND
WORSHIPED HIM. THEN, OPENING THEIR TREASURES, THEY OFFERED
HIM GIFTS, GOLD AND FRANKINCENSE AND MYRRH. AND BEING
WARNED IN A DREAM NOT TO RETURN TO HEROD, THEY DEPARTED
TO THEIR OWN COUNTRY BY ANOTHER WAY.

(Matthew 2:9-12)

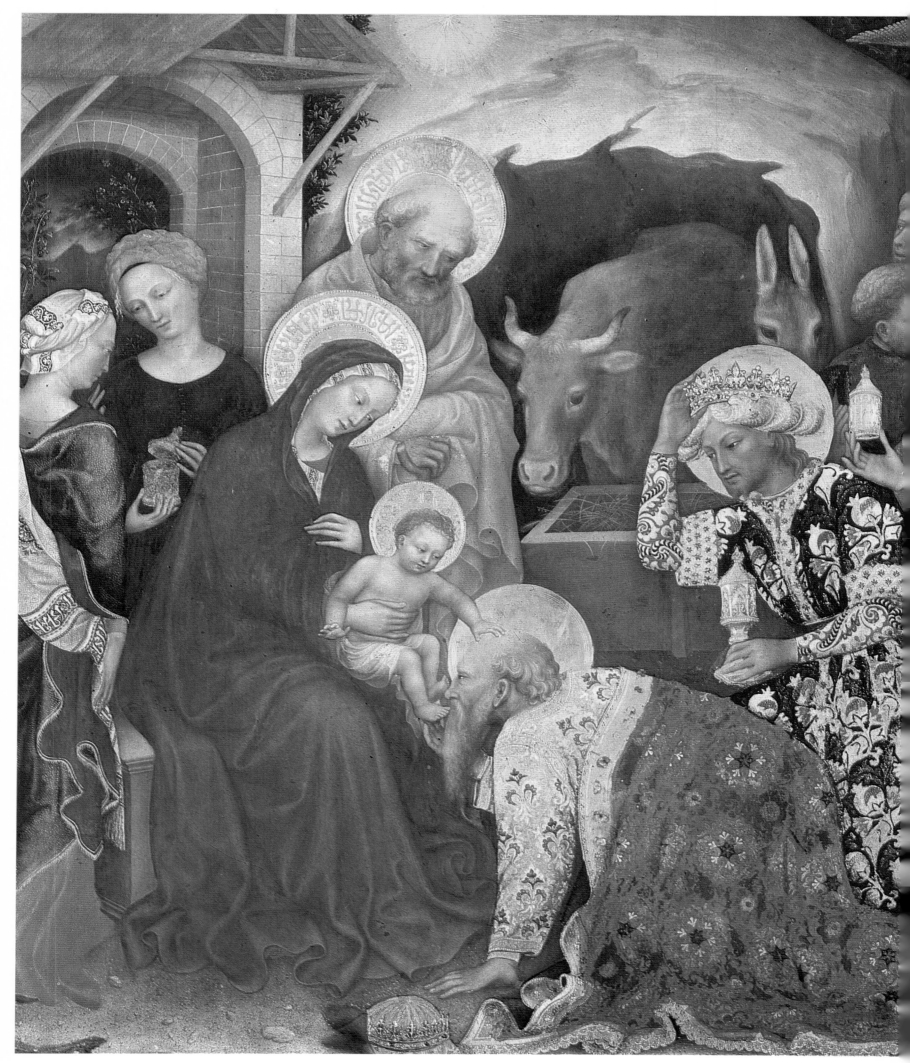

GENTILE DA FABRIANO

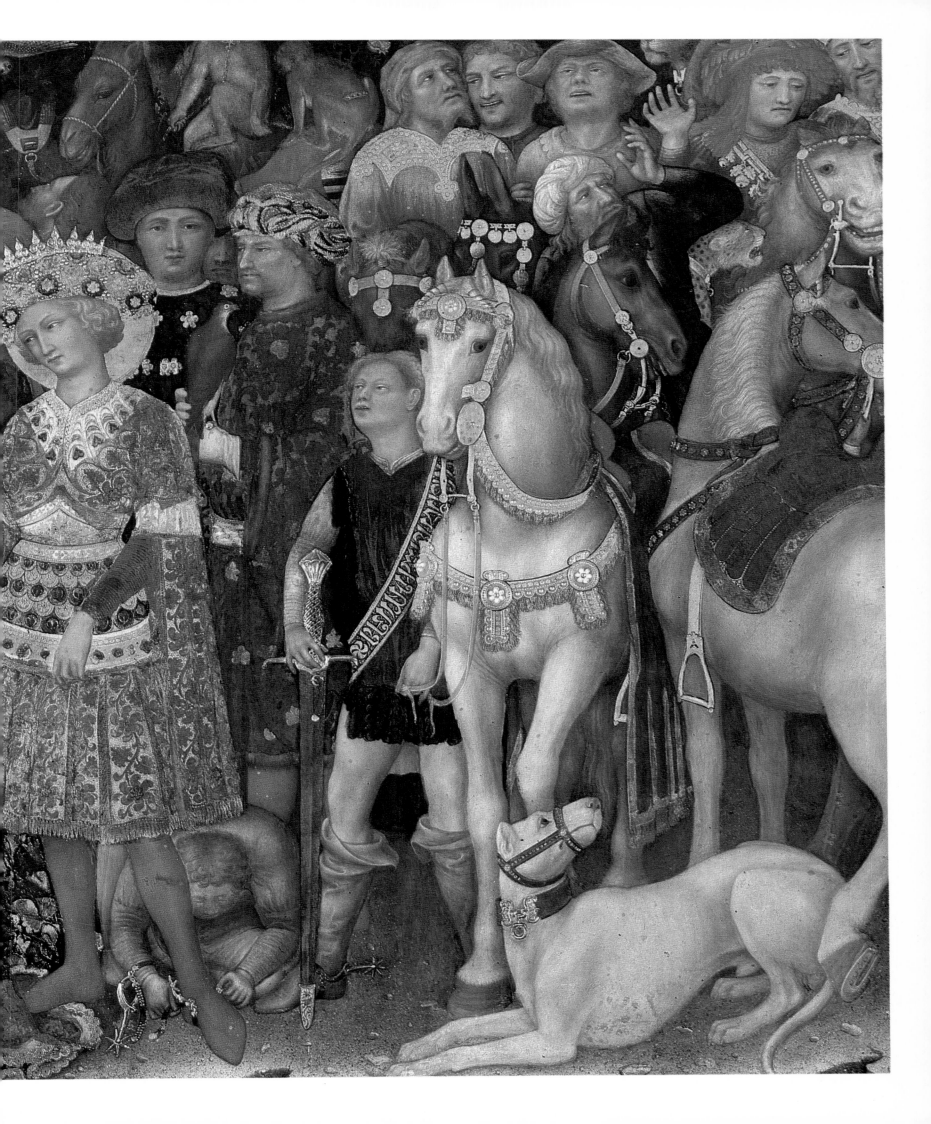

AN ANGEL OF THE LORD APPEARED TO JOSEPH IN A DREAM AND SAID,

"RISE,

TAKE THE CHILD AND HIS MOTHER,

AND FLEE TO EGYPT,

AND REMAIN THERE TILL I TELL YOU;

FOR HEROD IS ABOUT TO SEARCH FOR THE CHILD,

TO DESTROY HIM."

(Matthew 2:13)

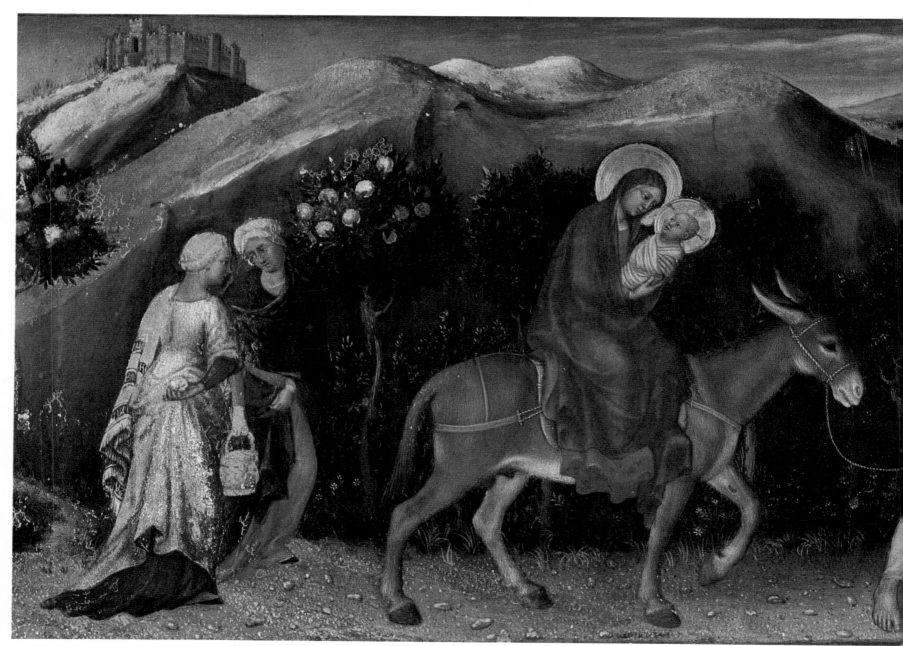

GENTILE DA FABRIANO

AND HE ROSE AND TOOK THE CHILD AND HIS MOTHER BY NIGHT, AND DEPARTED TO EGYPT, AND REMAINED THERE UNTIL THE DEATH OF HEROD. THIS WAS TO FULFIL WHAT THE LORD HAD SPOKEN BY THE PROPHET,

"OUT OF EGYPT HAVE I CALLED MY SON."

(Matthew 2:14-15)

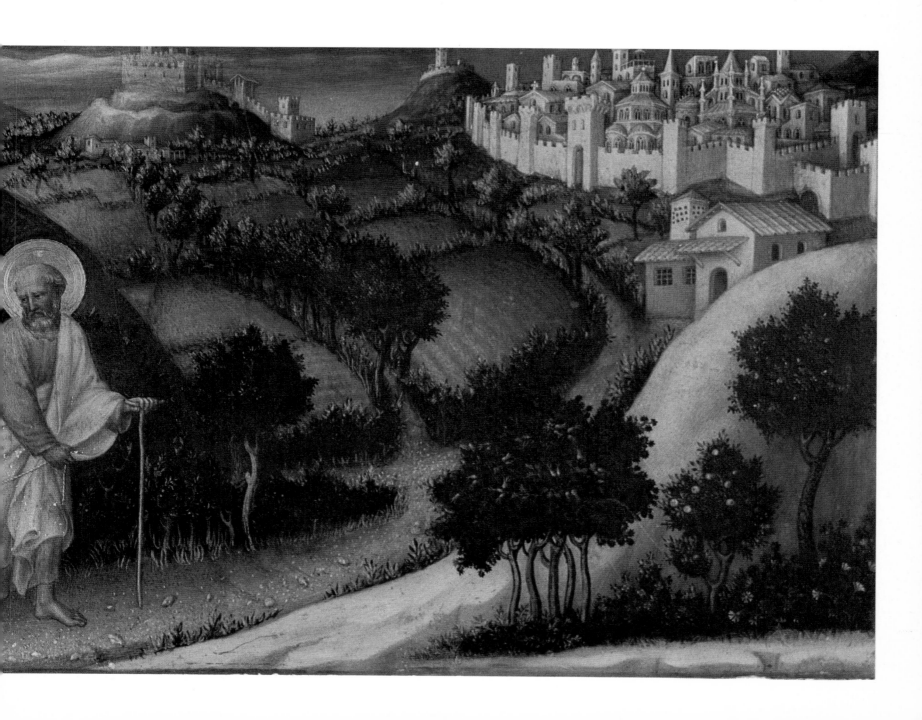

AFTER HEROD'S DEATH, THE ANGEL OF THE LORD APPEARED IN A DREAM TO JOSEPH IN EGYPT AND SAID, "GET UP, TAKE THE CHILD AND HIS MOTHER WITH YOU AND GO BACK TO THE LAND OF ISRAEL, FOR THOSE WHO WANTED TO KILL THE CHILD ARE DEAD." SO JOSEPH GOT UP AND, TAKING THE CHILD AND HIS MOTHER WITH HIM, WENT BACK TO THE LAND OF ISRAEL. BUT WHEN HE LEARNT THAT ARCHELAUS HAD SUCCEEDED HIS FATHER HEROD AS RULER OF JUDAEA HE WAS AFRAID TO GO THERE, AND BEING WARNED IN A DREAM HE LEFT FOR THE REGION OF GALILEE. THERE HE SETTLED IN A TOWN CALLED NAZARETH. IN THIS WAY THE WORDS SPOKEN THROUGH THE PROPHETS WERE TO BE FULFILLED: *HE WILL BE CALLED A NAZARENE.*

*(Matthew 2:19-23)***

MASACCIO

TRULY YOU ARE BLESSED AMONG ALL WOMEN BECAUSE, WHILE REMAINING A WOMAN, A CREATURE OF OUR RACE, YOU HAVE BECOME THE MOTHER OF GOD. FOR, IF THE HOLY ONE BORN OF YOUR WOMB IS TRULY GOD INCARNATE, THEN MUST YOU TRULY BE CALLED THE MOTHER OF GOD, SINCE YOU HAVE, IN ABSOLUTE TRUTH, BROUGHT FORTH GOD.

(St. Sophronius)

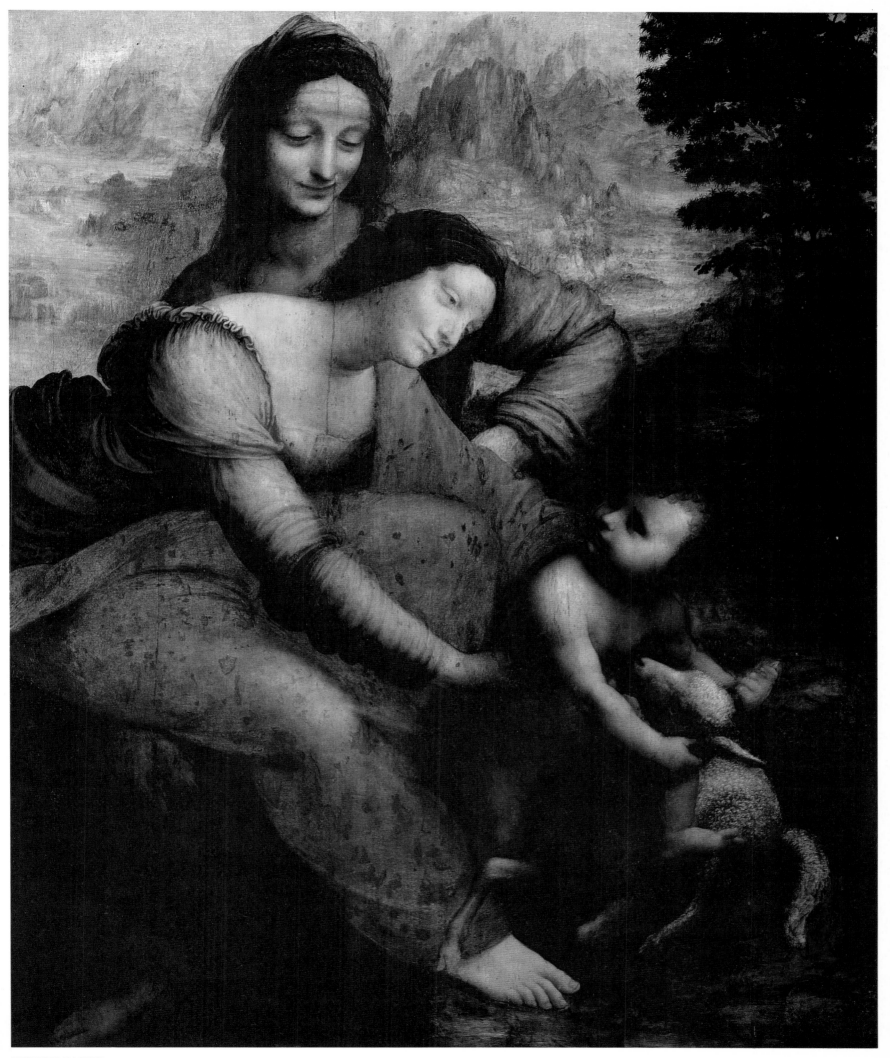

LEONARDO DA VINCI

HAIL, HOLY MOTHER!

THE CHILD

TO WHOM YOU GAVE BIRTH

IS THE KING OF HEAVEN AND EARTH

FOR EVER.

(Sedulius)

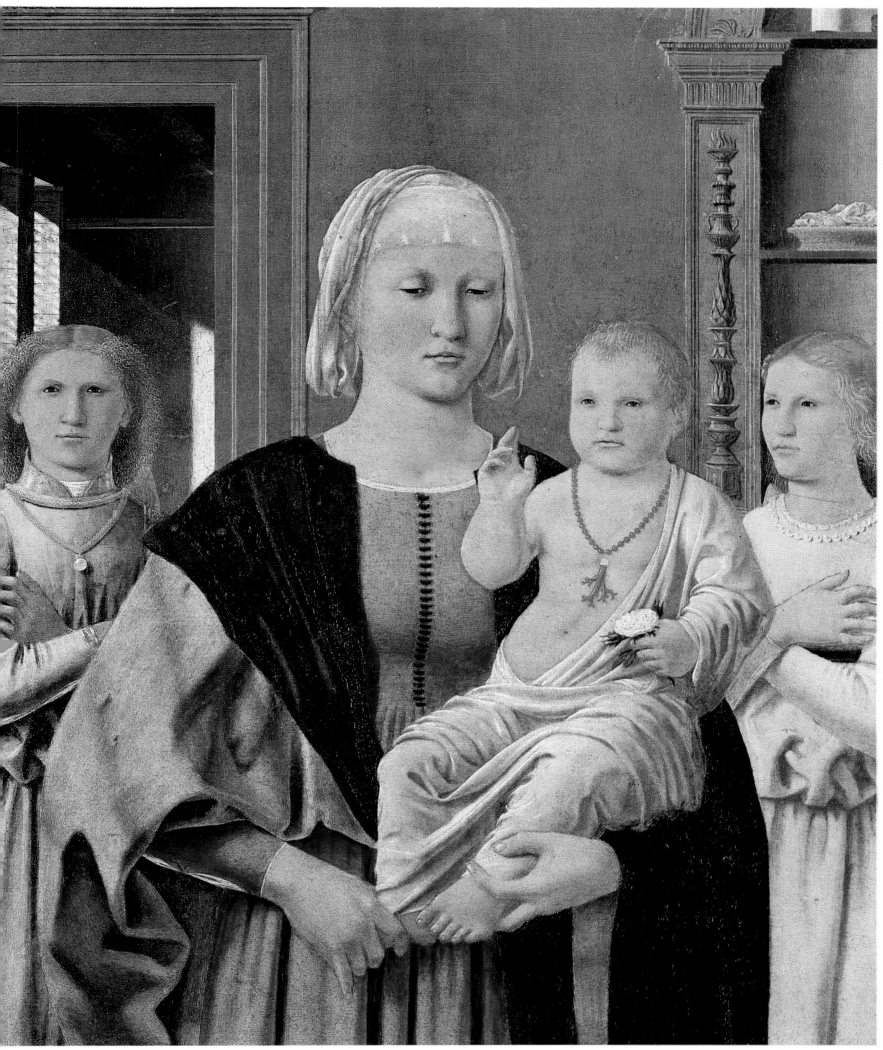

PIERO DELLA FRANCESCA

CHRIST AS GOD WAS BORN OF HIS FATHER,

AS MAN OF HIS MOTHER;

OF THE IMMORTALITY OF HIS FATHER,

OF THE VIRGINITY OF HIS MOTHER;

OF HIS FATHER WITHOUT A MOTHER,

OF HIS MOTHER WITHOUT A FATHER.

GOD SENT JOHN TO EARTH

AS HIS HUMAN PRECURSOR

SO THAT HE WAS BORN

WHEN THE DAYS WERE BECOMING SHORTER.

JOHN IS THE VOICE,

BUT THE LORD IS THE WORD

WHO WAS IN THE BEGINNING.

JOHN IS THE VOICE

THAT LASTS FOR A TIME;

FROM THE BEGINNING

CHRIST IS THE WORD

WHO LIVES FOR EVER.

(St. Augustine)

RAPHAEL

96

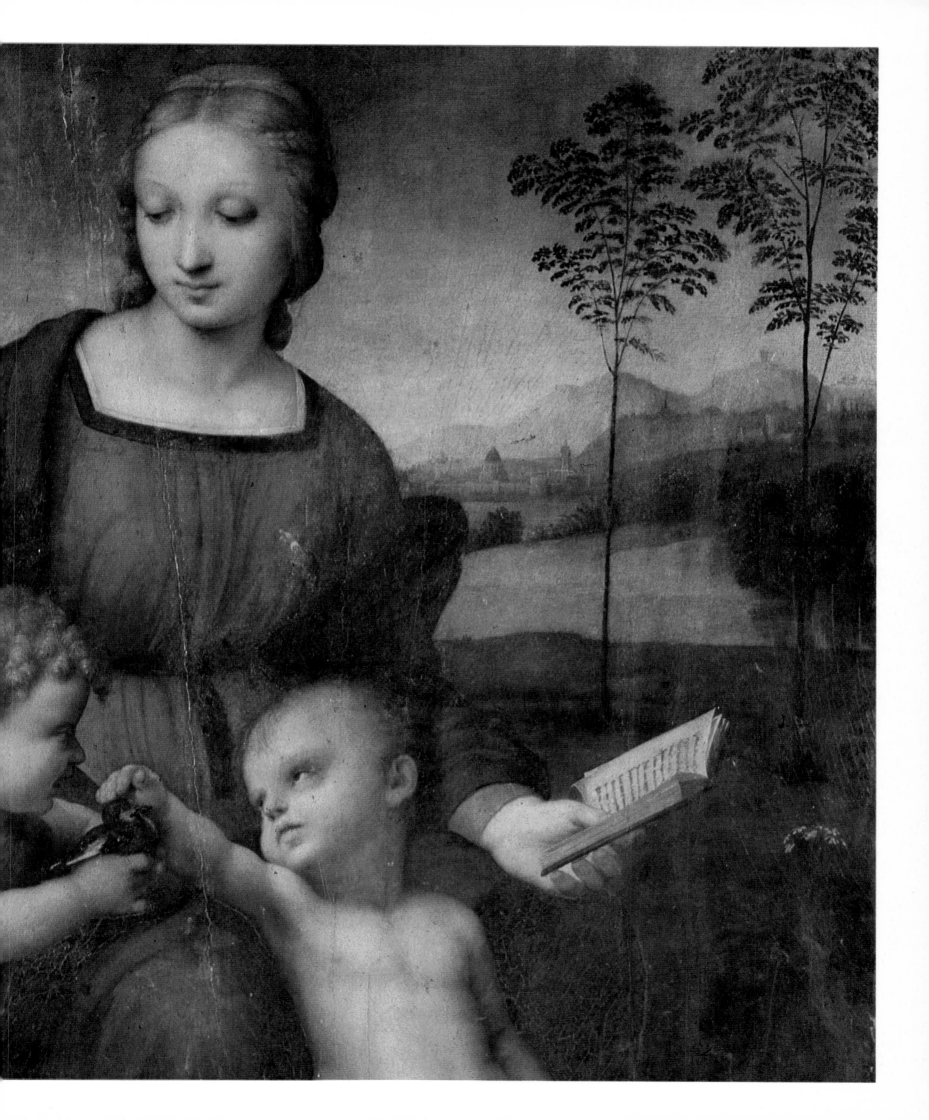

THE CHILD GREW AND BECAME STRONG,

FILLED WITH WISDOM;

AND THE FAVOR OF GOD

WAS UPON HIM.

(Luke 2:40)

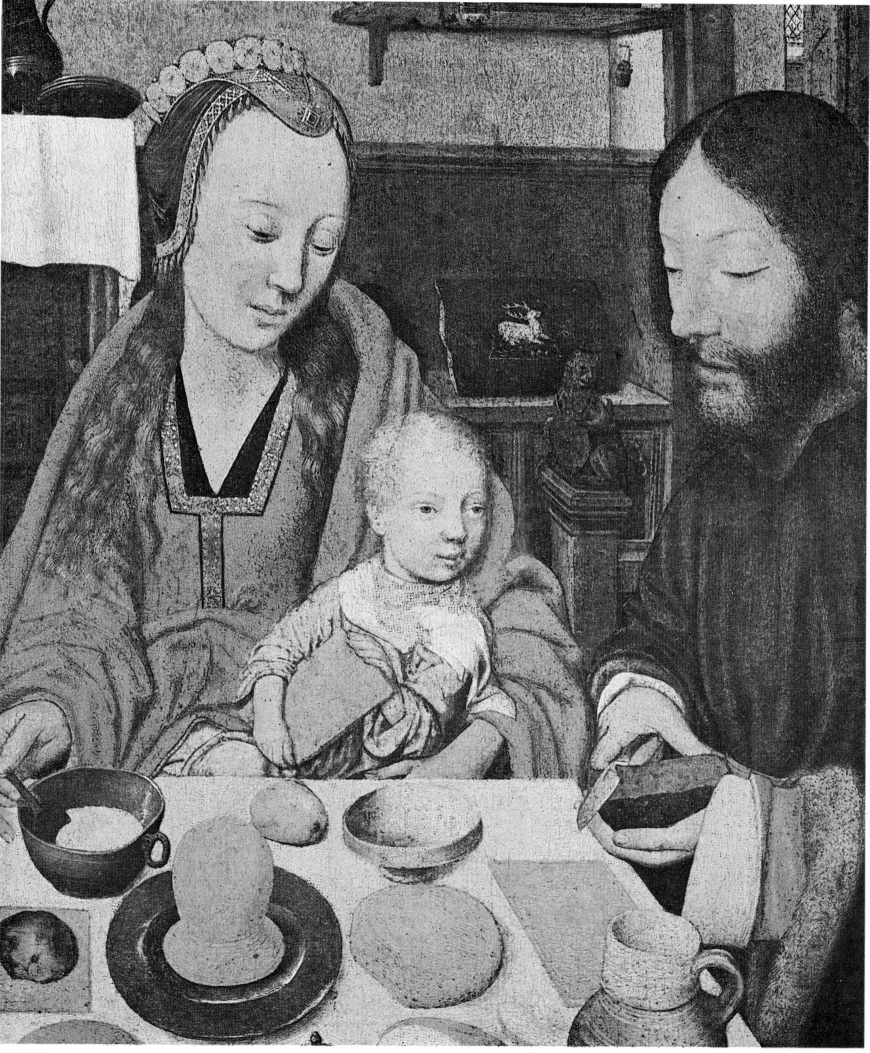

JAN MOSTAERT

NOW HIS PARENTS WENT TO JERUSALEM EVERY YEAR AT THE FEAST OF THE PASSOVER. AND WHEN HE WAS TWELVE YEARS OLD, THEY WENT UP ACCORDING TO CUSTOM; AND WHEN THE FEAST WAS ENDED, AS THEY WERE RETURNING, THE BOY JESUS STAYED BEHIND IN JERUSALEM. HIS PARENTS DID NOT KNOW IT, BUT SUPPOSING HIM TO BE IN THE COMPANY THEY WENT A DAY'S JOURNEY, AND THEY SOUGHT HIM AMONG THEIR KINSFOLK AND ACQUAINTANCES; AND WHEN THEY DID NOT FIND HIM, THEY RETURNED TO JERUSALEM, SEEKING HIM.

AFTER THREE DAYS THEY FOUND HIM IN THE TEMPLE, SITTING AMONG THE TEACHERS,

LISTENING TO THEM AND ASKING THEM QUESTIONS; AND ALL WHO HEARD HIM WERE AMAZED AT HIS UNDERSTANDING AND HIS ANSWERS. AND WHEN THEY SAW HIM THEY WERE ASTONISHED; AND HIS MOTHER SAID TO HIM, "SON, WHY HAVE YOU TREATED US SO? BEHOLD, YOUR FATHER AND I HAVE BEEN LOOKING FOR YOU ANXIOUSLY." AND HE SAID TO THEM, "HOW IS IT THAT YOU SOUGHT ME? DID YOU NOT KNOW THAT I MUST BE IN MY FATHER'S HOUSE?" AND THEY DID NOT UNDERSTAND THE SAYING WHICH HE SPOKE TO THEM. AND HE WENT DOWN WITH THEM AND CAME TO NAZARETH, AND WAS OBEDIENT TO THEM; AND HIS MOTHER KEPT ALL THESE THINGS IN HER HEART.

(Luke 2:41-51)

100

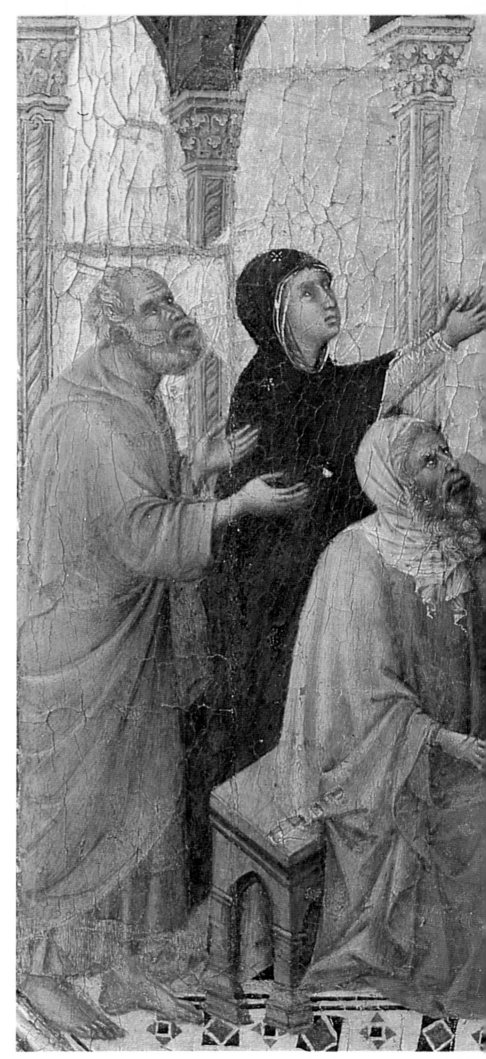

DUCCIO

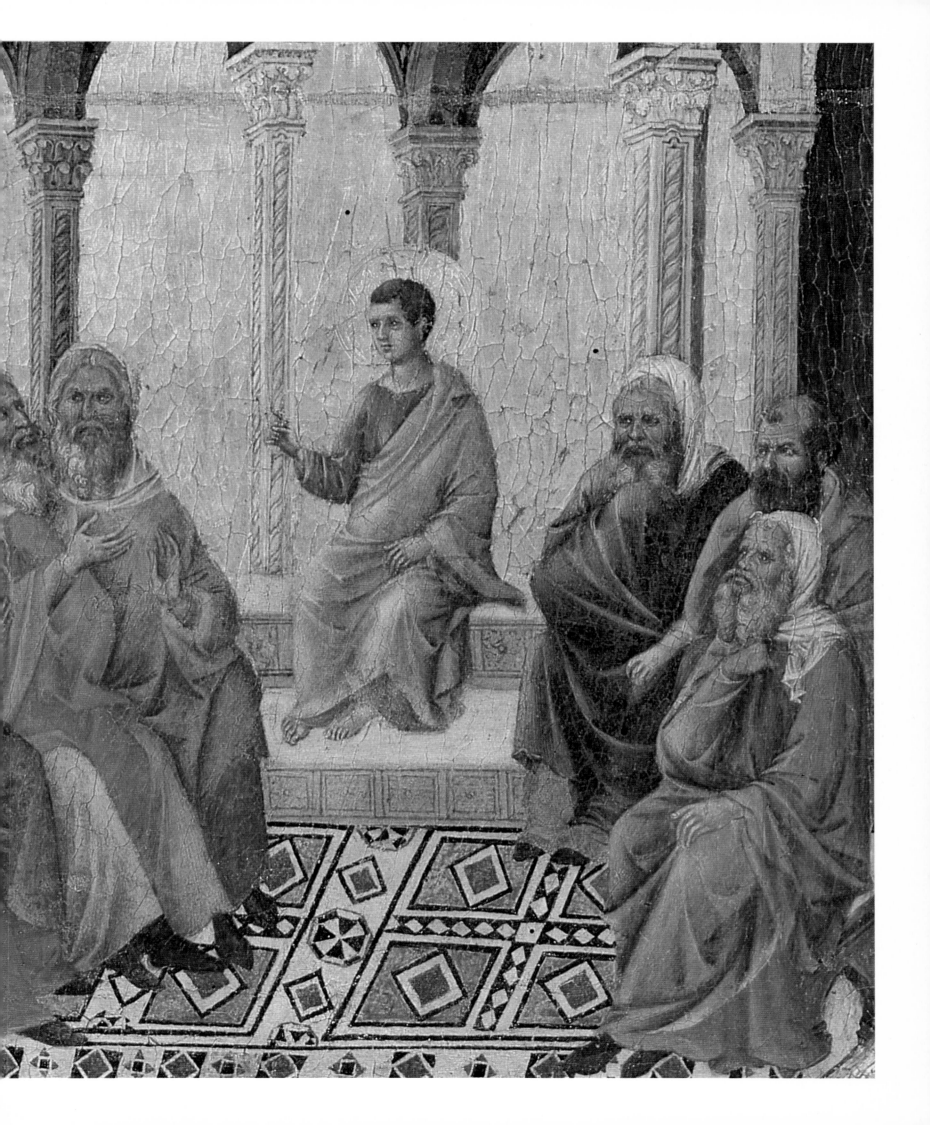

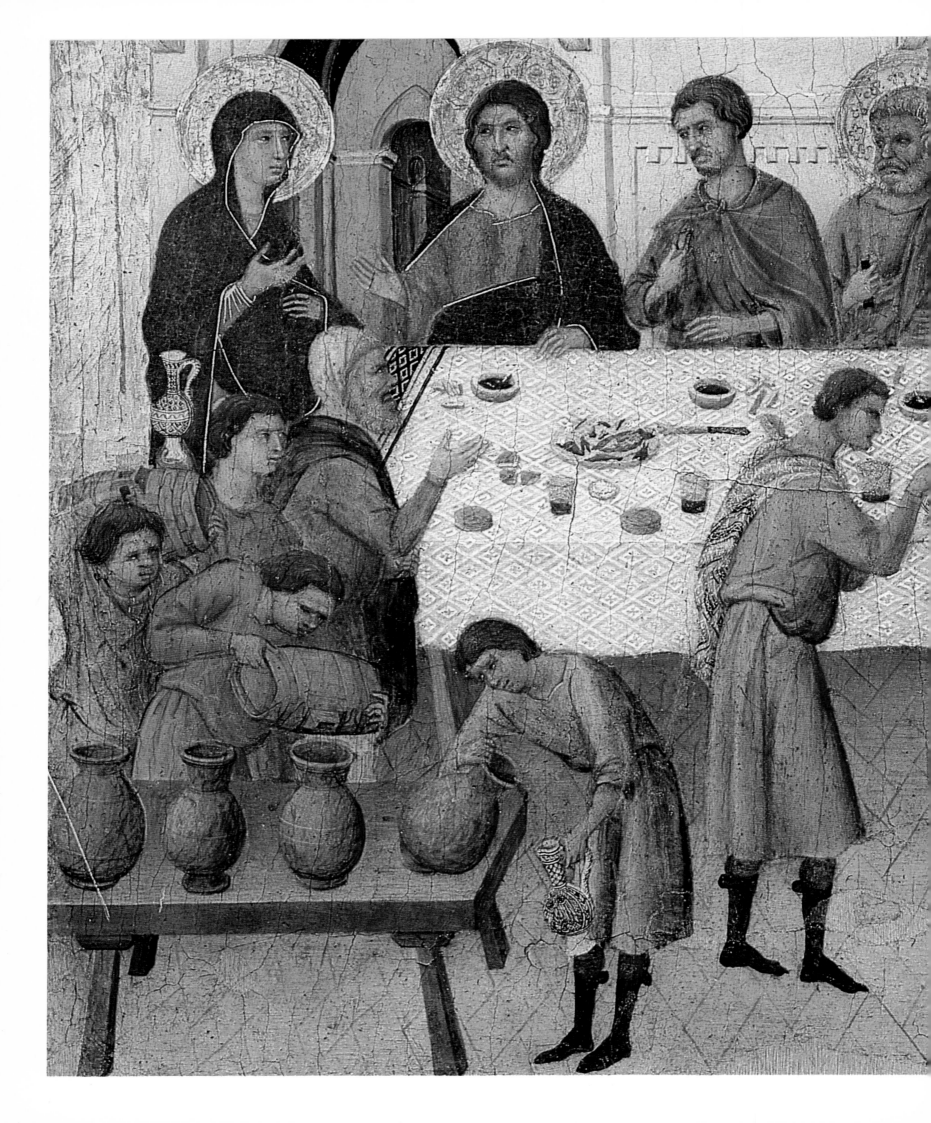

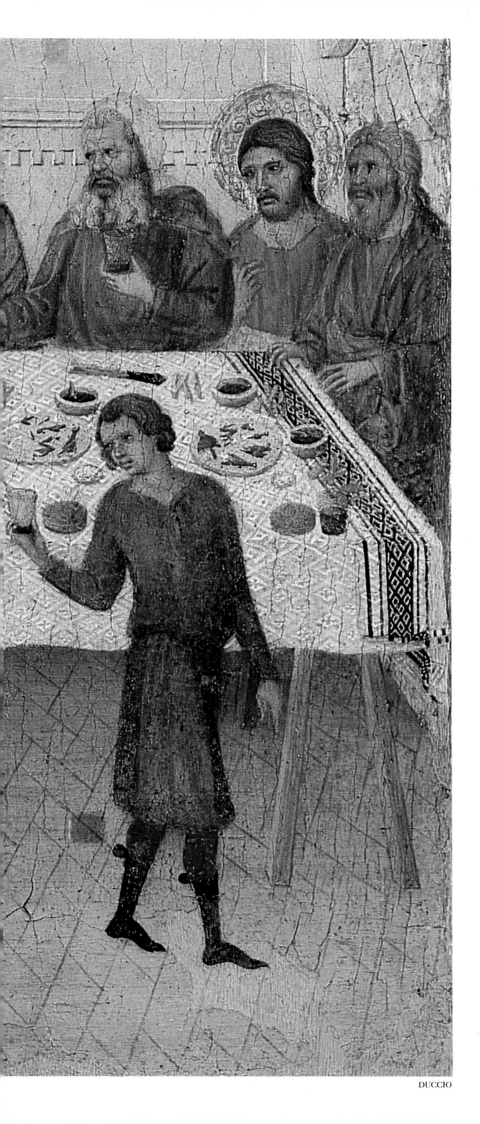

THERE WAS A WEDDING AT CANA IN GALILEE. THE MOTHER OF JESUS WAS THERE, AND JESUS AND HIS DISCIPLES HAD ALSO BEEN INVITED. WHEN THEY RAN OUT OF WINE, SINCE THE WINE PROVIDED FOR THE WEDDING WAS ALL FINISHED, THE MOTHER OF JESUS SAID TO HIM,

"THEY HAVE NO WINE."

JESUS SAID, "WOMAN, WHY TURN TO ME? MY HOUR HAS NOT COME YET." HIS MOTHER SAID TO THE SERVANTS,

"DO WHATEVER HE TELLS YOU."

*(John 2:1-5)***

DUCCIO

THERE WERE SIX STONE WATER JARS STANDING THERE, MEANT FOR THE ABLUTIONS THAT ARE CUSTOMARY AMONG THE JEWS: EACH COULD HOLD TWENTY OR THIRTY GALLONS. JESUS SAID TO THE SERVANTS,

"FILL THE JARS WITH WATER," AND THEY FILLED THEM TO THE BRIM. "DRAW SOME OUT NOW," HE TOLD THEM, "AND TAKE IT TO THE STEWARD."

THEY DID THIS; THE STEWARD TASTED THE WATER, AND IT HAD TURNED INTO WINE. HAVING NO IDEA WHERE IT CAME FROM—ONLY THE SERVANTS WHO HAD DRAWN THE WATER KNEW—THE STEWARD CALLED THE BRIDEGROOM AND SAID, "PEOPLE GENERALLY SERVE THE BEST WINE FIRST, AND KEEP THE CHEAPER SORT TILL THE GUESTS HAVE HAD PLENTY TO DRINK; BUT YOU HAVE KEPT THE BEST WINE TILL NOW."

THIS WAS THE FIRST OF THE SIGNS GIVEN BY JESUS: IT WAS GIVEN AT CANA IN GALILEE.

HE LET HIS GLORY BE SEEN, AND HIS DISCIPLES BELIEVED IN HIM.

(John 2:6-11)**

104

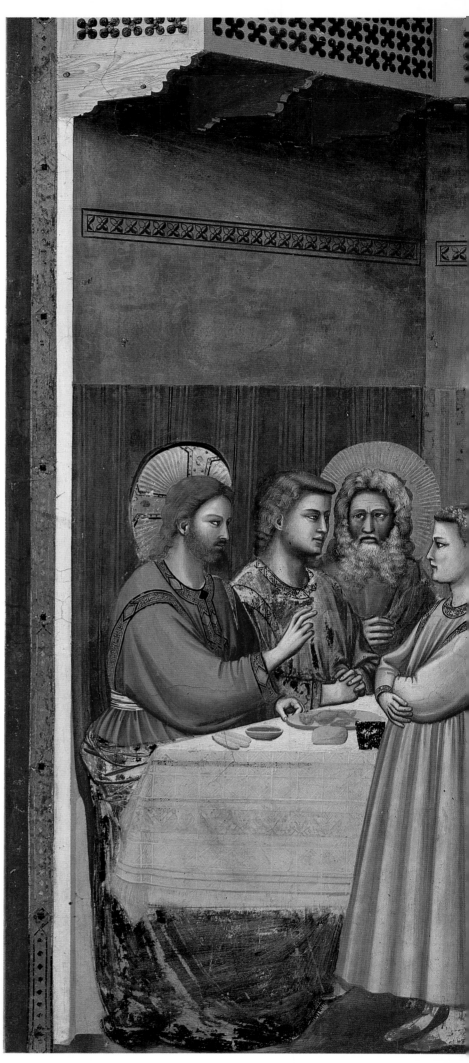

GIOTTO

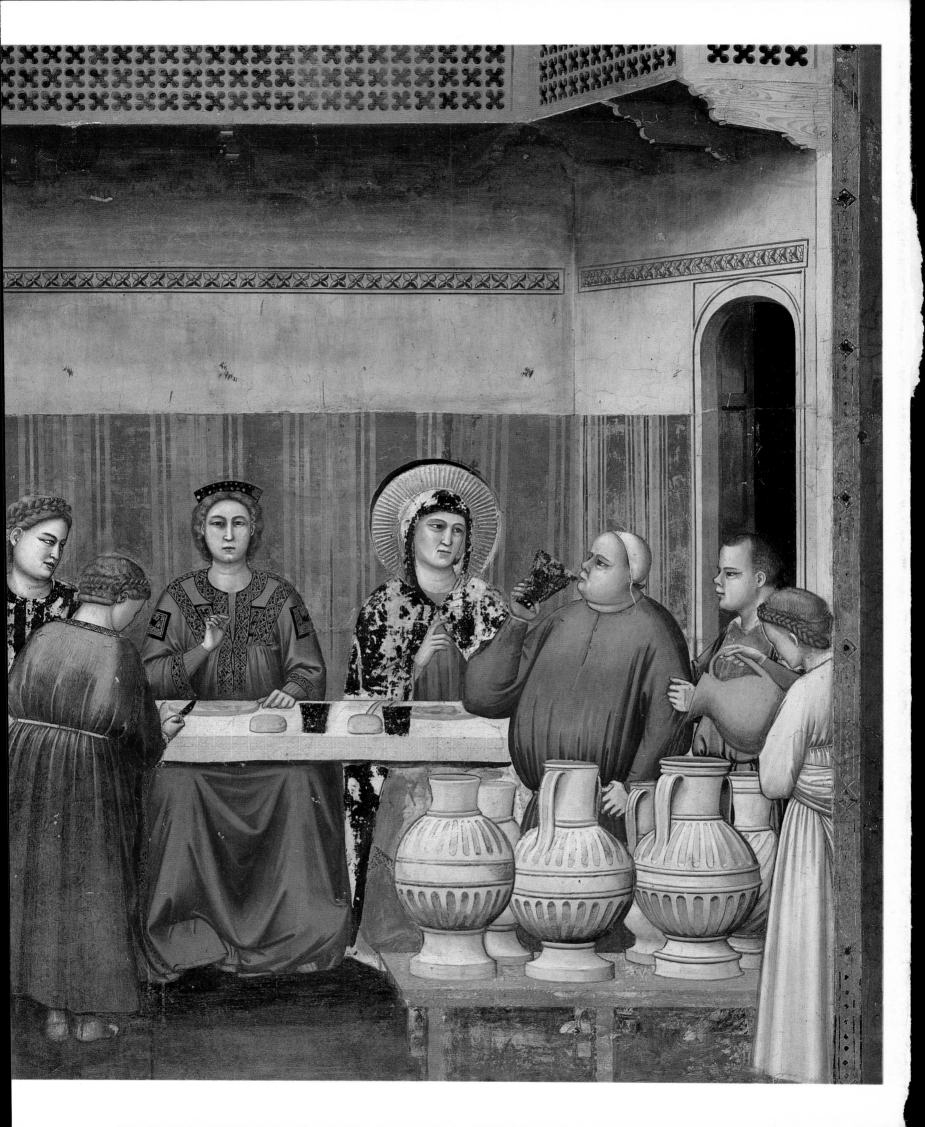

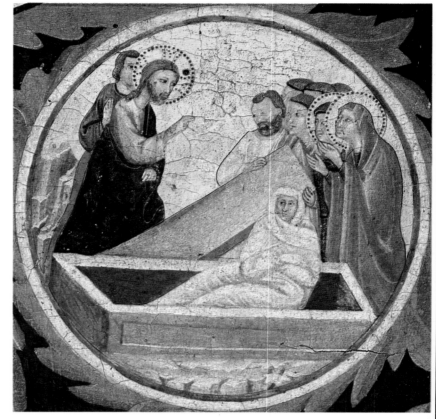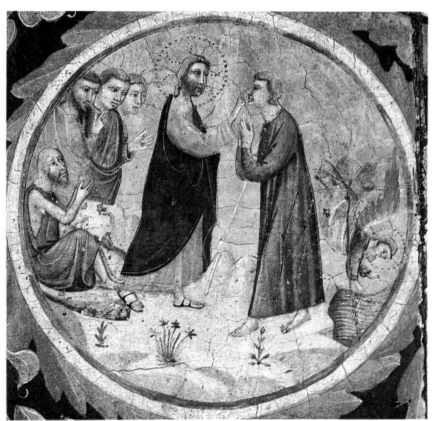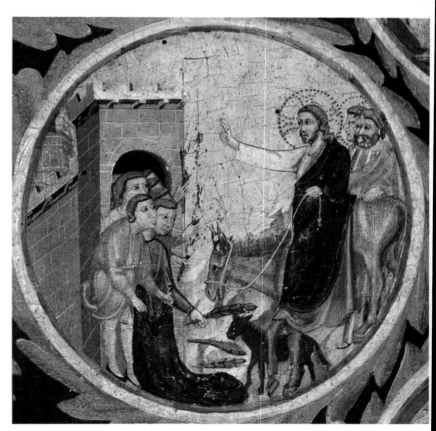

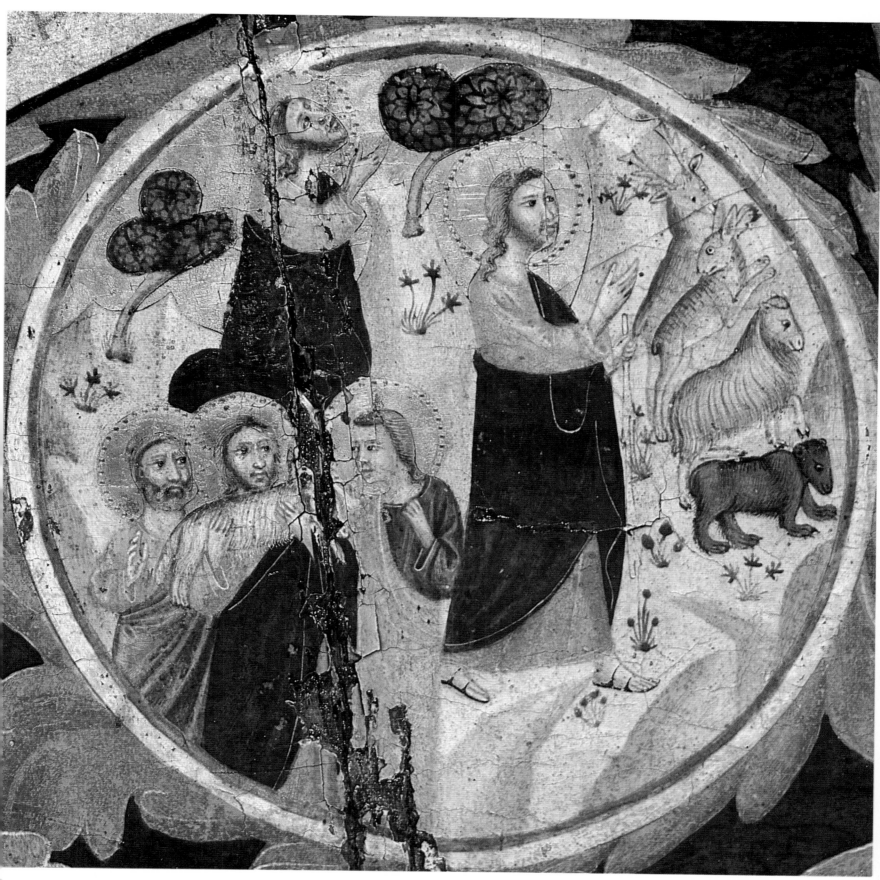

THE BLIND SEE...

THE LAME WALK...

THE DEAF HEAR...

THE DEAD ARE RAISED

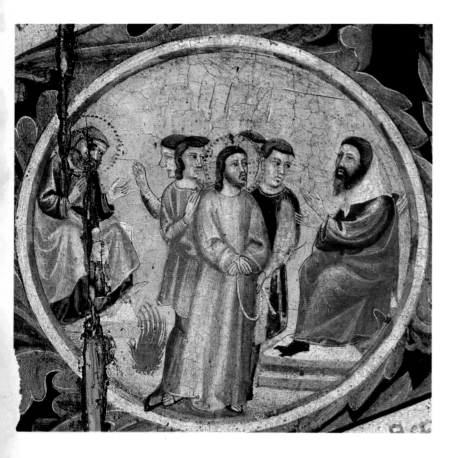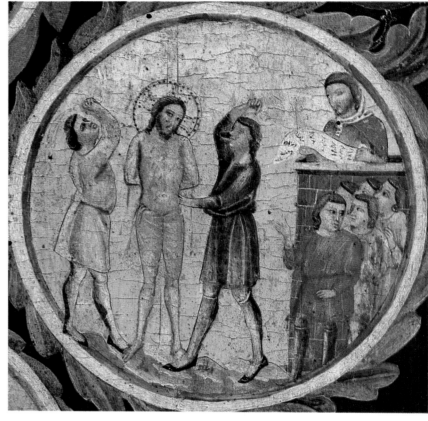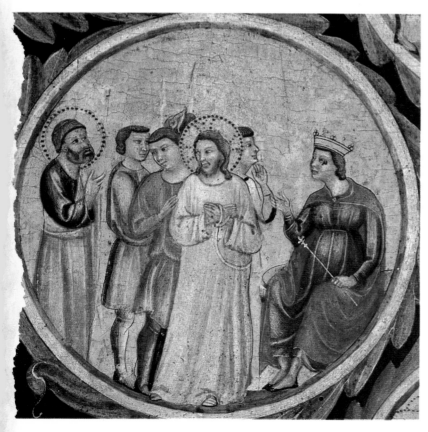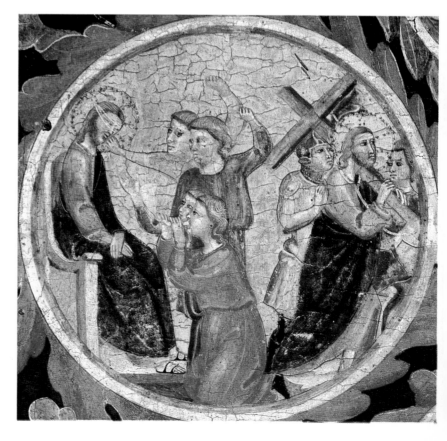

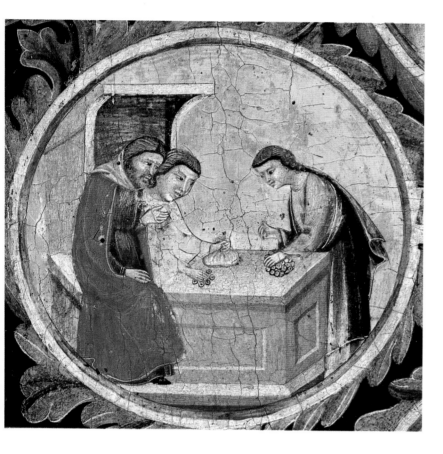

THERE FOLLOWED HIM A GREAT MULTITUDE OF THE PEOPLE, AND OF WOMEN WHO BEWAILED AND LAMENTED HIM. BUT JESUS TURNING TO THEM SAID,

"DAUGHTERS OF JERUSALEM, DO NOT WEEP FOR ME, BUT WEEP FOR YOURSELVES AND FOR YOUR CHILDREN.

FOR BEHOLD, THE DAYS ARE COMING WHEN THEY WILL SAY, 'BLESSED ARE THE BARREN, AND THE WOMBS THAT NEVER BORE, AND THE BREASTS THAT NEVER GAVE SUCK!' THEN THEY WILL BEGIN TO SAY TO THE MOUNTAINS, 'FALL ON US'; AND TO THE HILLS, 'COVER US.' FOR IF THEY DO THIS WHEN THE WOOD IS GREEN, WHAT WILL HAPPEN WHEN IT IS DRY?"

(Luke 23:27-31)

112

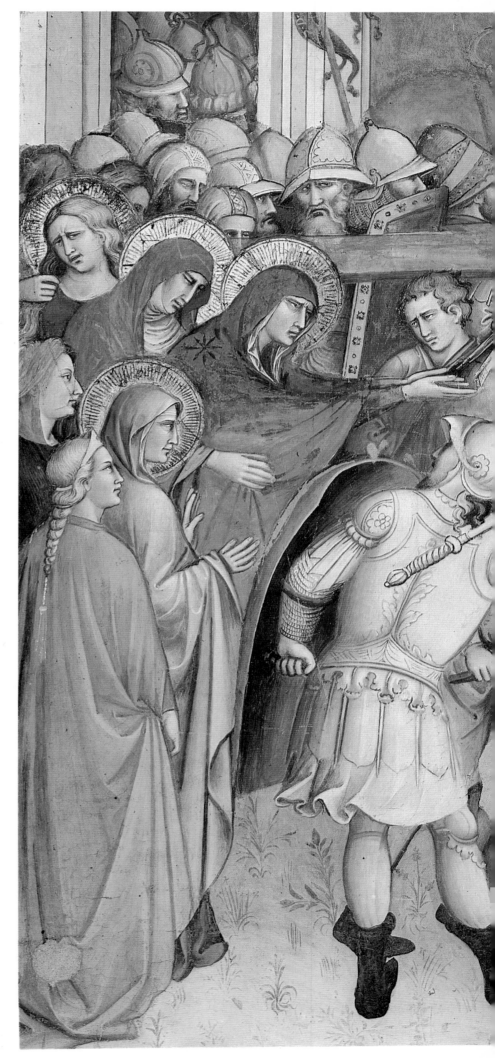

SPINELLO ARETINO

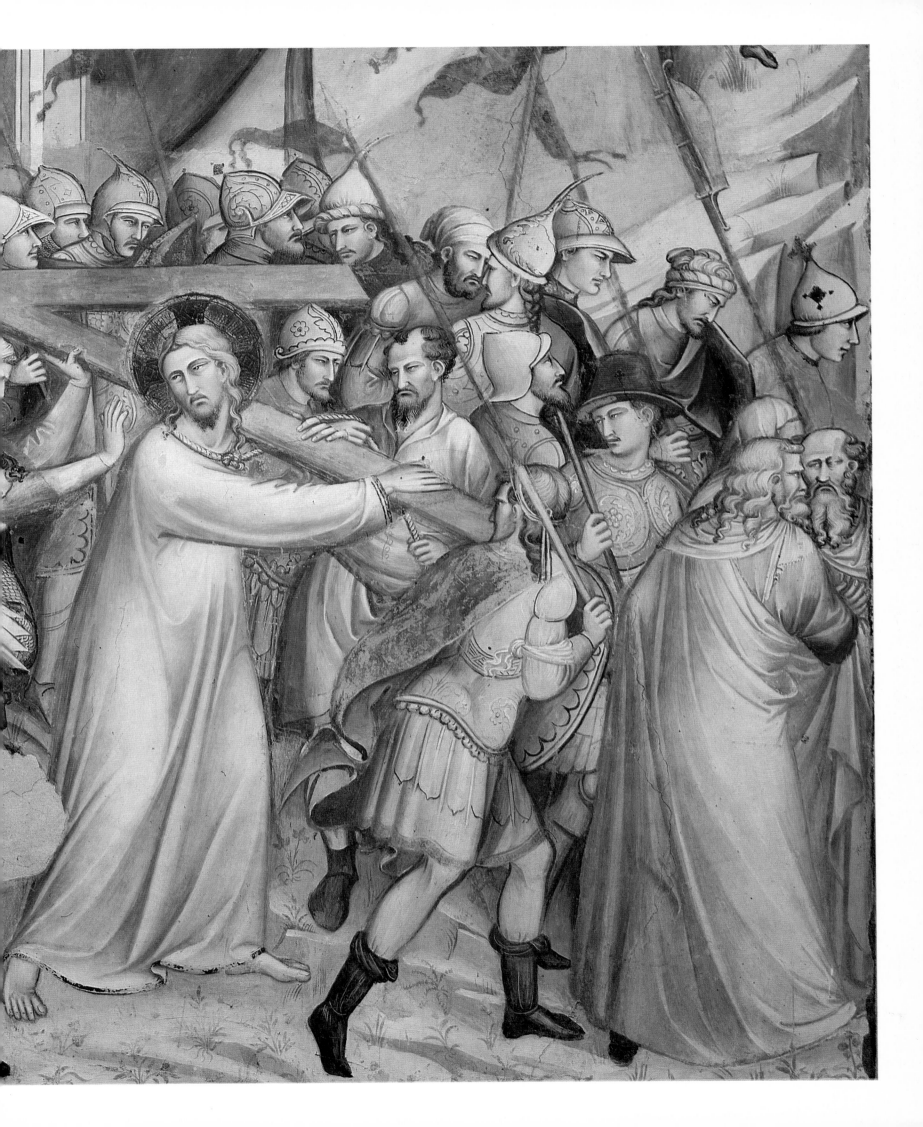

STANDING BY THE CROSS OF
JESUS WERE HIS MOTHER, AND
HIS MOTHER'S SISTER, MARY
THE WIFE OF CLOPAS, AND
MARY MAGDALENE. WHEN
JESUS SAW HIS MOTHER, AND
THE DISCIPLE WHOM HE
LOVED STANDING NEAR, HE
SAID TO HIS MOTHER,

"WOMAN, BEHOLD, YOUR SON!"

THEN HE SAID TO THE DISCIPLE,

"BEHOLD, YOUR MOTHER!"

AND FROM THAT HOUR THE
DISCIPLE TOOK HER TO HIS
OWN HOME.

(John 19:25-27)

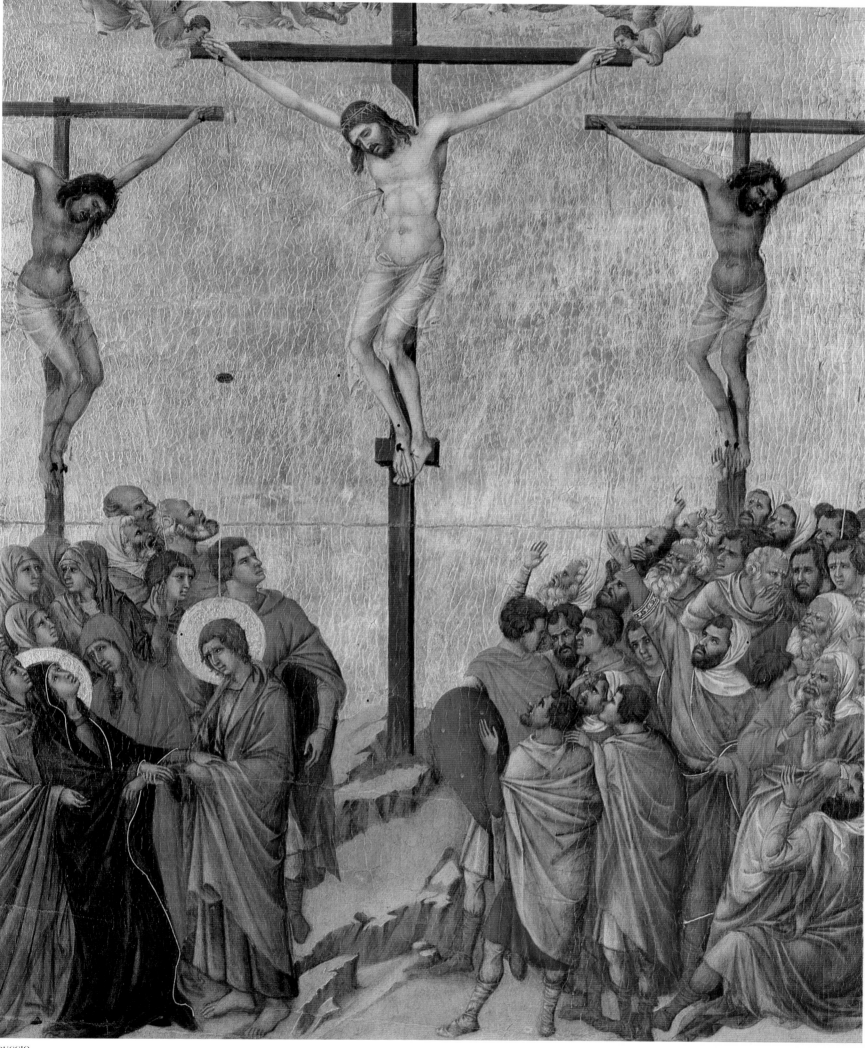

DUCCIO

IT WAS NOW ABOUT THE
SIXTH HOUR, AND THERE WAS
DARKNESS OVER THE WHOLE
LAND UNTIL THE NINTH
HOUR, WHILE THE SUN'S
LIGHT FAILED; AND THE CUR-
TAIN OF THE TEMPLE WAS
TORN IN TWO. THEN JESUS,
CRYING WITH A LOUD VOICE,
SAID,

"FATHER,

INTO YOUR HANDS I COMMIT MY SPIRIT!"

(Luke 23:44-46)

DONATELLO

AT THE CROSS HER STATION KEEPING,

STOOD THE MOURNFUL MOTHER WEEPING,

 CLOSE TO JESUS TO THE LAST.

THROUGH HER HEART, HIS SORROW SHARING,

ALL HIS BITTER ANGUISH BEARING,

 NOW AT LENGTH THE SWORD HAD PASSED.

OH, HOW SAD AND SORE DISTRESSED

WAS THAT MOTHER HIGHLY BLESSED

 OF THE SOLE BEGOTTEN ONE!

CHRIST ABOVE IN TORMENT HANGS,

SHE BENEATH BEHOLDS THE PANGS

 OF HER DYING, GLORIOUS SON.

IS THERE ONE WHO WOULD NOT WEEP,

WHELMED IN MISERIES SO DEEP,

 CHRIST'S DEAR MOTHER TO BEHOLD?

CAN THE HUMAN HEART REFRAIN

FROM PARTAKING IN HER PAIN,

 IN THAT MOTHER'S PAIN UNTOLD?

(Stabat Mater)

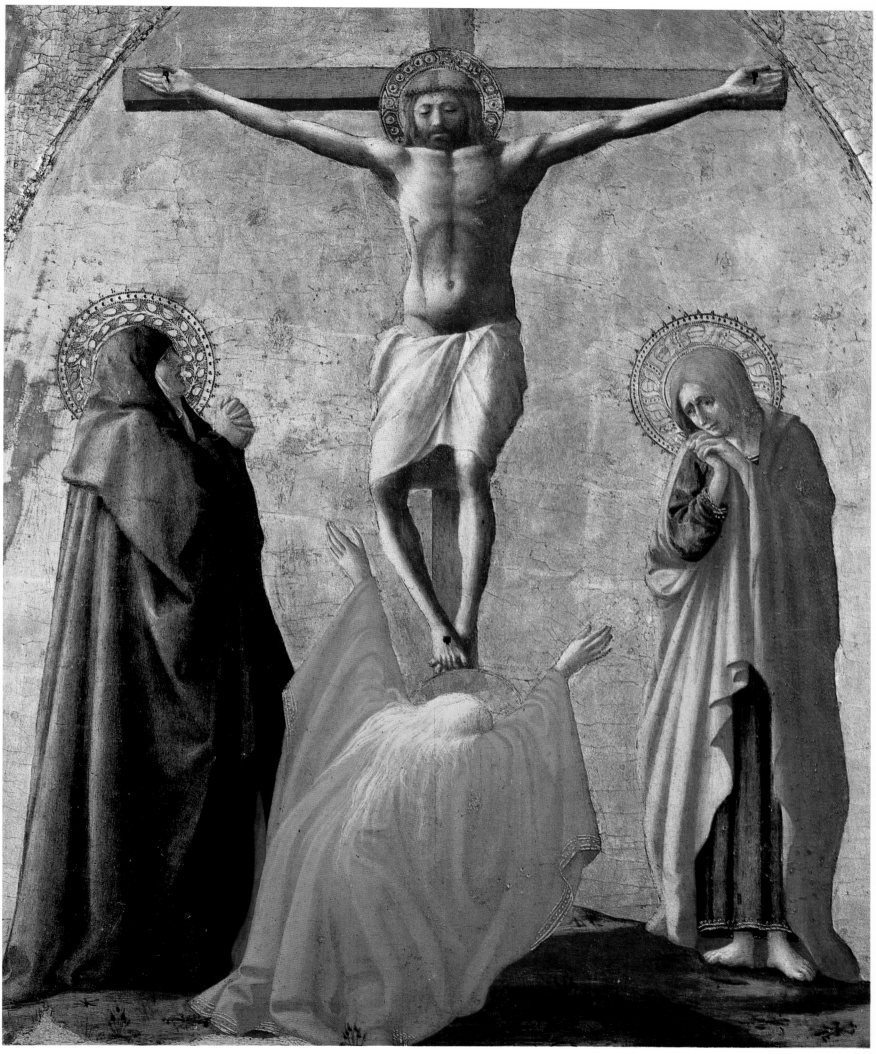

MASACCIO

NOW THERE WAS A MAN NAMED JOSEPH FROM THE JEWISH TOWN OF ARIMATHEA. HE WAS A MEMBER OF THE COUNCIL, A GOOD AND RIGHTEOUS MAN, WHO HAD NOT CONSENTED TO THEIR PURPOSE AND DEED, AND HE WAS LOOKING FOR THE KINGDOM OF GOD. THIS MAN WENT TO PILATE AND ASKED FOR THE BODY OF JESUS. THEN HE TOOK IT DOWN AND WRAPPED IT IN A LINEN SHROUD, AND LAID HIM IN A ROCK-HEWN TOMB, WHERE NO ONE HAD EVER YET BEEN LAID.

(Luke 23:50-53)

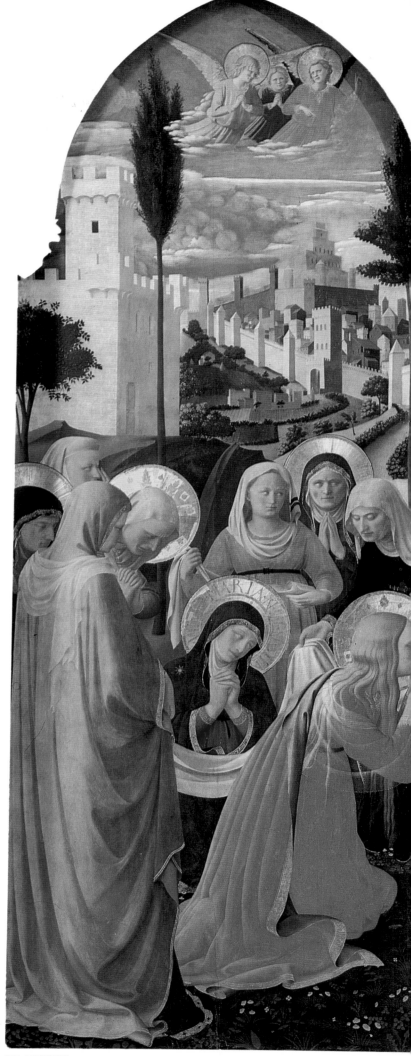

FRA ANGELICO

120

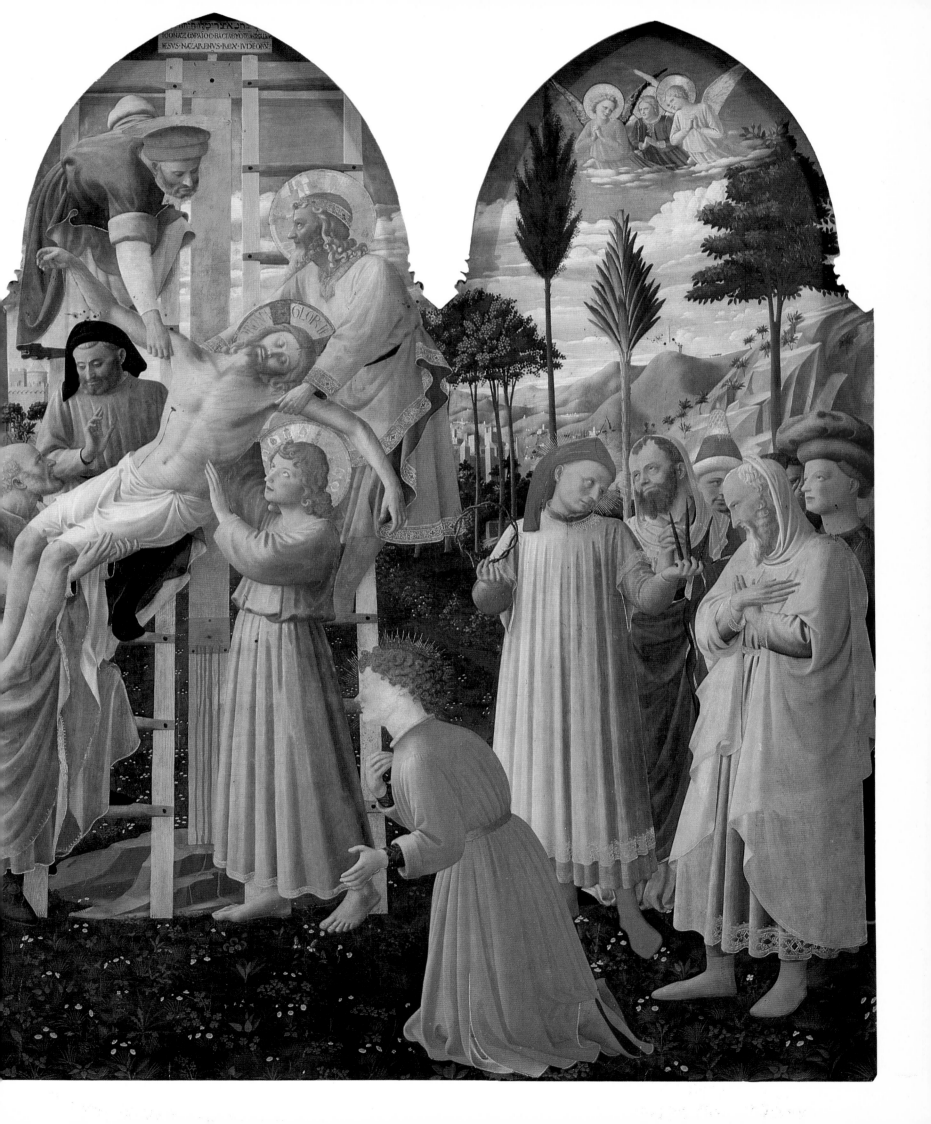

IT WAS THE DAY OF PREPARA-
TION, AND THE SABBATH WAS
BEGINNING. THE WOMEN WHO
HAD COME WITH HIM FROM
GALILEE FOLLOWED, AND SAW
THE TOMB, AND HOW HIS
BODY WAS LAID; THEN THEY
RETURNED, AND PREPARED
SPICES AND OINTMENTS.
ON THE SABBATH THEY
RESTED ACCORDING TO THE
COMMANDMENT.

(Luke 23:54-56)

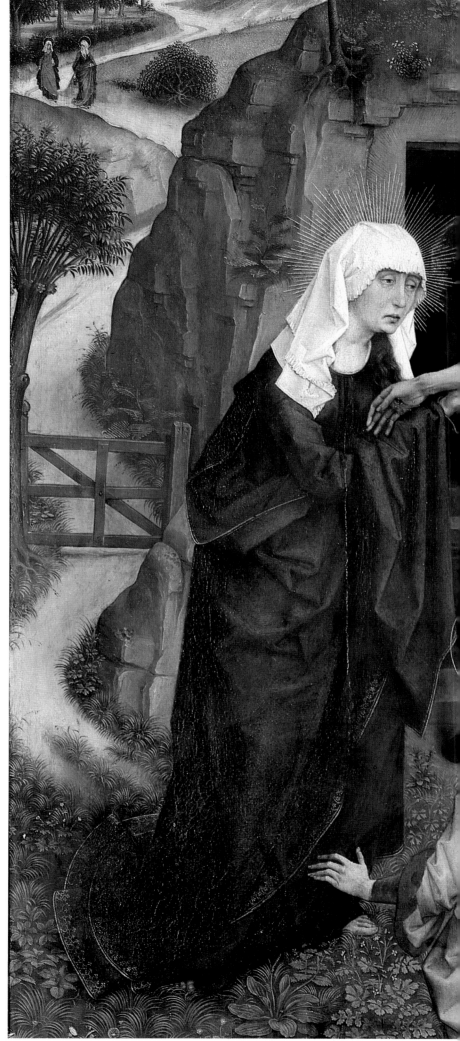

VAN DER WEYDEN

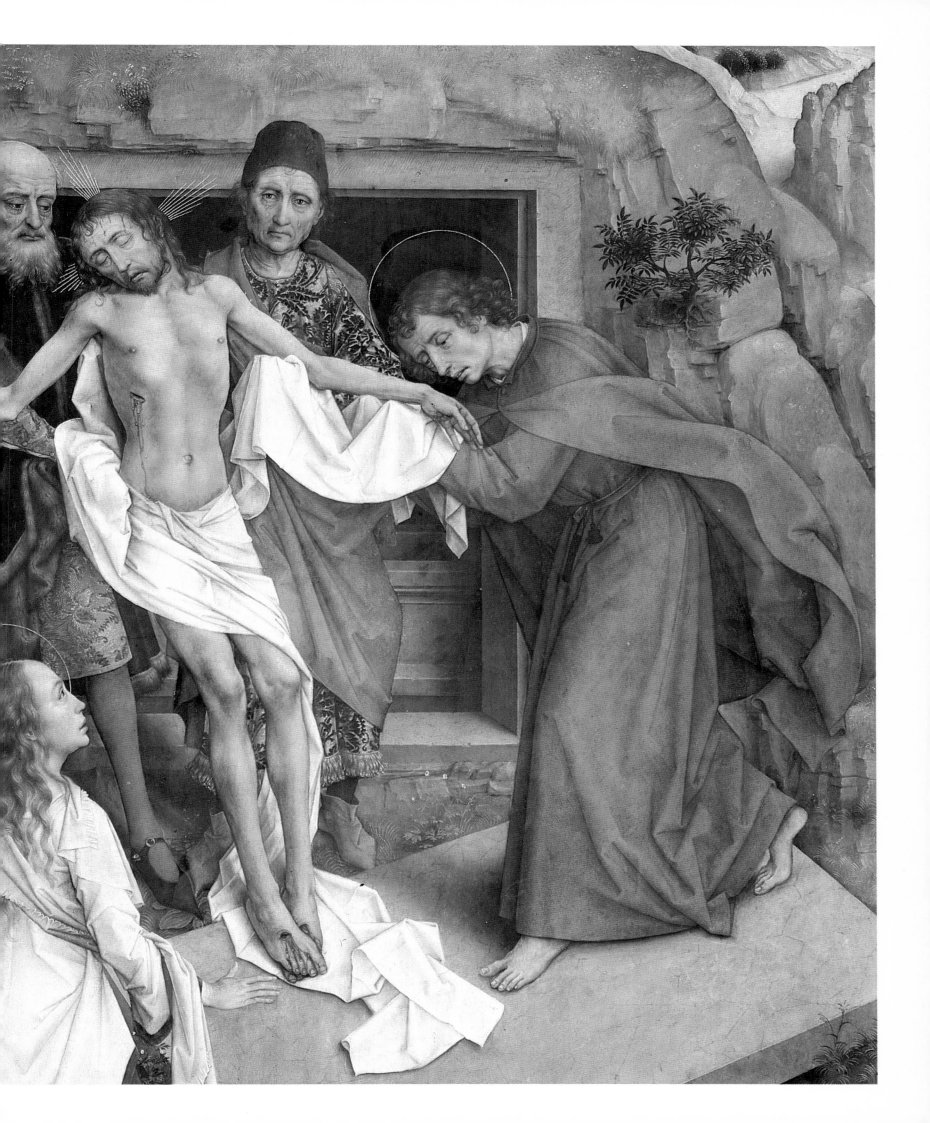

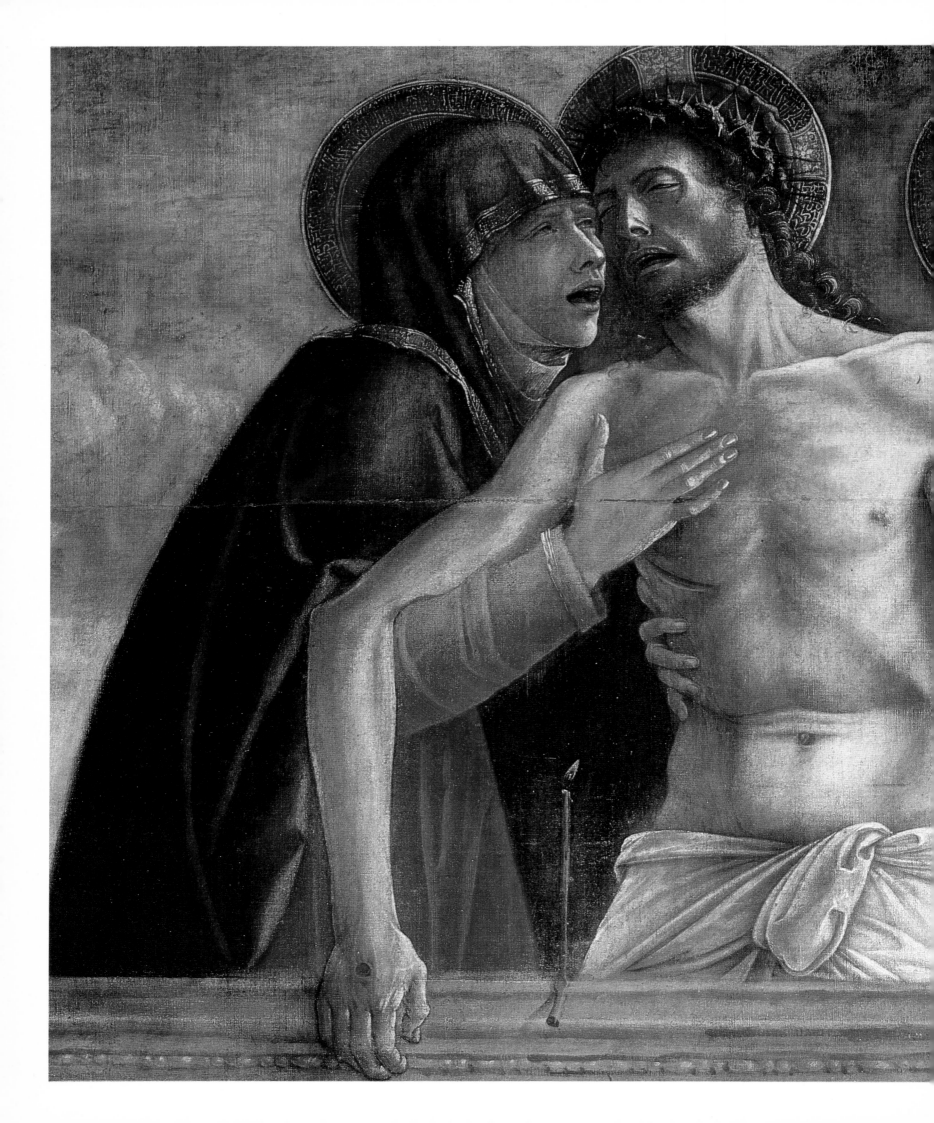

GIOVANNI BELLINI

THE MARTYRDOM OF THE VIRGIN, BEGUN IN THE PROPHECY OF SIMEON, REACHES ITS HEIGHT IN THE HISTORY OF THE PASSION OF OUR LORD. TO THE INFANT JESUS SIMEON HAD SAID, "THIS CHILD IS TO BE A SIGN WHICH WILL BE CONTRADICTED." TO THE MOTHER HE HAD SAID, "A SWORD SHALL PIERCE YOUR VERY SOUL!"

O TRULY BLESSED MOTHER, THE SWORD HAS PIERCED. THE ONLY WAY IT COULD CUT WAS TO SEE THE PIERCING OF YOUR DIVINE SON. AFTER HE HAD BREATHED HIS LAST, WHEN THE CRUEL SWORD COULD NOT TOUCH HIS SPIRIT AS IT PASSED THROUGH HIS SIDE, SURELY IT PIERCED YOUR OWN SOUL.

(St. Bernard)

"AND A SWORD
WILL PIERCE THROUGH
YOUR OWN SOUL ALSO."

(Luke 2:35)

BOTTICELLI

126

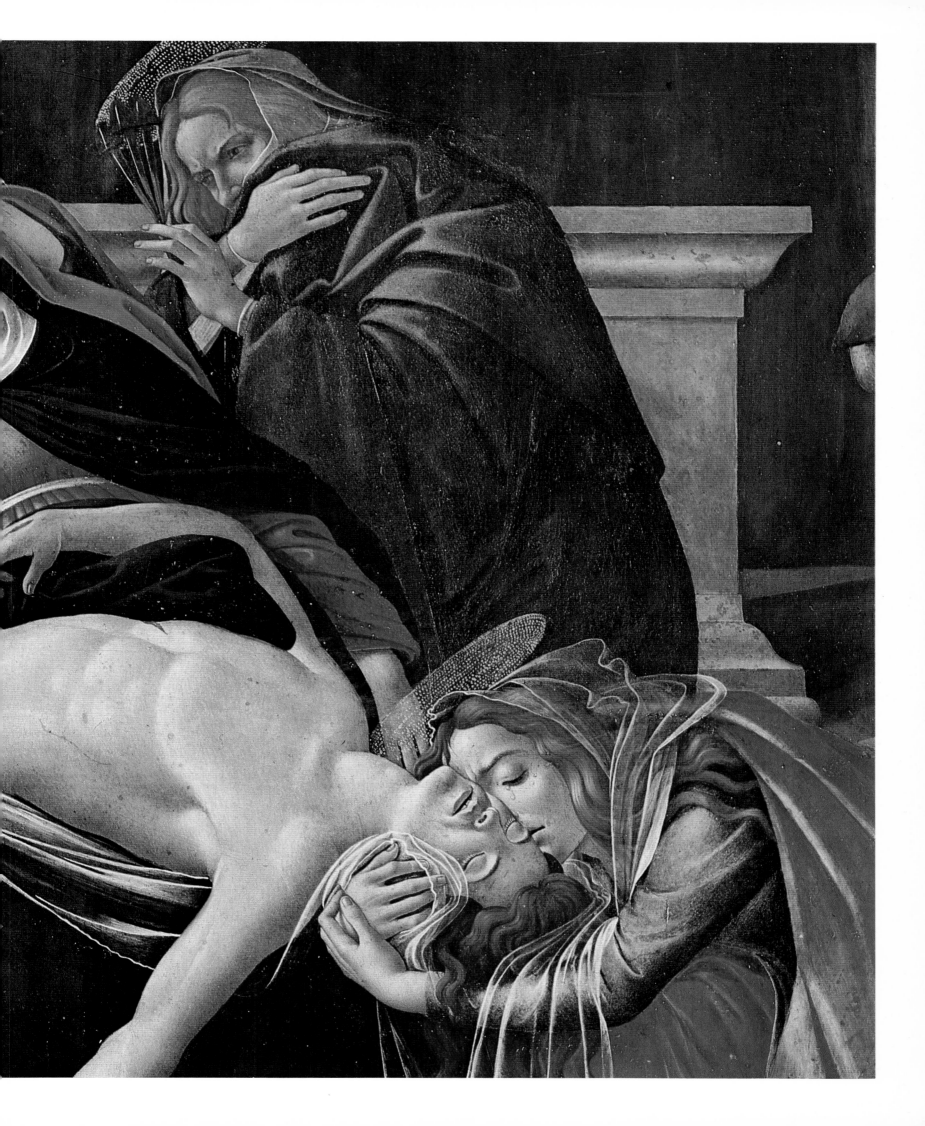

HIS SOUL WAS NO LONGER THERE, BUT YOURS DID NOT DRAW BACK. SURELY IT RECEIVED THE WOUND. WE CALL YOU MORE THAN A MARTYR BECAUSE THE PASSION OF SENSE PAIN WAS EXCEEDED BY THE COMPASSION OF LOVE.

WERE NOT THE WORDS, "MOTHER, BEHOLD YOUR SON," ANOTHER PIERCING SWORD? O SAD EXCHANGE. JOHN IS GIVEN TO YOU FOR JESUS, THE SERVANT FOR THE LORD, THE DISCIPLE FOR THE MASTER, THE SON OF ZEBEDEE FOR THE SON OF GOD, A PURE MAN FOR A TRUE GOD! HOW YOUR LOVING SOUL MUST HAVE SUFFERED, IF THE MERE THOUGHT OF IT CAN REND OUR HARD HEARTS.

(St. Bernard)

128

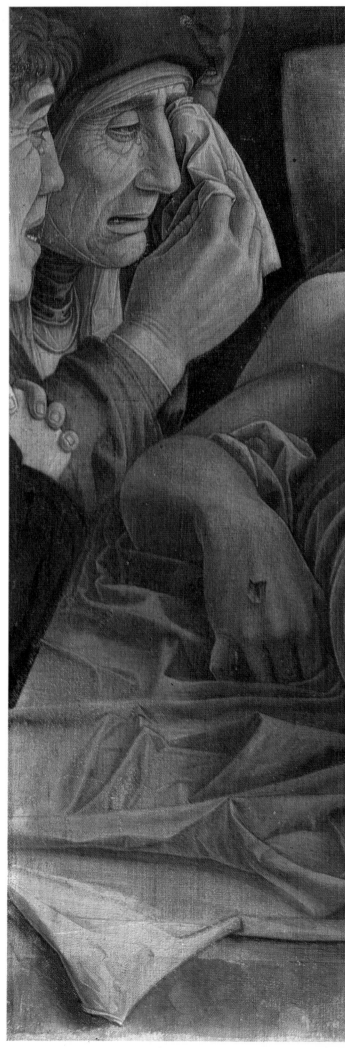

MANTEGNA

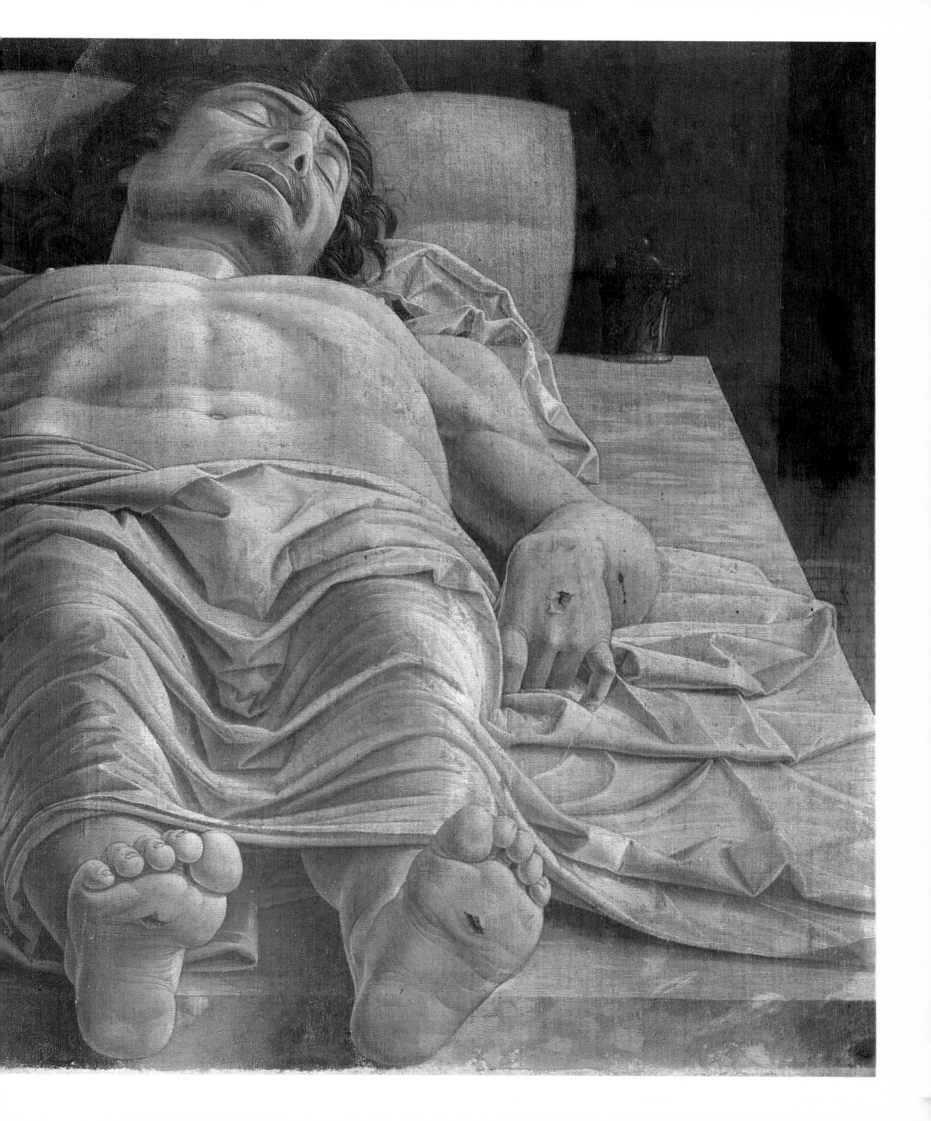

WHY DO YOU

AMONG

SEEK THE LIVING

SEEK DEAD?

ON THE FIRST DAY OF THE WEEK, AT EARLY DAWN, THEY WENT TO THE TOMB, TAKING THE SPICES WHICH THEY HAD PREPARED. AND THEY FOUND THE STONE ROLLED AWAY FROM THE TOMB, BUT WHEN THEY WENT IN THEY DID NOT FIND THE BODY. WHILE THEY WERE PERPLEXED ABOUT THIS, BEHOLD, TWO MEN STOOD BY THEM IN DAZZLING APPAREL; AND AS THEY WERE FRIGHTENED AND BOWED THEIR FACES TO THE GROUND, THE MEN SAID TO THEM,

"WHY DO YOU SEEK THE LIVING AMONG THE DEAD?

HE IS NOT HERE, BUT HAS RISEN. REMEMBER HOW HE TOLD YOU, WHILE HE WAS STILL IN GALILEE, THAT THE SON OF MAN MUST BE DELIVERED INTO THE HANDS OF SINFUL MEN, AND BE CRUCIFIED, AND ON THE THIRD DAY RISE." AND THEY REMEMBERED HIS WORDS, AND RETURNING FROM THE TOMB THEY TOLD ALL THIS TO THE ELEVEN AND TO ALL THE REST. NOW IT WAS MARY MAGDALENE AND JOANNA AND MARY THE MOTHER OF JAMES AND THE OTHER WOMEN WITH THEM WHO TOLD THIS TO THE APOSTLES.

(Luke 24:1-10)

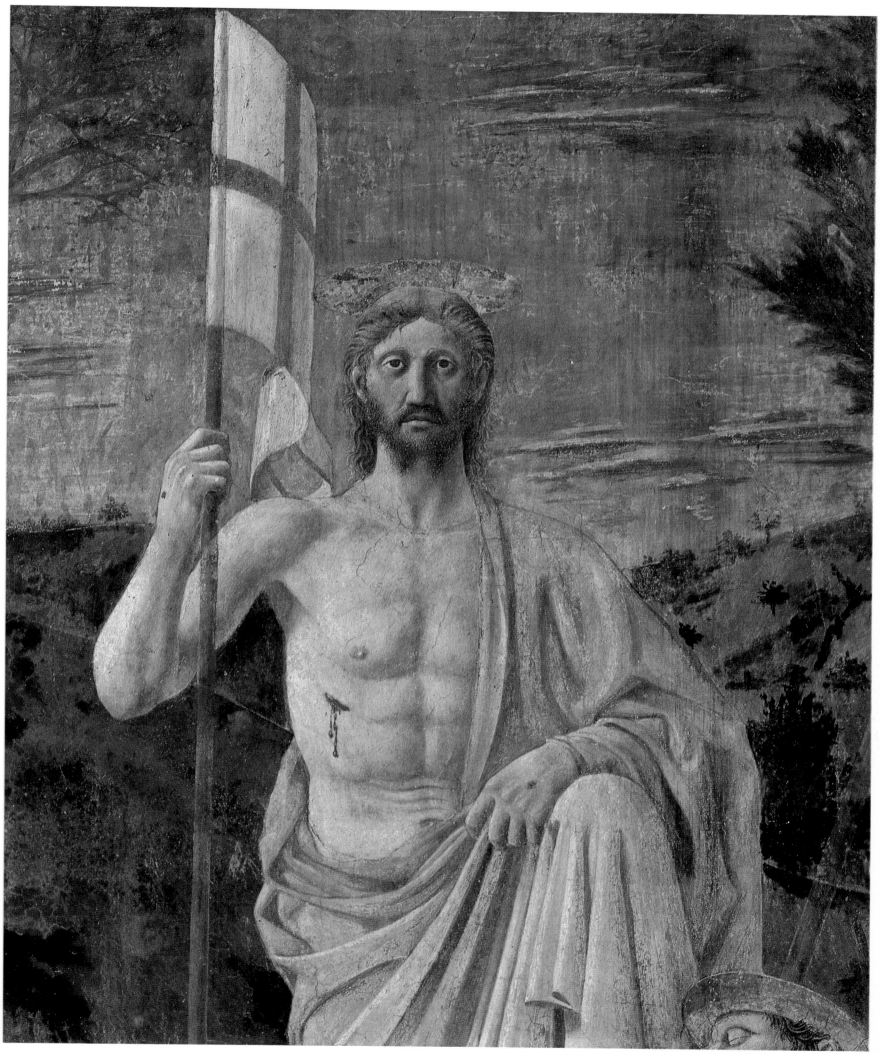

PIERO DELLA FRANCESCA

HE WAS LIFTED UP WHILE THEY LOOKED ON, AND A CLOUD TOOK HIM FROM THEIR SIGHT. THEY WERE STILL STARING INTO THE SKY WHEN SUDDENLY TWO MEN IN WHITE WERE STANDING NEAR THEM AND THEY SAID,

"WHY ARE YOU MEN FROM GALILEE STANDING HERE LOOKING INTO THE SKY?

JESUS WHO HAS BEEN TAKEN UP FROM YOU INTO HEAVEN, THIS SAME JESUS WILL COME BACK IN THE SAME WAY AS YOU HAVE SEEN HIM GO THERE."

SO FROM THE MOUNT OF OLIVES, AS IT IS CALLED, THEY WENT BACK TO JERUSALEM, A SHORT DISTANCE AWAY, NO MORE THAN A SABBATH WALK; AND WHEN THEY REACHED THE CITY THEY WENT TO THE UPPER ROOM WHERE THEY WERE STAYING; THERE WERE PETER AND JOHN, JAMES AND ANDREW, PHILIP AND THOMAS, BARTHOLOMEW AND MATTHEW, JAMES SON OF ALPHAEUS AND SIMON THE ZEALOT, AND JUDE SON OF JAMES. ALL THESE JOINED IN CONTINUOUS PRAYER, TOGETHER WITH SEVERAL WOMEN, INCLUDING MARY THE MOTHER OF JESUS, AND WITH HIS BROTHERS.

*(Acts 1:9-14)***

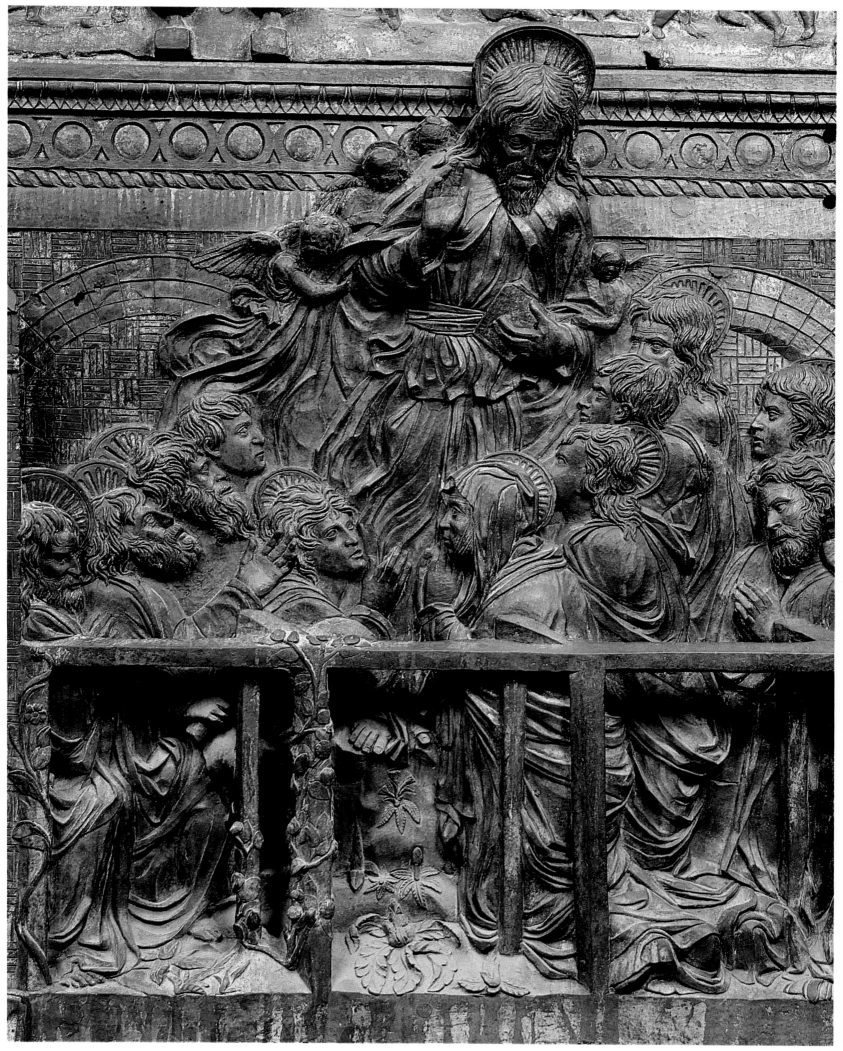

DONATELLO

WHEN PENTECOST DAY CAME ROUND, THEY HAD ALL MET IN ONE ROOM, WHEN SUDDENLY THEY HEARD WHAT SOUNDED LIKE A POWERFUL WIND FROM HEAVEN, THE NOISE OF WHICH FILLED THE ENTIRE HOUSE IN WHICH THEY WERE SITTING;

AND SOMETHING APPEARED TO THEM THAT SEEMED LIKE TONGUES OF FIRE; THESE SEPARATED AND CAME TO REST ON THE HEAD OF EACH OF THEM. THEY WERE ALL FILLED WITH THE HOLY SPIRIT,

AND BEGAN TO SPEAK FOREIGN LANGUAGES AS THE SPIRIT GAVE THEM THE GIFT OF SPEECH.

*(Acts 2:1-4)***

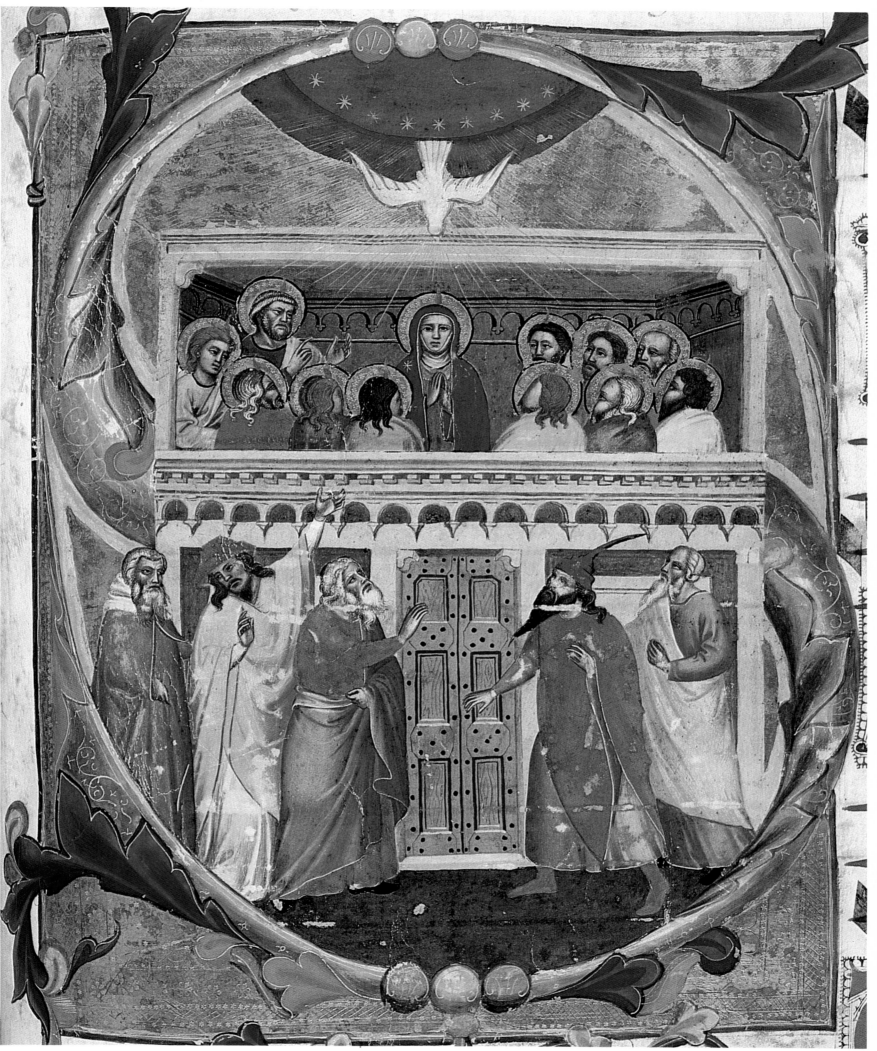

MINIATURE OF THE FOURTEENTH CENTURY

THE END OF MARY'S

EARTHLY PILGRIMAGE

WHEN THE ANGEL CRIED, "HAIL, FULL OF GRACE, THE LORD IS WITH YOU; YOU ARE BLESSED AMONG WOMEN!" HE TOLD US BY DIVINE COMMAND HOW TREMENDOUS WAS THE DIGNITY AND BEAUTY OF THE EVER-VIRGIN MARY. HOW WELL WE CAN UNDERSTAND THAT SHE WOULD BE "FULL OF GRACE," THIS VIRGIN WHO GLORIFIED GOD AND GAVE OUR LORD TO MANKIND, WHO POURED OUT PEACE UPON THE EARTH BY GIVING HOPE TO THE GENTILES, PROTECTION AGAINST TEMPTATION, PURPOSE TO LIFE AND REASON FOR SACRIFICE.

(St. Jerome)

DUCCIO

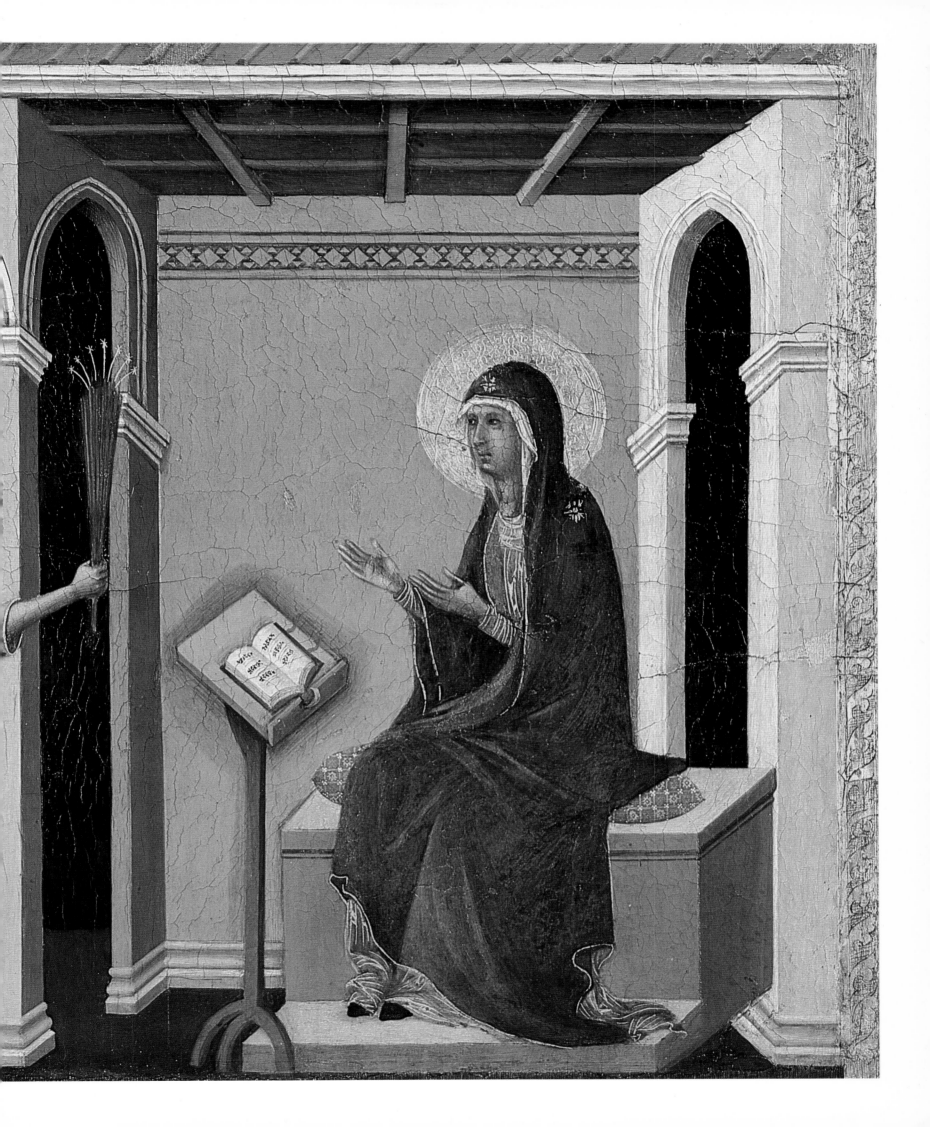

MARY'S LIFE ON EARTH DREW TO A CLOSE. HER EYES WERE FIXED ON HEAVEN; HER HEART BEAT WITH AFFECTION FOR GOD; HER FACE SHONE AND A SMILE WAS EVER ON HER LIPS. ALL AT ONCE HER HEART GAVE A START, AND MARY FLEW TO HEAVEN, TO THE EMBRACE OF HER BELOVED.

(Rev. James Alberione, S.S.P., S.T.D.)

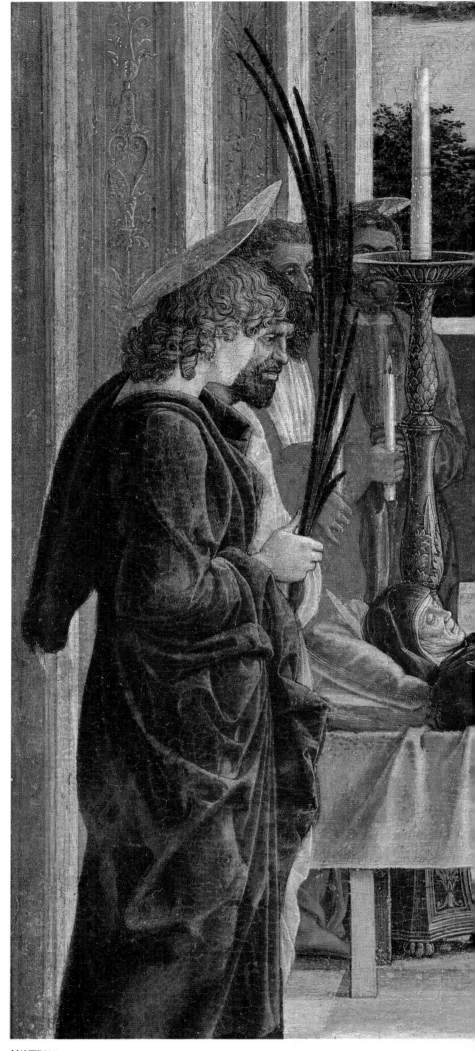

MANTEGNA

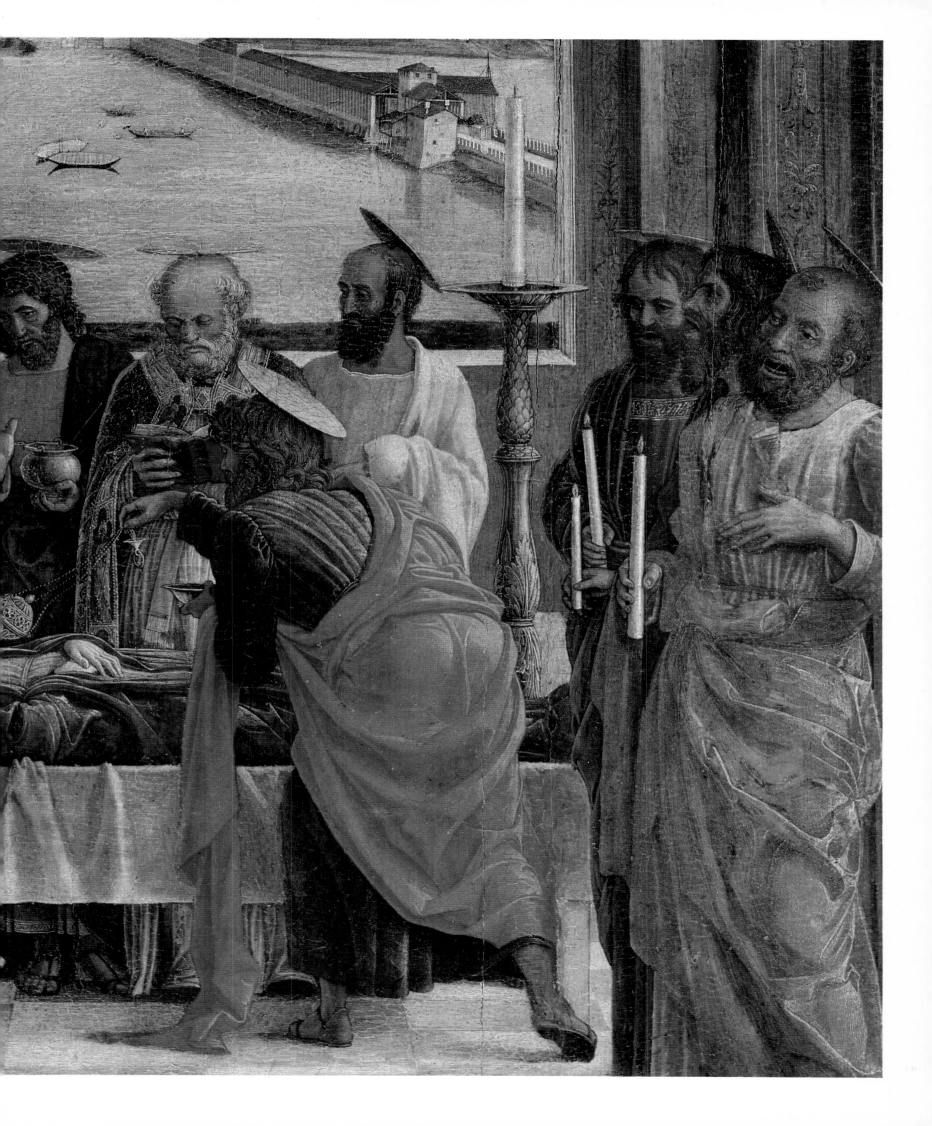

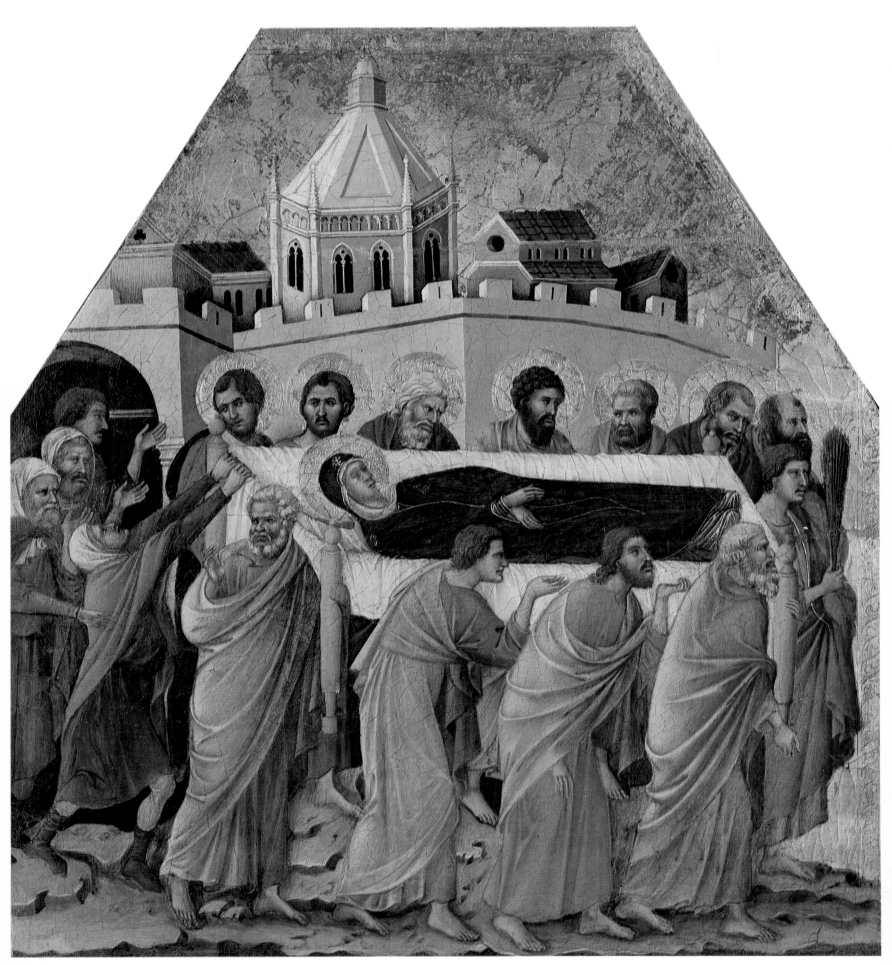

DUCCIO

TODAY THAT IMMACULATE VIRGIN, IN WHOM THERE IS NO SPOT OF EARTHLY TAINT, BUT ONLY THE LOVE OF HEAVENLY DELIGHTS, TODAY SHE RETURNS NOT TO DUST BUT SHE IS BROUGHT INTO THE MANSIONS OF HEAVEN—SHE, HERSELF, A LIVING HEAVEN! FROM HER THE SOURCE OF ALL LIFE WAS GIVEN TO MANKIND.

(St. John Damascene)

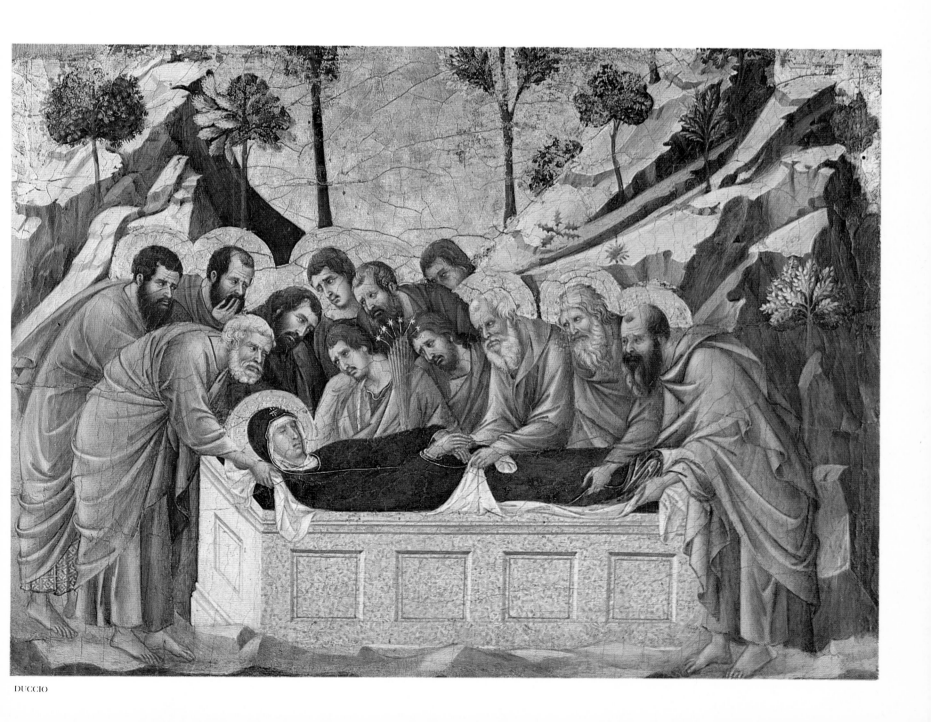

DUCCIO

ALL-POWERFUL AND EVER-LIVING GOD,
YOU RAISED THE IMMACULATE VIRGIN MARY,
MOTHER OF YOUR SON,
BODY AND SOUL TO THE GLORY OF HEAVEN.
MAY WE THINK OF HEAVEN AS OUR FINAL GOAL
AND COME TO SHARE HER GLORY.

(From the Liturgy)

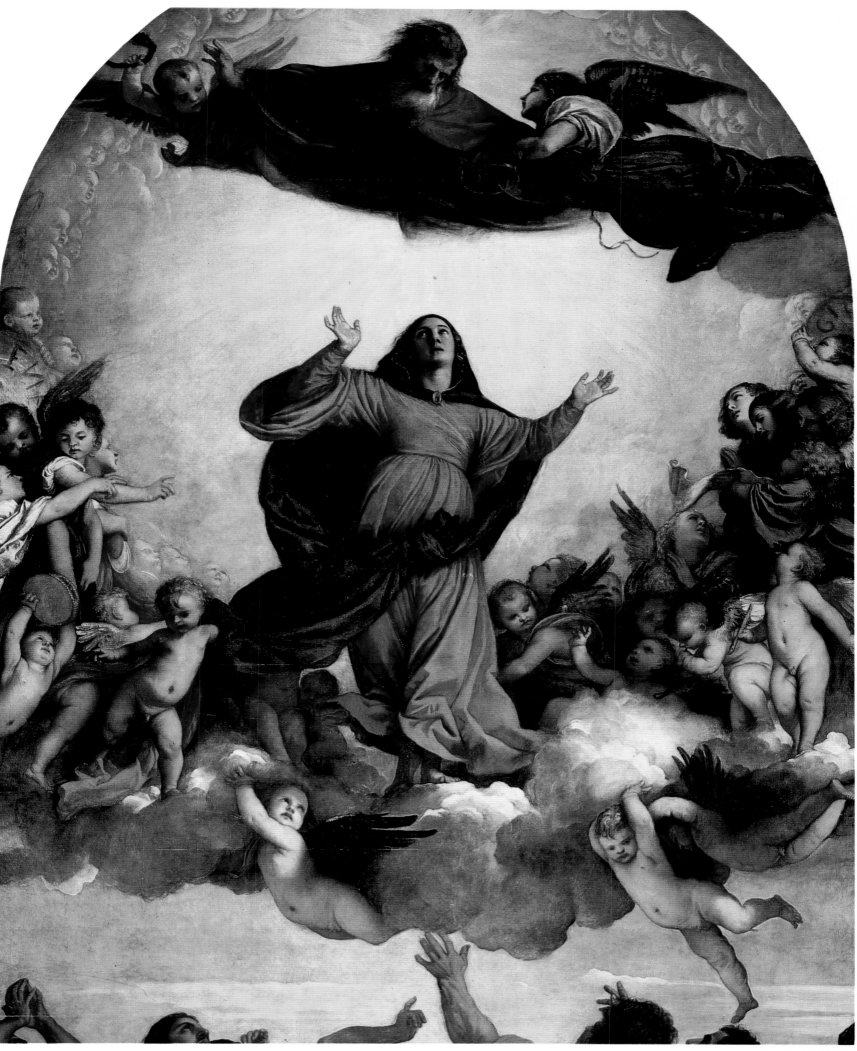

TITIAN

THAT MARY IS QUEEN AND OUT-
STANDING IN HER GLORY, IS
CHANTED BY THE PSALMIST IN
THAT PSALM ESPECIALLY PROPHET-
ICAL OF CHRIST AND HIS VIRGIN
MOTHER. FIRST HE SAYS OF CHRIST,
"YOUR THRONE, O GOD, EXISTS
FOREVER." THEN HE ADDS OF OUR
LADY, "THE QUEEN SHALL SIT AT
YOUR RIGHT SIDE." THIS INDICATES
HER OUTSTANDING POWER.

HE FOLLOWS THIS WITH THE
WORDS, "ROBED IN GOLD," TO
EXPRESS THE GLORIOUS GIFT OF
CORPORAL IMMORTALITY SHOWN BY
HER ASSUMPTION. NEVER COULD IT
HAPPEN THAT THE BODY WHICH
ENVELOPED THE WORD-MADE-FLESH,
WHICH WAS PERFECTLY SANCTIFIED
ON EARTH, COULD EVER RETURN
TO DUST, TO BE THE FOOD OF
WORMS.

(St. Bonaventure)

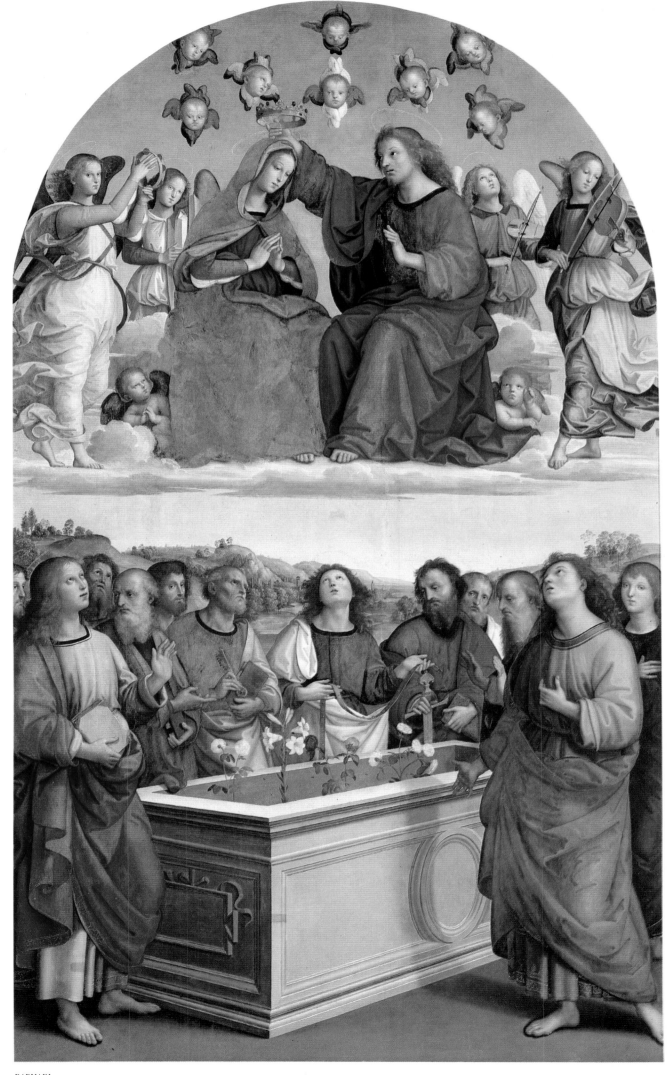

RAPHAEL

MARY IS THE QUEEN OF ALL THE ELECT IN THE KINGDOM OF CHRIST, THE GREAT KING. THIS QUEEN IS SECOND TO NONE OF THE ELECT WHO REIGN WITH CHRIST AS CO-HEIRS. SHE IS FAR SUPERIOR TO ALL THE ANGELS AND ALL THE SAINTS.

THERE IS NOT ONE WHO EXCELS HER IN DIGNITY, BEAUTY, OR HOLINESS. ONLY MARY AND GOD THE FATHER HAVE THE SON IN COMMON. ONLY THE HOLY TRINITY IS ABOVE HER; ALL OTHERS ARE BELOW HER IN DIGNITY AND GLORY.

(St. Peter Canisius)

NOT ONLY IS MARY THE MOTHER OF GOD, SHE IS ALSO QUEEN AND MISTRESS, STRICTLY SPEAKING, SINCE CHRIST, GOD AND LORD, WHO WAS BORN OF HER, REMAINS ALWAYS THE KING.

(St. Athanasius)

ANDREA BONAIUTI

151

YOU, O MARY, HAVE BEEN PLACED ABOVE EVERY OTHER CREATURE, NO MATTER HOW GREAT. YOU HAVE RECEIVED MORE GIFTS THAN GOD HAS EVER BESTOWED IN ALL HIS GOODNESS ON ANY CREATURE. YOU HAVE GROWN RICHER THAN ALL BY THE POSSESSION OF GOD LIVING WITHIN YOU. NO ONE ELSE EVER CONTAINED GOD WITHIN, AS YOU DID!

NOT ONLY HAVE YOU RECEIVED THE LORD GOD, CREATOR OF ALL, BUT HE TOOK FLESH FROM YOU IN A WONDROUS MANNER. HE GREW IN YOUR WOMB AND WAS BORN TO REDEEM A RACE WHICH GROANED UNDER HIS FATHER'S CURSE, AND TO OFFER MAN UNENDING SALVATION, POURING HIMSELF OUT LAVISHLY.

THEREFORE I HAVE CRIED OUT TO YOU, AND WILL CONTINUE TO DO SO, UNCEASINGLY, "HAIL, FULL OF GRACE, THE LORD IS WITH YOU; YOU ARE BLESSED AMONG WOMEN!"

(St. Sophronius)

152

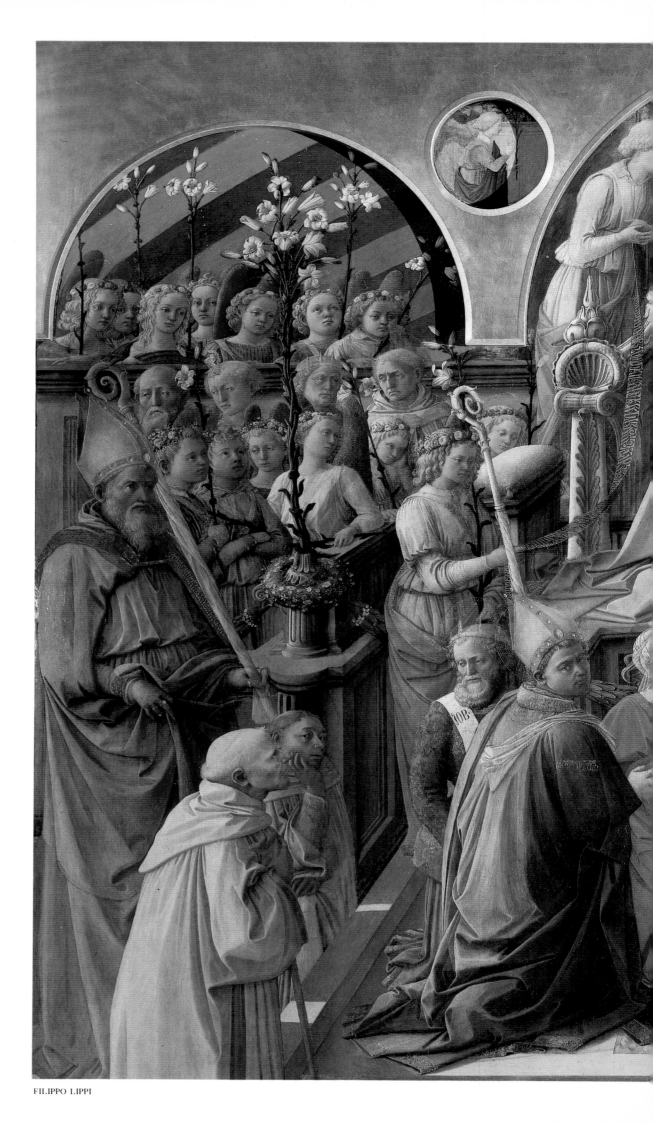

FILIPPO LIPPI

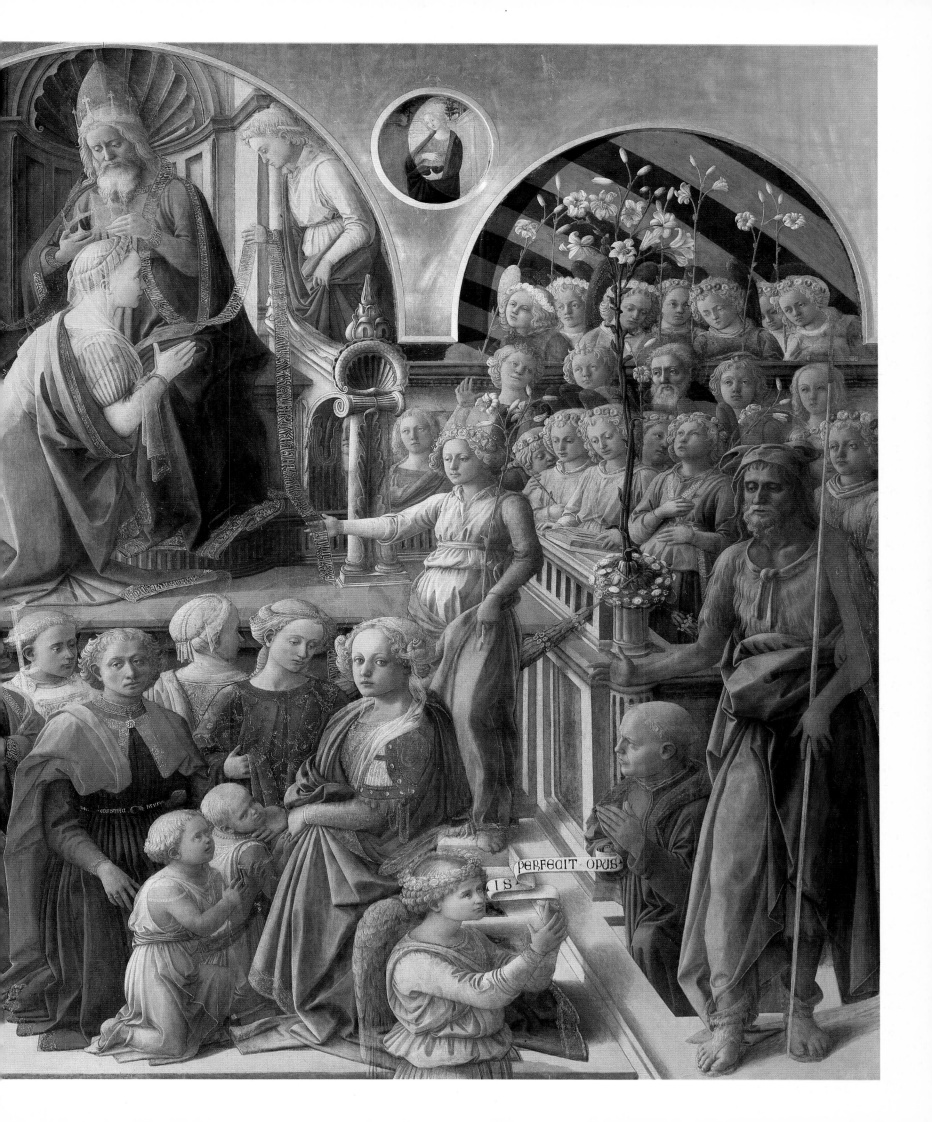

PERFECIT·OPVS

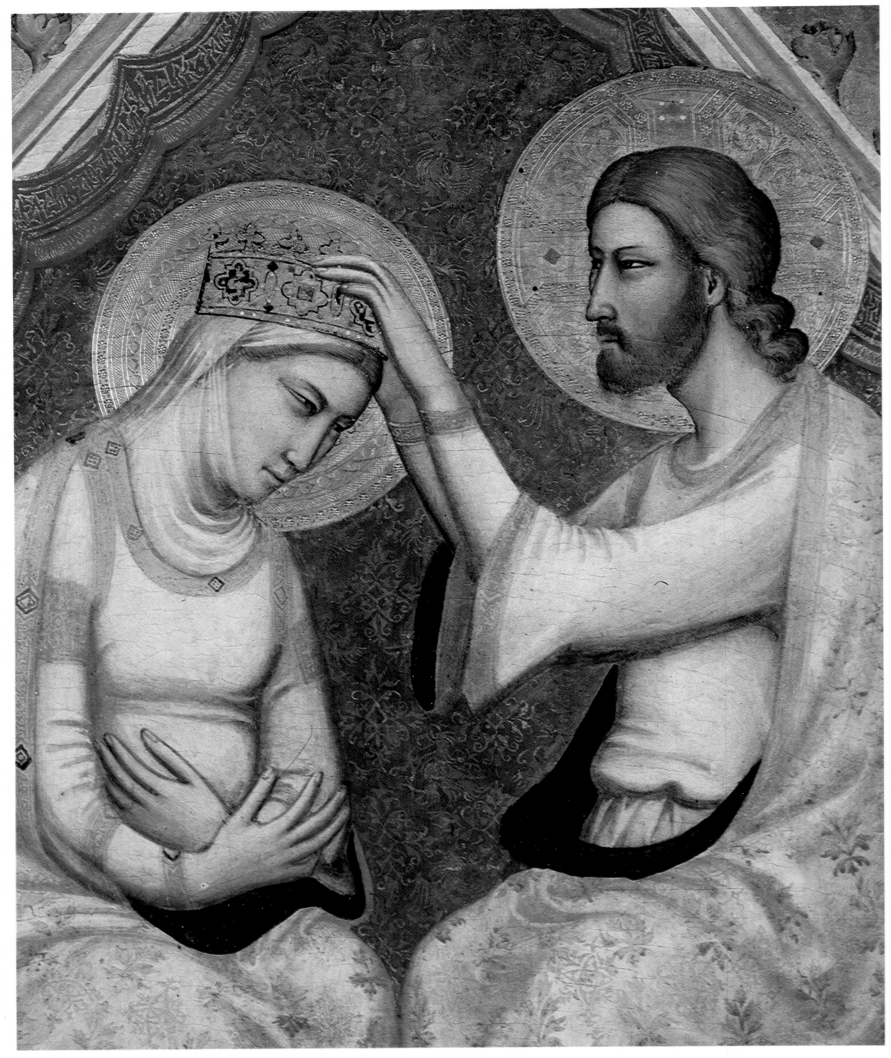

GIOTTO

VIRGIN MOTHER, DAUGHTER OF YOUR SON,

MOST HUMBLE AND EXALTED OF ALL CREATURES,

FROM GOD'S ETERNAL COUNSELS, YOU ARE HIS CHOSEN ONE.

OUR HUMAN NATURE GREATLY YOU DID GRACE

AND SO ENNOBLED IT THAT HE WHO FORMED IT

SCORNED NOT TO BE FORMED BY YOU, AS MEMBER OF OUR RACE.

WITHIN YOUR WOMB ENKINDLED WAS LOVE'S POWER,

AND IN THE WARMTH OF EVERLASTING PEACE

HAS SPRUNG AND BLOSSOMED THIS ETERNAL FLOWER.

YOUR LOVE FOR US IS BRIGHT AS NOONTIME SUN,

O YOU WHO HERE BELOW AMONG US MORTALS

ARE LIVING FONT OF HOPE SERENELY SPRUNG.

O LADY, FULL OF POWER AND OF MIGHT,

WHOEVER SEEKS GRACE AND TURNS NOT TO YOU—

A WINGLESS BIRD, ATTEMPTS IN VAIN HIS FLIGHT.

YOUR GOODNESS TO ALL THOSE WHO TO YOU TURN

IS OFTEN WITH A LAVISH HAND BESTOWED

TO ANSWER PLEAS UNSPOKEN—NOUGHT YOU SPURN.

IN YOU ARE MERCY, TENDERNESS, COMPASSION;

IN YOU IS GENEROSITY SUBLIME;

IN YOU ALL CREATURES' GOODNESS HAS BEEN FASHIONED.

(Dante, Paradiso XXXIII)

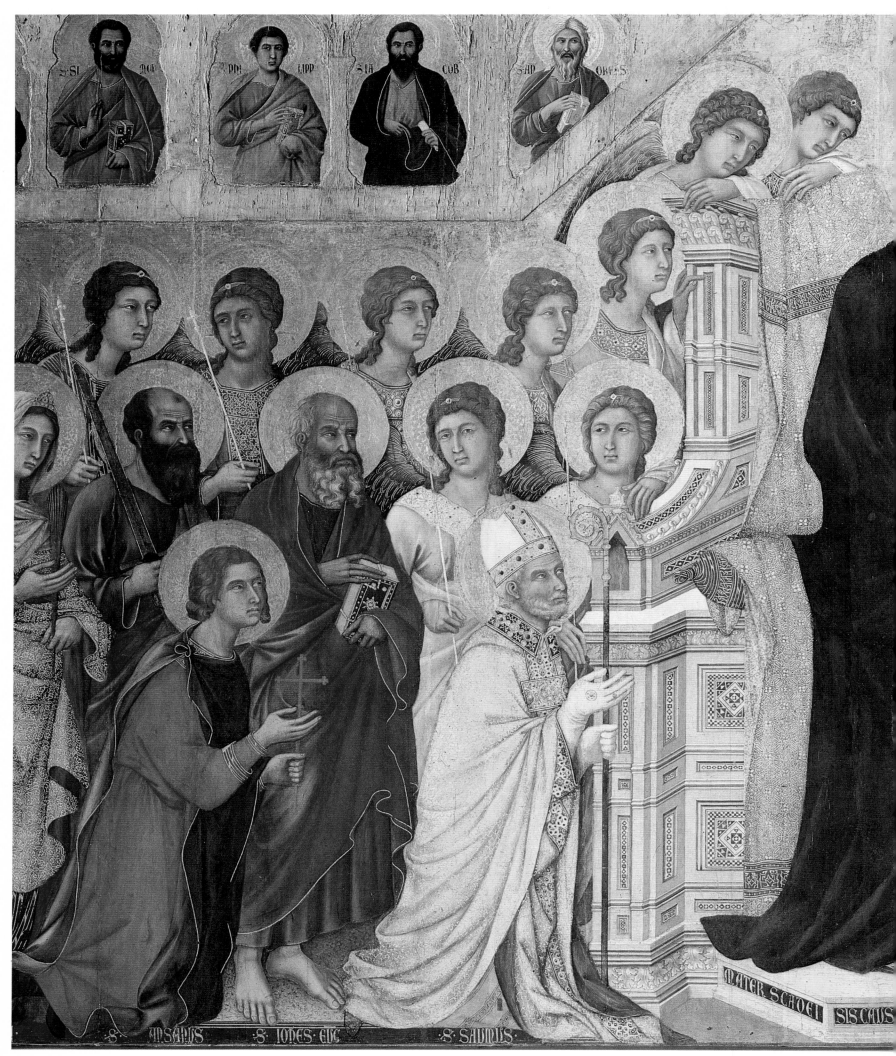

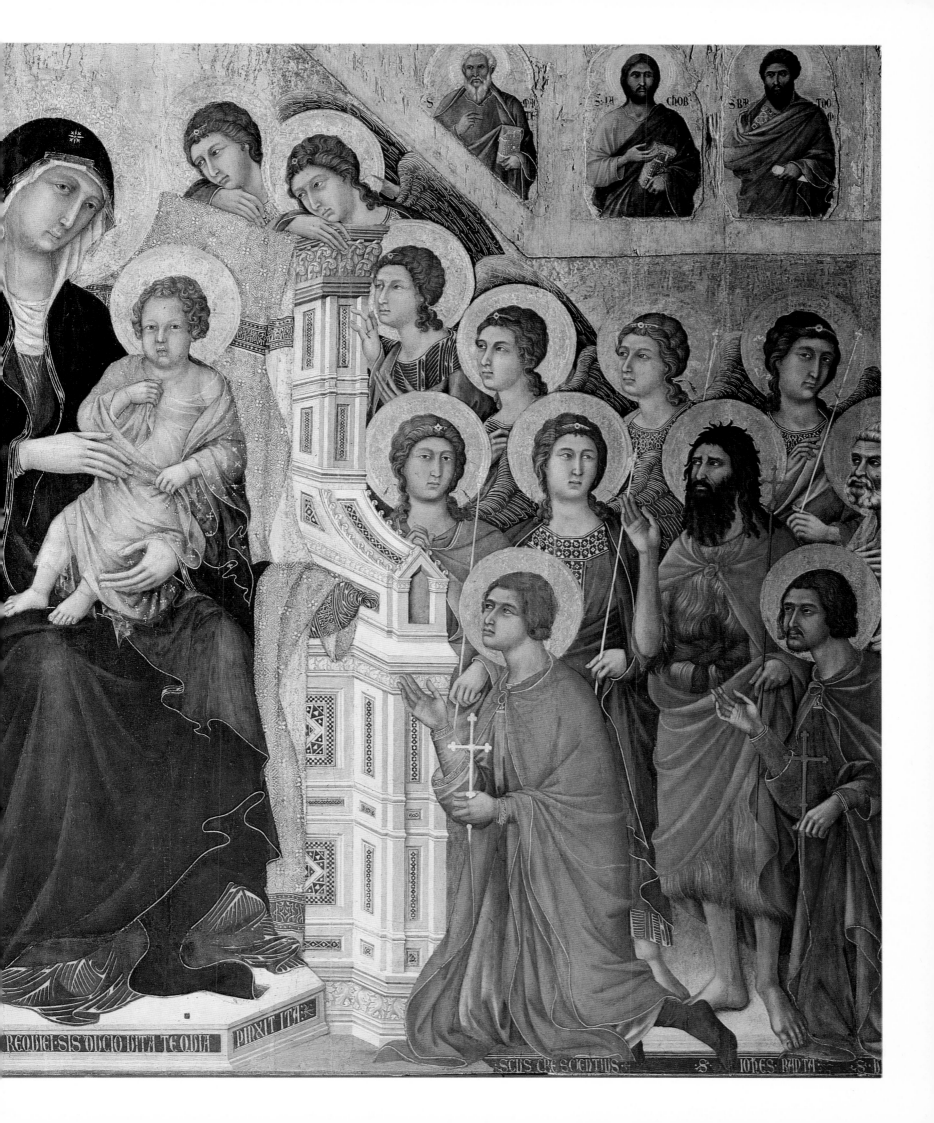

REQUE SIS OUGIO UITA TEODIA · PINXIT ITA ·

SCDS CR SCDNTIUS · S · IOHES BAPTA · S

NOTE

The choice of the texts which accompany the illustrations of this *Life of the Madonna in Art* was suggested by the themes and subjects presented. Like hymnology and the liturgy, iconography is a living testimony of the Tradition of the Church. Mary, the Mother of Jesus, is a subject who belongs in a very singular way to Sacred Scripture, to Tradition and to theology.

There are not many biographical facts provided in the Sacred Scriptures. To the various prophecies given in the Old Testament, the New Testament limits itself to adding just a little more information.

Nothing is said about Mary's first years: her parents, the place and time of her birth, her adolescence and education. Nothing is said about the last years of her earthly life.

And yet, particular biographical information of singular interest is not lacking—such as: the name of Mary in the genealogy of St. Matthew, the Madonna during the private life of Jesus (annunciation, visitation, perplexity of St. Joseph, birth of Jesus, adoration of the shepherds, circumcision of Jesus, purification of Mary, prophecy of Simeon, adoration of the Magi, flight into Egypt, return to Nazareth, losing of Jesus in Jerusalem, life in Nazareth); the Madonna during the public life of Jesus (the wedding at Cana, Mary with Jesus, praise of Mary, Mary at the foot of the cross, Mary with the Apostles, Mary as spiritual center of the primitive Church). We can theologically affirm that all the truths regarding the person of Mary which during the course of the centuries have been dogmatically defined by the Church, are ultimately based on the Word of God contained in Sacred Scripture.

The traditional sources of the life of Mary go back to the first half of the second century. Some Christians from the early times, not being able to resign themselves to the scarcity of biographical information on the Virgin provided for us in the Gospels and canonical books, took care to fill in those gaps with legendary writings, which are commonly called "apocrypha," in order to distinguish them from the inspired and canonical books. The first among these apocryphal books—first in the order of time and of importance—is the so-called Protoevangelium of James. The first two parts of this book already existed in the first half of the second century.

From this apocryphal work we have taken texts which refer to the episodes of Mary's childhood (the parents of Mary, Joachim and Anne, the annunciation of the angel to Joachim and Anne, the birth of Mary, Mary's presentation in the temple, the espousals of Mary). We have also added some texts from the Fathers and Doctors of the Church and some universal poems.

The historical figure of Mary would be most incomplete if, besides viewing the events of her life revealed to us by the scriptural and traditional sources, we did not fix our gaze attentively on her most singular psychology, considered in the light of theological science. It is in fact impossible to present a complete figure of Mary, and above all, an exact interpretation of the words and deeds of her life, without the light of theology.[1]

Rev. Samuele Olivieri, O.F.M.

1. For Marian theology, see the Marian passages of Vatican II, which follow Fr. Alberione's life of Mary at the end of this volume.

MARY,
HOPE OF THE WORLD

Rev. James Alberione, S.S.P., S.T.D.

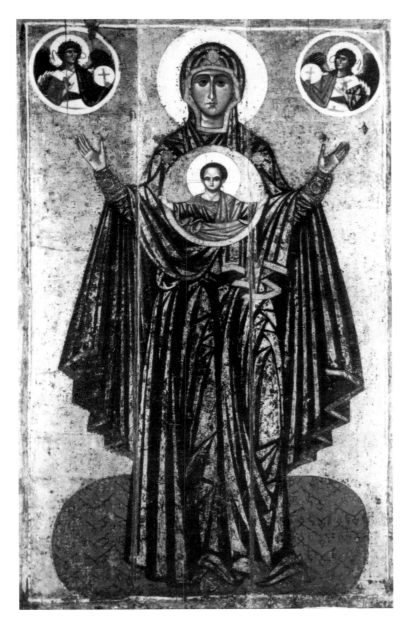

Virgin of the Great Panagia (Russian Icon from the Spaski Monastery at Jaroslavl from the Twelfth Century). Moscow, Tretyakov Museum.

TYPES OF MARY

There are many types in the Old Testament which, although referring in their true and literal sense to other physical and moral persons, are applied by the Fathers and by the Church in her liturgy to Mary most holy.

Many biblical personages make us think of Mary. Israel's heroines cannot be compared to her in sanctity, but as liberators of their people they resemble the woman who is the conqueror of the serpent and co-redemptrix of the world. God willed that Mary be preceded by a legion of chosen souls, admirable for their virtue, who in some way should foreshadow the *blessed among all women* and set forth for our admiration the characteristics of the Mother of the Savior. Such

were Sarah; Rachel; Miriam, the sister of Moses; Deborah; Jael; Judith, who, in triumphing over Holofernes, became "the glory of Jerusalem, the joy of Israel and the honor of her people"; and Esther, whose beauty won the king's heart and made all her people find favor in his sight.

THE BIRTH OF MARY

The prophets had given the Chosen People an infallible criterion for recognizing the advent of the Savior. A *sign* was to appear: a virgin, remaining a virgin, would become the Mother of the Messiah—the Desired of nations. The Hebrew people were watching the root of Jesse, the royal line of David, out of which the *great sign* was to rise: *Behold, a virgin shall conceive.*

Duccio: *Madonna with the Child* (1300-05). London, National Gallery.

The hour of redemption was about to strike; all awaited the sign of Isaiah:

> But a shoot shall sprout from the stump of Jesse, and from his roots a bud shall blossom (Is. 11:1).*

The beautiful figure of Mary appeared like a sun. And this radiant sun had its dawning in Mary's Immaculate Conception, in her birth and in the bestowing of her name.

The Immaculate Conception. Mary entered the world full of grace, all beautiful, all holy. "She," writes St. Ambrose, "is the rod on which there was never the knot of original sin nor the bark of actual sin." St. Ephrem calls Mary, "the Spouse of God, who reconciled us to Him." St. Germanus of Constantinople calls her "the most admirable of everything admirable."

How is it possible, however, to contemplate a beautiful fruit without thinking of the plant that

161

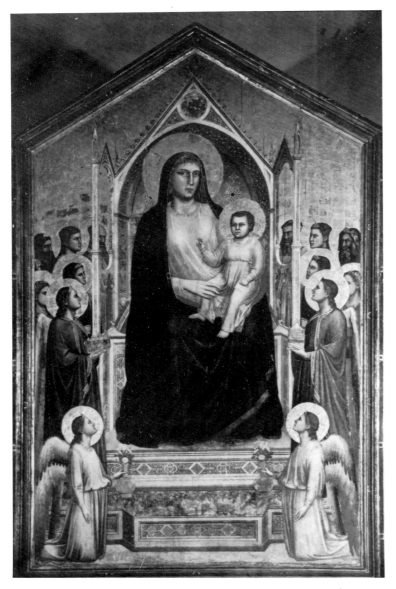

Giotto: *Madonna in Majesty* (1306-10). Florence, Uffizi Gallery.

produced it? St. Joachim and St. Anne were Mary's fortunate parents. Their names were given to us by tradition.

They were endowed with faith, hope and charity, filled with every virtue. Through their prayer and fasting they hastened the redemption of Israel. Thus Joachim, the chosen soul whose name means preparation of the Lord, and his wife Anne, whose name means grace, gave birth to the Lady, to the Queen of heaven and earth.

Mary is the bright glory of St. Joachim and St. Anne.

Mary's birth. Mary was conceived the most beautiful creature, not only exempt from sin, but clothed with so much grace that she surpassed the very angels themselves and the saints. In the liturgy of Mary's nativity, the Church sings, "The birth of the glorious Virgin Mary brought joy to the entire world."

St. John Damascene says, "I greet you, lamb, in whom the good Shepherd will soon come to take on human flesh, which will permit Him to be the Lamb of God, the true paschal Lamb immolated for the redemption of His people."

Mary's birthplace is unknown. Some think it was Sephoris, others Bethlehem, and still others Nazareth.

Western tradition holds that Mary's native city was Nazareth. In the office of the Holy House we read, in fact, that the Holy House of Loreto, which came from Nazareth, received the first cries of the infant Mary.

The Blessed Virgin's life can be considered under a threefold aspect:

1. **Mary in the divine mind:** She existed in God's thought, in prophecies, and in the longing of humanity.

2. **Mary in her earthly life:** She passed through this life without a shadow of guilt. Destined by God to crush Satan's head, she did not know sin; destined to be man's co-redemptrix, she corresponded fully to her calling.

3. **Mary in the life of glory:** She lives in heaven, she lives in the Church, and she lives in the hearts of the faithful, who are continuously blessed by her favors.

MARY IS FORETOLD

Mary was in the mind of God from all eternity.

'From of old I was poured forth,
 at the first, before the earth' (Prv. 8:23).*

When the Lord ordained the creation of the world, He prepared a scale of beings of varying beauty. It was formed of inanimate and animate creatures—plants, animals and man. Above them God placed the angels, creatures superior to man because they are pure spirits.

But the most beautiful creature of all, the one in whom all the marvels of the natural and supernatural order are gathered, is Mary. She is God's masterpiece.

The Son, uncreated Wisdom, thought of her from all eternity, and prepared for Himself, in her heart, a worthy tabernacle in which to dwell.

The Holy Spirit, who was to unite Mary to Himself as His celestial Spouse, willed her to be so rich in sanctity as to surpass all the angels and saints from the very moment of her conception.

His foundation upon the holy mountains
the Lord loves:
The gates of Zion,
 more than any dwelling of Jacob.
Glorious things are said of you,
 O city of God! (Ps. 87:1-3)*

'Before all ages, in the beginning, he created me,
 and through all ages I shall not cease to be.
In the holy tent I ministered before him,
 and in Zion I fixed my abode.
Thus in the chosen city he has given me rest,
 in Jerusalem is my domain.
I have struck root among the glorious people,
 in the portion of the Lord, his heritage'
 (Sir. 24:9-12).*

The mind of God in Sacred Scripture. The first prophecy was made by God Himself:

'I will put enmity between you and the woman,
 and between your offspring and hers;
He will strike at your head,
 while you strike at his heel' (Gn. 3:15).*

The virgin shall be with child, and bear a son, and shall name him Immanuel (Is. 7:14).*

Mary is the rod of Jesse:

...A shoot shall sprout from the stump of Jesse,
 and from his roots a bud shall blossom (Is. 11:1).*

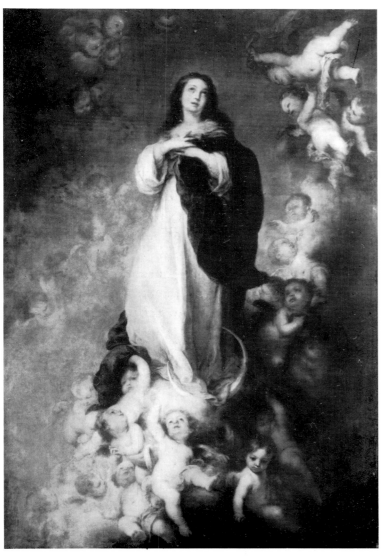

Murillo: *The Immaculate Conception* (1678). Madrid, Prado.

The rod of Jesse blossomed: the Virgin bore the God-Man, and the Lord restored peace, reconciling heaven and earth.

'Like a cedar on Lebanon I am raised aloft,
 like a cypress on Mount Hermon,
Like a palm tree in Engedi,
 like a rosebush in Jericho,
Like a fair olive tree in the field,
 like a plane tree growing beside the water.
Like cinnamon, or fragrant balm, or precious myrrh,
 I give forth perfume;
I spread out my branches like a terebinth,
 my branches so bright and so graceful.
I bud forth delights like the vine,
 my blossoms become fruit fair and rich'
 (Sir. 24:13-17).*

My lover speaks; he says to me,
 'Arise, my beloved, my beautiful one,
 and come!
'For see, the winter is past,
 the rains are over and gone.
The flowers appear on the earth,
 the time of pruning the vines has come,
 and the song of the dove is heard in our land.'
 (Sg. 2:10-12).*

God contemplates Mary who has formed His delight from all eternity; let us, therefore, as well-beloved children, imitate our divine Father. He is so pleased with Mary; may we, too, delight to contemplate her greatness.

When we look at Mary, temptations are put to flight, the mind is enlightened, and the passions are calmed. With Mary's help, we triumph over every concupiscence, because nothing can resist her. This is why St. Bernard writes: "In dangers, in sorrows and in doubts, think of Mary, invoke Mary; may her name never cease to be on our lips, may she never depart from our hearts."

Mary always listens to the petitions of those who beg her protection.

All the prophets desired Mary; let us, too, desire her and pray to her. Whoever finds Mary, finds God and eternal life.

Happy the man watching daily at my gates,
 waiting at my doorposts;
For he who finds me finds life,
 and wins favor from the Lord (Prv. 8:34-35).*

In every necessity, let us confidently have recourse to this Mother of Mercy; she will always grant our requests.

Mary's birth filled heaven and earth with joy. God the Father rejoiced as He lovingly contemplated in that tiny infant His immaculate daughter and the Mother of the Eternal Word. God the Son rejoiced as

He contemplated in her His most beloved Mother. God the Holy Spirit rejoiced as He took delight in His masterpiece and contemplated in her His most pure and faithful Spouse. The angels rejoiced as they hailed her their royal sovereign. Finally, humanity rejoiced, for in her it recognized the long-awaited dawn of that divine Sun—the Redeemer, who was to drive away the darkness of sin.

Let us exultantly hail Mary, the celestial child, the temple of purest gold into which Jesus will enter when the fullness of time comes.

Let us thank the Lord for having given us such a great and good Mother.

Oh, the beauty of Mary's soul!

The name of Mary. Fifteen days after their child's birth, Joachim and Anne gave her the name of Mary. This most holy, most sweet, and most worthy name suits the Virgin perfectly. It came from the treasures of the Divinity and was given to her to express the dignity of the role to which the Lord had pre-ordained her.

Mary's name signifies: a) Star of the sea, b) Enlightener, and c) Lady.

Mary is the Star of the sea because she shows poor mortals, who are tossed about by passions, the shortest and safest way to reach the longed-for haven. *Hail, Star of the sea!* you are the brightly shining star from which proceeds the brilliant ray of the God-Man. You are a most helpful star, lighting up our way by the examples of your life, by the blessings of your mercy, by the splendor of your glory.

The name Mary also means Lady: the Lady par excellence, the Lady of heaven and earth. She is the Star of the sea for men, Enlightener of angels, Lady of the universe.

Therefore, the name Mary was not given to the Virgin of Nazareth by chance; it signified the seeds of virtues reposing in the child, which would develop to the point of most sublime perfection.

"Mary's name," writes one of the Fathers of the Church, "refreshes the weary, cures the weak, enlightens the blind, touches the hardened, comforts the struggling, and shakes off Satan's yoke. Upon hearing it, heaven rejoices, the earth exults, the angels are gladdened, the demons tremble, and hell is disturbed." Like the name of Jesus, Mary's name is "honey to the mouth, harmony to the ear, and joy to the heart."

Let us honor, invoke and defend Mary's name. Let us honor the name of the Virgin, who is the Immaculate, the one full of grace, the Queen of the universe. Let us invoke this name in dangers, in temptations, in sorrows and in tribulations. Let us defend the name of Mary by blessing it when the wicked profane it.

A Thought from St. Bernard: "And the Virgin's name was Mary." Let us say a few things about this name which can be interpreted to mean "Star of the sea," an apt designation for the Virgin Mother.

She is most beautifully likened to a star, for a star pours forth its light without losing anything of its nature. She gave us her Son without losing anything of her virginity. The glowing rays of a star take nothing away from its beauty. Neither has the Son taken anything away from His Mother's integrity.

She is that noble star of Jacob, illuminating the whole world, penetrating from the highest heavens to the deepest depths of hell. The warmth of her brilliance shines in the minds of men, encouraging virtue, extinguishing vice. She is that glorious star lighting the way across the vast ocean of life, glowing with merits, guiding by example.

When you find yourself tossed by the raging storms on this great sea of life, far from land, keep your eyes fixed on this Star to avoid disaster. When the winds of temptation or the rocks of tribulation threaten, look up to the Star, call upon Mary!

When the waves of pride or ambition sweep over you, when the tide of detraction or jealousy runs against you, look up to the Star, call upon Mary! When the shipwreck of avarice, anger, or lust seems imminent, call upon Mary!

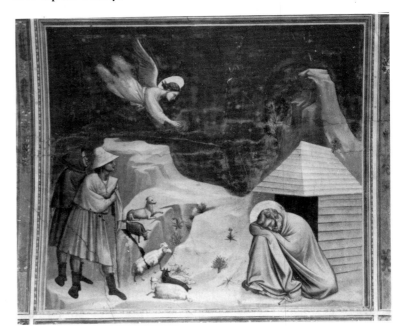

Giotto: *The Dream of Joachim* (1304-06). Padua, Scrovegni Chapel.

If the horror of sin overwhelms you and the voice of conscience terrifies you, if the fear of judgment, the abyss of sadness, and the depths of despair clutch at your heart, think of Mary! In dangers, difficulties and doubts, think about Mary, call upon Mary!

Keep her name on your lips, her love in your heart. Imitate her, and her powerful intercession will surround you. Following her, you will not stray. Praying to her, you will ward off disaster and despair. Meditate about her and you will not err. Cling to her and you cannot fall.

With her protection, there is nothing to fear. Under her leadership, you will succeed. With her encouragement, all is possible.

And someday you yourself will experience the depth of meaning in St. Luke's phrase, "And the Virgin's name was Mary." With only these few phrases of meditation we are strengthened in the clarity of her brilliance. How much greater strength we can derive by silent contemplation! In the scintillating light of this Star our fervent service of her Son will glow ever more brilliant.

A Thought from St. Peter Damian: Let us rejoice in the consideration of the Blessed Virgin's nativity; yes, let us rejoice at this birth as we do for the birth of Christ Himself. Today the Queen of the world is born to us, the Gate of Heaven, the Tabernacle of the Lord, the Ladder of Heaven by which the King of eternity will descend to our lowliness, and by means of which man the sinner will be able to ascend again to his God.

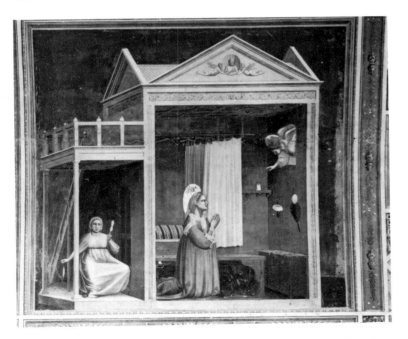

Giotto: *The Annunciation to St. Anne* (1304-06). Padua, Scrovegni Chapel.

THE PRESENTATION IN THE TEMPLE

Divine Providence, which guides everything with firmness and sweetness, was watching over the child Mary, and preparing her for the high position of Mother of God. Toward this end, by means of her parents, God led the heavenly child to the Temple of Jerusalem.

The Presentation in the Temple. Tradition narrates that in gratitude to the Lord for the blessing of a daughter, Joachim and Anne vowed to consecrate her

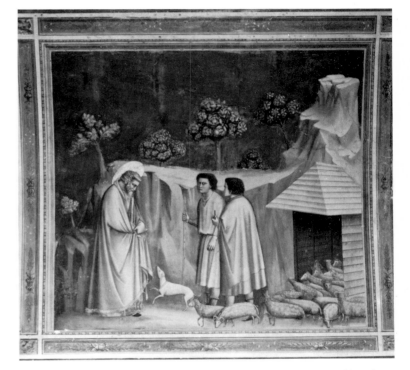

Giotto: *Joachim with the Shepherds* (1304-06). Padua, Scrovegni Chapel.

to Him in the Temple as soon as her age permitted it. And they were faithful to their promise.

Mary was scarcely three years old when, accompanied by her parents, she first set foot in the Temple. Here the noble child was admitted to the elect group of virgins consecrated to God. The exact time of Mary's presentation in the Temple is unknown. The Church celebrates the feast of the Presentation on November 21st.

The purpose of Mary's presentation in the Temple was twofold: that she might consecrate herself to the Lord and receive a suitable spiritual formation.

In the left nave of St. Peter's Basilica in Rome there is an altar in honor of the Presentation. A splendid mosaic represents the Virgin as she is being presented in the Temple. There Mary can be seen ascending the steps of the Temple, radiant with joyful eagerness. The priest is greeting her warmly.

Who will tell us of Mary's angelic life in the Temple? "Her mind," writes St. Ambrose, "was always absorbed in the Supreme Good. Her humility, her obedience and her modesty, which is a girl's most valuable asset, matched her silence. To use every minute of the day for the honor of God, she combined mental activity with manual labor. Her soul was never tempted to sloth, and necessity alone made her take repose. Even then, she kept watch in the presence of the Supreme Goodness, dreaming of the glories of the Lord and the wisdom of the divine Word, which she had read during the day."

Mary lived for prayer, for study and for work. Every day she meditated upon the great truths. She spoke little but wisely, she often conversed with angels, and the Lord revealed the mysteries of His mercy to her.

What an example the child Mary gave, from the shadow of the sanctuary, to girls of all times! Oh, if only all girls would walk in her footsteps, if only they would imitate her virtues!

Whoever leaves the world for the silence and recollection of religious life, following Mary's example, has much for which to thank God. This is such a great grace that it merits the deepest gratitude. Let us ask the grace to learn to live like Mary and to follow in the holy footsteps of her childhood.

Vow of virginity. In presenting Mary to the Temple, her parents offered her to God; but she also took an active part in the sacrifice of herself to the Lord.

It is a common belief that Mary was the first among all women to consecrate her virginity to God with an

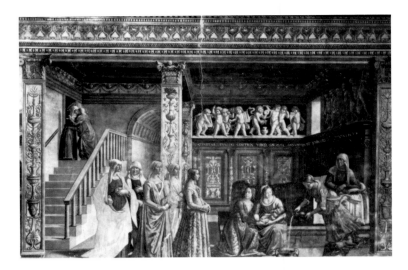

Domenico Ghirlandaio: *The Virgin's Birth* (1485-90). Florence, S. Maria Novella.

unconditional and irrevocable promise. That is to say, she emitted a formal and explicit vow. Proof of this is found in her reply to the angel: "How can this be since I do not know man?" (Lk. 1:34)*

St. Augustine observes that Mary never would have requested such an explanation if she had not already consecrated herself to the Lord.

Hence we can conclude that the Most Blessed Virgin not only proposed to observe perpetual virginity but that she bound herself to it by a vow.

A Thought from St. John Damascene: The Virgin rejected the thought of all earthly things and embraced every virtue. She progressed to such a degree of perfection that she soon deserved to be made the worthy temple of God.

MARY'S YOUTH

True devotees of Mary are those who imitate her virtues. Children of Mary are her imitators. By imitating Mary we shall draw close to Jesus: to Jesus through Mary.

Mary in the loss of her parents. It is commonly believed that the Blessed Virgin lost her beloved parents when she was about eleven. Just when she was living a life of angelic happiness in the house of the Lord, Mary had to taste of that chalice which fills the hearts of children with the most human sadness.

The precise time of Joachim's and Anne's blessed passing is unknown, but the Fathers affirm that Mary became an orphan when still in the Temple. Where were Mary's parents buried? It is not easy to say. Anselm of Krakow wrote that they were buried at Jerusalem.

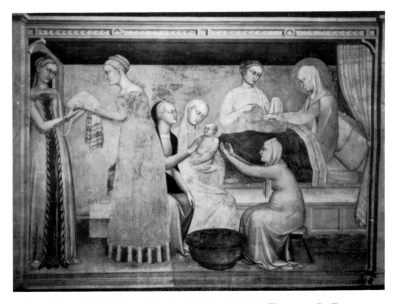

Giovanni da Milano: *The Virgin's Birth* (1366). Florence, S. Croce.

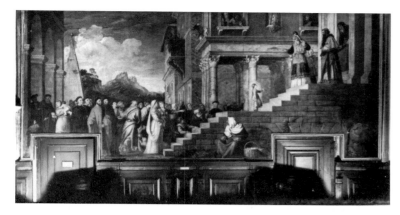

Titian: *The Presentation of Mary in the Temple* (1534-38). Venice, Academic Gallery.

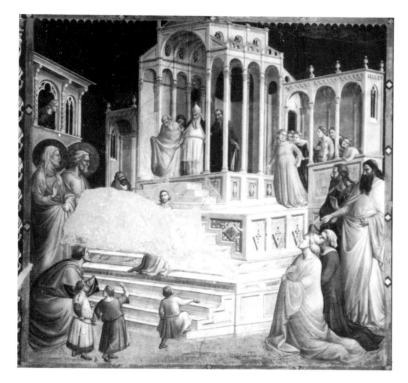

Taddeo Gaddi: *The Presentation of Mary in the Temple* (1320). Florence, S. Croce.

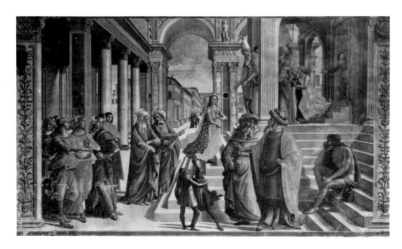

Domenico Ghirlandaio: *The Presentation of Mary in the Temple* (1485-90). Florence, S. Maria Novella.

At the loss of her parents, Mary showed herself perfectly conformed to the will of God and she undoubtedly exclaimed, "May Your will be done, O Lord!" Her faith and hope made her see in the death of her beloved parents the passage from exile to homeland, from earth to heaven, from labor to repose.

MARY'S ESPOUSALS

It was God's will that the Blessed Virgin should be united in matrimony to the chaste St. Joseph. There were many reasons for this. According to St. Thomas, it was fitting that Christ be born of a married Virgin—and this for Himself, for His Mother, and for us. It was fitting *for Himself*, so that His genealogy might be established according to the husband's name, and that He might have a protector and provider as soon as He was born. *For His Mother* it was fitting so that no one should cast suspicion on her innocence, so that she would not be punished by the Law for becoming a mother without being lawfully wed, and so that she would have in St. Joseph an irrefutable witness of her virginal purity. *For us* it was fitting, so that virgins might be taught to preserve the treasure of their good reputation unblemished.

God watches over souls who act out of love for Him. Mary had consecrated herself totally to God and intended to serve Him alone, remaining a virgin. But because she was a virgin, the Lord had chosen her to be the Mother of His Son and had disposed that she should become the spouse of Joseph. And Mary obeyed.

But who was Joseph? Sacred Scripture says that he was a *just man*, words which are equal to the highest praise. Joseph, according to the genealogy given by St. Matthew and St. Luke, was a descendant of the family of David. In Joseph's time, however, the family of David no longer sat on the throne. Always upright and blameless, Joseph, in his youth, was most exemplary. For this reason he was chosen by God to be the spouse of Mary.

Although bound by a vow so contrary to marriage, Mary accepted her union with Joseph, for she always trusted in divine Providence and let God guide her in all things.

God united two very holy souls so that they might help one another. From the Temple in Jerusalem Mary went to Nazareth with her betrothed. Joseph's fortunate home was soon to receive the sun which would light up everything. Joseph became aware of this in contemplating this marvelous creature, more

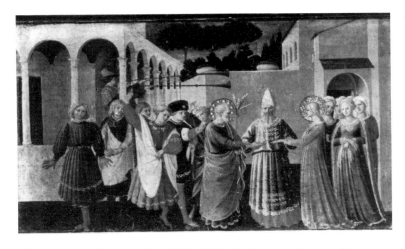

Fra Angelico: *Espousals of the Virgin* (1433-34). Cortona, Diocesan Museum.

perfect than the angels. She would transform his modest home into the most delightful haven of peace, of affection and of order.

Mary was beautiful—sweetly beautiful when absorbed in prayer, beautiful when performing her domestic duties, beautiful when, in the most secluded corner of the house, she labored for her little Jesus, her God, who was to call her *Mama!*

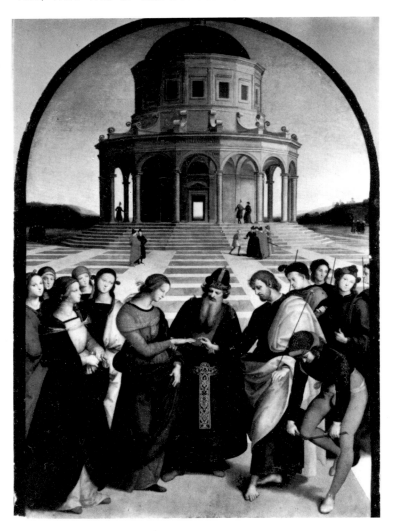

Raphael: *The Espousals of the Virgin* (1504). Milan, Gallery of Brera.

The Lord unites the souls He wishes to sanctify. There was nothing earthly in the union between Mary and Joseph; everything bore a celestial imprint. Their lives were united that they might rise to God with doubled fervor.

Joseph was the guardian whom God chose to protect His Mother's purity; and she, by her presence and her manner, enkindled in her spouse an even greater love of chastity. Let us look at Mary and Joseph and let us model our lives on their example.

THE ANNUNCIATION TO MARY

St. Luke narrates: "Now in the sixth month the angel Gabriel was sent from God to a town of Galilee called Nazareth, to a Virgin betrothed to a man named Joseph, of the house of David, and the virgin's name was Mary. And when the angel had come to her, he said, 'Rejoice, O highly favored daughter! The Lord is with you. Blessed are you among women'" (cf. Lk. 1:26-28).

Mary's humility. "At the angel's salutation," writes St. Augustine, "Mary was filled with grace; Eve was cleansed from her guilt; Eve's curse was changed into Mary's blessing. A Virgin became the Mother of God, in order to reconcile man with God, to give peace to the world, triumph to heaven, salvation to mankind, and life to the dead. Mary was troubled by the angel's words and wondered what his salutation could mean." But the angel added, "Do not be afraid, Mary, for you have found favor with God" (Lk. 1:30).

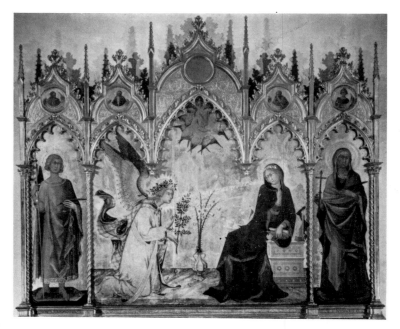

Simone Martini: *The Annunciation* (1333). Florence, Uffizi Gallery.

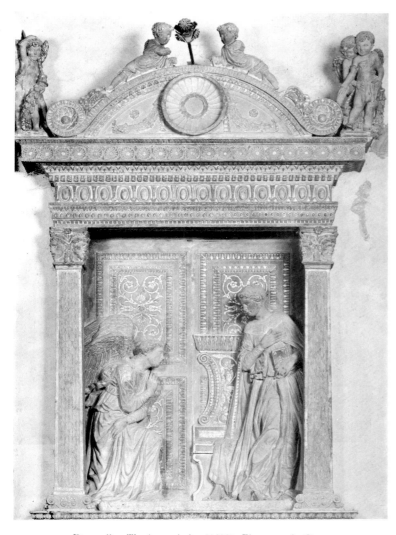

Donatello: *The Annunciation* (1433). Florence, S. Croce.

"Ah, do not fear, Mary," comments St. Bernard. "Be not astonished if an angel comes, because He who is far greater than an angel will descend to you. How is it that you are surprised at the coming of an angel, when you have with you the Lord of the angels? Are you not perhaps worthy of seeing an angel, when virginity is an angelic life? As proof of this: 'Behold, you shall conceive in your womb,' continued the angel, 'and shall bring forth a Son; and you shall call His name Jesus' (cf. Lk. 1:31)."

At this point God's messenger paused, respectfully awaiting Mary's reply.

"O Blessed Virgin," exclaims St. Bernard, "the Patriarchs, the Prophets and the entire world, prostrate at your feet, anxiously await your freeing consent. And not without reason, for the consolation of the afflicted, the redemption of slaves, the freedom of the damned and the salvation of all the children of Adam and of the entire universe depend upon your word. O incomparable Virgin, give a prompt and affirmative reply. Hasten, O Lady, to utter this word, for heaven, limbo and earth await your reply, trembling. But what am I

saying? The very Lord and King of the universe desires your consent because through this consent He wants to save the world. Heaven, limbo and earth rejoice and sing—Mary consents! She answers: 'Behold, I am the handmaid of the Lord; let it be to me according to your word' (Lk. 1:38). At that moment Mary becomes the Spouse and the Mother of God!"

St. Peter Damian writes: "The Word was made flesh. This is what nature admires, the angel reveres, and man desires; this is what astonishes heaven, consoles the earth and troubles hell."

"O profound and wondrous humility of Mary!" cries St. Bonaventure. "An archangel greets her, tells her that she is full of grace and announces that the Holy Spirit will descend upon her. She sees herself raised to the honored position of God's Mother, she sees herself placed above all creatures, made the Queen of heaven and earth, yet Mary does not become proud. On the

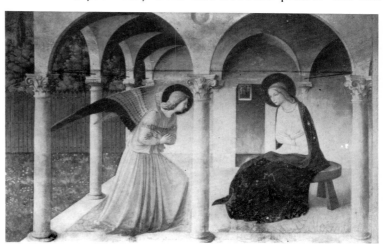

Fra Angelico: *The Annunciation* (1438-42). Florence, Museum of S. Marco.

contrary, all this glory is for her nothing but a greater reason for becoming even more admirably humble. She declares, 'Behold the handmaid of the Lord' (cf. Lk. 1:38)."

Mary was exalted in proportion to the extent to which she humbled herself. Humility is the secret of sanctity. If Mary had not been humble, the Holy Spirit would not have descended upon her. And if He had not descended upon her, she would not have become the Mother of God. It is clear that if she became God's Mother by the Holy Spirit, God, as she herself affirmed, regarded the humility of His handmaid more than her virginity. O true humility which gave a God to men and life to mortals, which renewed the heavens, purified the earth, opened Paradise and delivered souls from slavery.

We progress in virtue to the extent that we progress in humility.

Mary's purity. With her vow of virginity, Mary prevented herself from becoming the Mother of the Savior and having the legitimate satisfaction of loving children. Notwithstanding this, God made her the greatest of mothers. Mary's purity was so rare that, according to St. Bernard, it drew down upon her the pleased gaze of the Lord and made Him decide to choose her as His Mother.

Mary's obedience. St. Thomas of Villanova affirms that Mary never contradicted the Lord, neither in thought, word, nor action. In fact, stripped of any will of her own, she obeyed God's will always and in all things. Mary's heart was continuously suffused with the sentiment of submission to the divine will, as she made clear to the Archangel Gabriel when he announced to her the plans of the Most High: "Behold the handmaid of the Lord; be it done to me according to your word" (cf. Lk. 1:38).

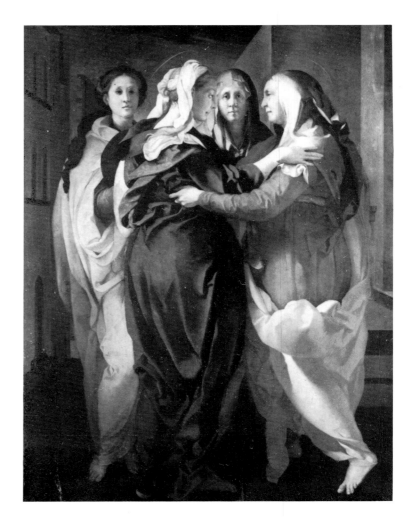

Pontormo: *The Visitation* (1528-29). Carmignano, Pieve di S. Michele.

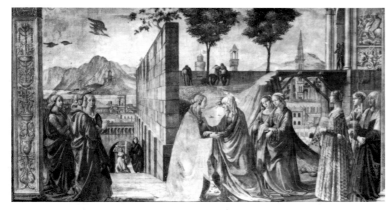

Domenico Ghirlandaio: *The Visitation* (1485-90). Florence, S. Maria Novella.

MARY'S VISIT TO ST. ELIZABETH

At the annunciation, the angel had told Mary that her cousin Elizabeth had become a mother even though advanced in age. Certain of giving pleasure to her cousin, Mary hastened to go to her, happy to serve her as a devoted handmaid.

St. Elizabeth lived in a village lost among the mountains. Although the roads leading to it were hazardous, and the journey there was a dangerous one, Mary set out, repeating with the Prophet Habakkuk,

> God, my Lord, is my strength;
>> he makes my feet swift as those of hinds
>> and enables me to go upon the heights (Hb. 3:19).*

Thereupon Mary set out, proceeding in haste into the hill country to a town of Judah, where she entered Zechariah's house and greeted Elizabeth. When Elizabeth heard Mary's greeting, the baby leapt in her womb. Elizabeth was filled with the Holy Spirit and cried out in a loud voice: 'Blest are you among women and blest is the fruit of your womb. But who am I that the mother of

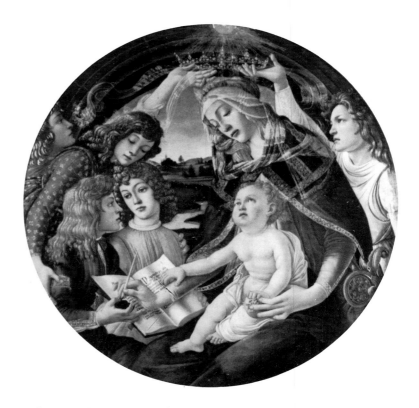

Botticelli: *The Madonna of the Magnificat* (1483-85). Florence, Uffizi Gallery.

my Lord should come to me? The moment your greeting sounded in my ears, the baby leapt in my womb for joy. Blest is she who trusted that the Lord's words to her would be fulfilled' (Lk. 1:39-45).*

It is almost as though she said: You, Mary, are the woman chosen from all eternity to crush the serpent's head, to give birth to the divine Word, and to open heaven. Elizabeth's words are somewhat the same, in certain points, as those of the angel; therefore, it is evident that she spoke under divine inspiration.

Mary did not delight in these words of praise; she was touched by them and, in a burst of prophetic enthusiasm, she broke forth in the immortal words of the *Magnificat:*

> 'My being proclaims the greatness of the Lord,
> my spirit finds joy in God my savior,
> For he has looked upon his servant in her lowliness;
> all ages to come shall call me blessed.
> God who is mighty has done great things for me,
> holy is his name;
> His mercy is from age to age
> on those who fear him.
>
> 'He has shown might with his arm;
> he has confused the proud in their inmost thoughts.
> He has deposed the mighty from their thrones
> and raised the lowly to high places.
> The hungry he has given every good thing,
> while the rich he has sent empty away.
> He has upheld Israel his servant,
> ever mindful of his mercy;
> Even as he promised our fathers,
> promised Abraham and his descendants forever'
> (Lk. 1:46-55).*

Mary's encounter with Elizabeth was the meeting of two great souls, the greeting of two saints. What a fragrance of sanctity, of humility and of fervor rose from this scene of the visitation! Elizabeth exalts Mary; Mary thanks and exalts the Lord! Fortunate are you, Elizabeth, who have before you the Mother of the Savior, the Queen of Heaven!

From Elizabeth let us learn to love Mary and be devoted to her.

Devotion to the Mother of God is a sure sign of salvation, for she is the Guide, the Queen, the Mother and the Protectress of the elect. Mary never fails to give her faithful devotees abundant grace, help and comfort in order to insure their salvation. He who loves and venerates Mary with filial devotion is infinitely blessed.

Mary's reply to St. Elizabeth. Elizabeth glorified Mary by calling her blessed among women, for blessed is the fruit of her womb; she declared herself unworthy of the high honor of welcoming her Lord's Mother into her home. On hearing such praise, Mary attributed everything to God by singing, "My soul glorifies the Lord!" She referred to God, as to the only Source of all goodness, the praise given her. It seems as though she meant to say, "You, Elizabeth, exalt the Lord's Mother, but my soul exalts and glorifies God." For this reason, St. Bernard calls the *Magnificat*, "The exaltation of Mary's humility." This is the song of thanksgiving and of grateful humility. Mary, exalted by St. Elizabeth for her faith and her greatness, and proclaimed the Mother of the Savior, humiliated herself more than ever and proclaimed her nothingness and her weakness, attesting that all that she had came from God.

Like Mary let us also give praise to God: "To...the one only God be honor and glory" (cf. 1 Tm. 1:17). May our prayer always be directed first to praising and thanking the Lord. Selfish prayer is less acceptable to God and obtains less fruit.

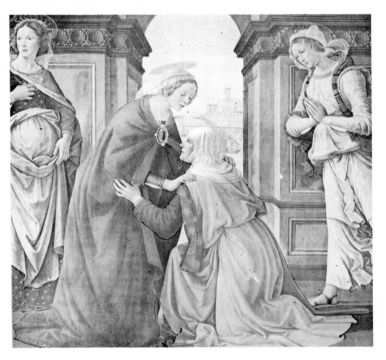

Ghirlandaio: *The Visitation* (1491) Paris, Louvre Museum.

A Thought from St. Peter Damian: Fortunate Elizabeth! Before her stood the Mother of the Redeemer, the Queen of Heaven; she greeted her sweetly. Even more fortunate, however, was the child she bore in her womb, for he was the first object of this royal visit. Enlightened by the Holy Spirit, he recognized the majesty of the Queen of Angels who was greeting his mother, and it was given to him to understand the power of that greeting.

MARY'S RETURN TO NAZARETH

The Blessed Virgin stayed at her cousin Elizabeth's house for about three months, serving her as a most humble handmaid. She then returned to Nazareth. The Gospel narrates that Joseph, "an upright man unwilling to expose her to the law, decided to divorce her quietly" (Mt. 1:19).*

These few words reveal the turmoil in Joseph's soul and the struggle going on within him. On the one hand, he knew Mary's eminent virtues and her angelic purity; on the other hand, the time for the solemn ceremony of introducing his spouse into his home having arrived, he felt that he could not go through with it since the law forbade it. Mary was a virgin, a most pure virgin, and Joseph, more than anyone else, knew this well: suspicion would have been blasphemy in his eyes. And yet Mary though a virgin was also a mother. How should he act in the conflict between his persuasion of Mary's innocence and the Law which, by forbidding him to take Mary into his home, would expose her to public disgrace? Being a just man, Joseph was minded to separate from Mary, and he sought God's direction as to how he should carry out his plan. "Not being able to speak to men," wrote Saint Peter Chrysologus, "he confided everything to God in prayer." So as not to arouse evil suspicions regarding Mary, he resolved to put her away privately. It is easy also to imagine Mary's state of mind in those days. Yet her humility prevented her from revealing the great mystery and the supreme dignity to which God had elevated her. She was certain that God would take care of everything, and she was not mistaken.

The angel of the Lord appeared in a dream and said to him: 'Joseph, son of David, have no fear about taking Mary as your wife. It is by the Holy Spirit that she has conceived this child. She is to have a son and you are to name him Jesus because he will save his people from their sins' (Mt. 1:20-21).*

The light had come, the clouds were dispersed. Joseph had been informed of the mysteries of the Incarnation, and his respect for Mary's sanctity took on even greater proportions.

Awakening from his dream, Joseph did as the angel of the Lord had ordered, and he took to himself Mary his wife.

Let us learn to confide in God, and to have recourse to Him in all our difficulties:

Call to me, and I will answer you (Jer. 33:3).*

THE NATIVITY OF JESUS

As the ninth month after the time of the angel's message approached, Mary most holy and St. Joseph awaited the birth of the Savior of the world with the most profound sentiments of faith, hope and love.

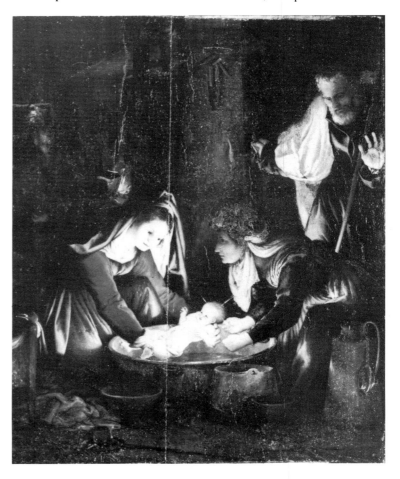

Lorenzo Lotto: *The Nativity* (1527-28). Siena, National Gallery.

Giovan Francesco Barbieri, called the Guercino: *The Angel's Apparition to St. Joseph* (1621). Naples, Royal Palace.

172

In those days Caesar Augustus published a decree ordering a census of the whole world. This first census took place while Quirinius was governor of Syria. Everyone went to register, each to his own town. And so Joseph went from the town of Nazareth in Galilee to Judea, to David's town of Bethlehem—because he was of the house and lineage of David—to register with Mary, his espoused wife, who was with child (Lk. 2:1-5).*

Having reached the height of its power, Rome wanted to ascertain the exact number of its subjects.

Palestine, too, being a Roman Province, had to give an account. Joseph imparted the news of the imperial order to his beloved wife. Everyone had to go to the place of origin of his own tribe! Mary and Joseph were descendants of David, who had been born in Bethlehem. Therefore, they would have to go to Bethlehem, the city of their ancestor.

Mary's promptness in obeying the emperor. The journey from Nazareth to Bethlehem was a long and hazardous one, and Joseph feared for his wife. But Mary reassured him, saying, "Fear not, the Lord is with us," and they set out. Behold the promptness of the Queen of heaven in subjecting herself to the commands of her lawful superiors.

The cold reception at Bethlehem. Having reached Bethlehem, the holy couple sought lodging in the homes of their relatives and at the public inns, but

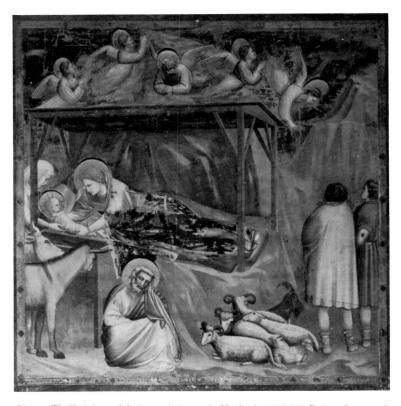

Giotto: *The Nativity and the Annunciation to the Shepherds* (1304-06). Padua, Scrovegni Chapel.

they could find none. The city was in a turmoil on account of the crowds of strangers flocking from every direction. For the two from Nazareth there was no room!

> To his own he came,
> yet his own did not accept him (Jn. 1:11).*

Bethlehem's inhabitants rejected Mary and Joseph, and they humbly went away, without a single complaint or word of bitterness.

They were forced to seek shelter outside the city. There were in Palestine many grottoes used by the shepherds to shelter their flocks. It was in one of these that Mary and Joseph took refuge. And in that stable, Mary "gave birth to her first-born son and wrapped him in swaddling cloths, and laid him in a manger" (Lk. 2:7).

Thus, in the most abject misery, under the rule of Augustus, the long-awaited Messiah was born, giving us an admirable example of humility even at the very moment of His birth.

Mary at the manger. Who can adequately describe the happiness and tender affection that filled Mary's heart when she first held the Infant Jesus in her arms? What sweet tears she must have shed over Him! What warm kisses! What tender embraces! What loving smiles! What boundless love! "O unique childbirth without pain," exclaims St. Bernard, "unique in purity and freedom from corruption, who will tell of your wonders?"

In the nearby fields shepherds were watching their flocks. And behold, an angel enveloped in luminous splendor appeared to them to announce the joyful tidings:

> And in that region there were shepherds out in the field, keeping watch over their flock by night. And an angel of the Lord appeared to them, and the glory of the Lord shone around them, and they were filled with fear. And the angel said to them, 'Be not afraid; for behold, I bring you good news of a great joy which will come to all the people; for to you is born this day in the city of David a Savior, who is Christ the Lord. And this will be a sign for you: you will find a babe wrapped in swaddling cloths and lying in a manger.' And suddenly there was with the angel a multitude of the heavenly host praising God and saying,
> 'Glory to God in the highest,
> and on earth peace among men with whom he is pleased!'
> When the angels went away from them into heaven, the shepherds said to one another, 'Let us go over to Bethlehem and see this thing that has happened, which the Lord has made known to us.' And they went with

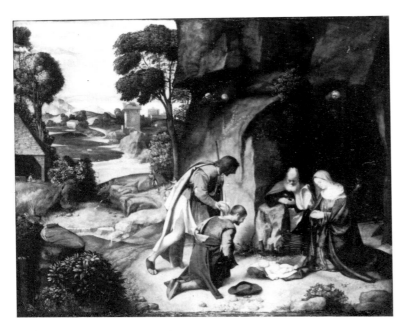

Giorgione: *Adoration of the Shepherds* (1505). Washington, National Gallery.

haste, and found Mary and Joseph, and the babe lying in a manger. And when they saw it they made known the saying which had been told them concerning this child; and all who heard it wondered at what the shepherds told them. But Mary kept all these things, pondering them in her heart. And the shepherds returned, glorifying and praising God for all they had heard and seen, as it had been told them (Lk. 2:8-20).

What a sweet and touching scene! Mary smilingly presented her Son for the shepherds to adore, and explained to them the mysteries upon which the Christian faith rests, the ineffable greatness of the Word of God, and the humility of His Incarnation. Prostrate on the ground with their hands folded, the shepherds listened to her words, adored the Lord, and then returned with joy to their flocks.

In that night a great revelation was made to Mary. On the one hand she understood God's infinite love for men:

> For to us a child is born,
> to us a son is given;
> and the government will be upon his shoulder,
> and his name will be called
> 'Wonderful Counselor, Mighty God,
> Everlasting Father, Prince of Peace' (Is. 9:6).

On the other hand, her own passion began at that very moment for she well understood her Son's mission. This was the beginning of her life of adoration, thanksgiving, reparation for our sins, and intense love for Jesus, the God-Man.

Mary is the model of adorers. In the Holy Eucharist we have the same Jesus who constituted the great delight and love of Mary. Let us love Him and pray to Him as His Mother did.

THE PRESENTATION OF JESUS IN THE TEMPLE

Eight days after the birth of Jesus, Mary, diligent observer of the Law, presented the Divine Infant for the ceremony of circumcision by which a Hebrew infant was officially enrolled in Judaism and declared a legitimate son of Abraham.

By nature Jesus was not subject to this law, but He willed to submit Himself to it, so as to give us an example of obedience. It was then that the name of Jesus was given to Him, as the angel had said even before He was conceived in His Mother's womb.

Mary chose to observe another law, even though she was not required to do so by reason of her position, unique in the world, as a Virgin Mother. According to the law of Moses, forty days after giving birth to a child, every woman was obliged to go to the Temple for her purificaton. Furthermore, if the child was her firstborn, he had to be consecrated to the Lord.

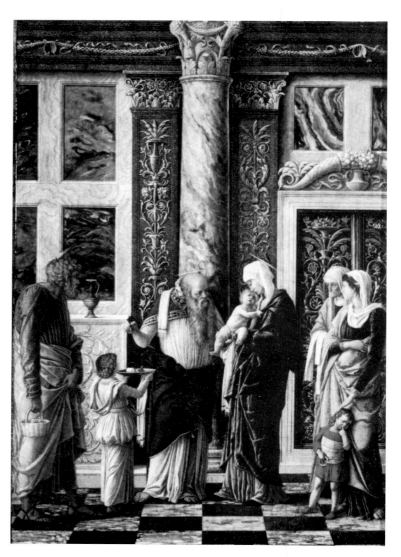

Andrea Mantegna: *The Circumcision* (1464-70). Florence, Uffizi Gallery.

174

The Law specified that for the poor, the offering of two turtledoves or two pigeons was sufficient.

When forty days had passed, Mary went to the Temple for the double ceremony of purification and presentation. What an example of humility! The Gospel explicitly narrates the event:

> And when the time came for their purification according to the law of Moses, they brought him up to Jerusalem to present him to the Lord (as it is written in the law of the Lord, 'Every male that opens the womb shall be called holy to the Lord') and to offer a sacrifice according to what is said in the law of the Lord, 'a pair of turtledoves, or two young pigeons' (Lk. 2:22-24).

And the Virgin Mother fulfilled the offering of her Son. The offering was accepted and was to be consummated on Calvary.

A venerable old man, Simeon by name, just and devout, was awaiting the consolation of Israel. The Holy Spirit was in him and had revealed to him that he would not die before seeing the Christ of the Lord. Led by the Holy Spirit, he went to the Temple. Yielding to his desires, Mary placed the Divine Infant in his arms. Simeon took Him, contemplated Him with ardent love, and enthusiastically exclaimed:

> 'Now, Master, you can dismiss your servant in peace;
> you have fulfilled your word.
> For my eyes have witnessed your saving deed
> displayed for all the peoples to see:
> A revealing light to the Gentiles,
> the glory of your people Israel' (Lk. 2:29-32).*

Mary and Joseph were greatly impressed: how did Simeon know the secret of the Messiah? Suddenly, however, the holy man interrupted his blessing, and his face grew troubled. He turned to the young Mother and said:

> 'This child is destined to be the downfall and the rise of many in Israel, a sign that will be opposed—and you yourself shall be pierced with a sword—so that the thoughts of many hearts may be laid bare' (Lk. 2:34-35).*

What an impression these words must have made on Mary's soul! From that moment on, always before her eyes was a vision of persecutions, calumny, anxieties, agony and death.

The elderly prophetess Anna, daughter of Phanuel, of the tribe of Asher, was also present at this scene, for she worshiped in the Temple night and day, with fastings and prayers. Enlightened from on high, she also echoed Simeon's canticle glorifying God, speaking of Jesus "to all who were awaiting the redemption of Jerusalem" (cf. Lk. 2:38).

THE ADORATION OF THE MAGI

With great joy, Mary had watched the shepherds render homage to the Infant Jesus. However, besides the shepherds, who were humble and simple people, great and learned men also came to adore the Infant. Jesus chose to call to Himself the gentiles also, because He had come on earth for all men without any distinction of class or nationality. Mary saw the Magi, who had come from the Orient, kneel before Jesus, acknowledging His sovereignty.

The arrival of the Magi in Bethlehem. The following is St. Matthew's account:

> Now when Jesus was born in Bethlehem of Judea in the days of Herod the king, behold, wise men from the East came to Jerusalem, saying, 'Where is he who has been born king of the Jews? For we have seen his star in the East, and have come to worship him.' When Herod the king heard this, he was troubled, and all Jerusalem with him; and assembling all the chief priests and scribes of the people, he inquired of them where the Christ was to be born. They told him, 'In Bethlehem of Judea; for so it is written by the prophet:

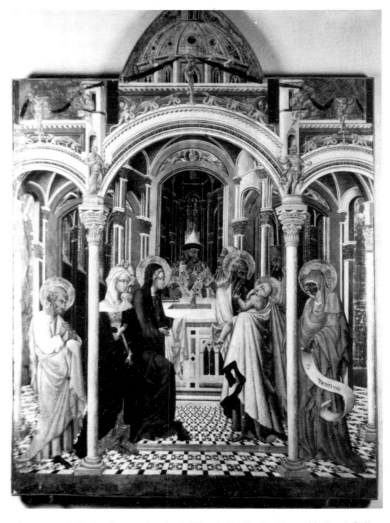

Giovanni di Paolo: *Presentation in the Temple* (1447-48). Siena, National Gallery.

"And you, O Bethlehem, in the land of Judah,
are by no means least among the rulers of Judah;
for from you shall come a ruler
who will govern my people Israel."'

Then Herod summoned the wise men secretly and ascertained from them what time the star appeared; and he sent them to Bethlehem, saying, 'Go and search diligently for the child, and when you have found him bring me word, that I too may come and worship him.' When they had heard the king they went their way; and lo, the star which they had seen in the East went before them, till it came to rest over the place where the child was. When they saw the star, they rejoiced exceedingly with great joy; and going into the house they saw the child with Mary his mother, and they fell down and worshiped him. Then, opening their treasures, they offered him gifts, gold and frankincense and myrrh (Mt. 2:1-11).

History does not tell us who these Magi were—whether they were kings or wise men, whether they were three or more, or what their names were. Tradition, however, says that they were kings from Arabia, and it even gives their names: Melchior, Gaspar, Balthasar.

After the humble folk, the shepherds, there came to the manger the great and the powerful—great men who yet knew how to humble themselves.

When they reached the grotto, the star disappeared. There at the grotto was Mary—*the morning star*, who appeared then in all her splendor. Mantled in virtue and sanctity, she came forth from the shadows and, presenting the Infant Jesus, said, "This is my Son."

During their visit to Bethlehem the Magi learned the entire Gospel and left the grotto transformed into saints and apostles. They presented to the Virgin their gifts for Jesus: gold, frankincense and myrrh. Mary obtained for them an increase of wisdom and charity, an increase of piety and devotion, love of mortification, and of pure and holy living.

According to tradition, when the Magi returned to their own land they won many souls to Christ. They were steadfast in persecution, they spread devotion to Mary, and they shed their blood for Jesus Christ. Their bodies were transported to Constantinople, then to Milan and, finally, to Cologne, where today they are still kept and honored.

The Magi found Jesus through Mary. The Evangelist writes: "And entering the house, they found the Child with Mary His Mother" (cf. Mt. 2:11).

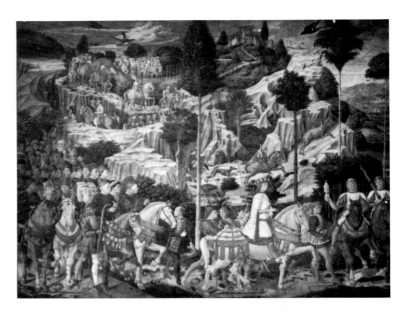

Benozzo Gozzoli: *The Cortege of the Magi* (1459). Florence, Medici Palace.

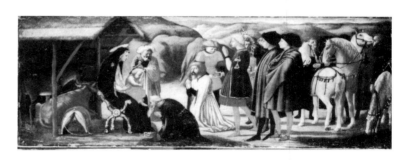

Masaccio: *The Adoration of the Magi* (1426). Berlin, Staatliche Museum.

Having reached their destination, they found Him upon whom their faith rested, but it was Mary who brought them to know Jesus, who showed Him to them and presented Him for them to adore. The Gospel does not describe the graces which flooded the souls of the Magi at that time, but undoubtedly they were numerous. From Mary they learned the mystery of the Incarnation, and for this reason, they adored Jesus. In return, they received so many spiritual gifts, so much enlightenment, consolation and celestial fervor that they desired labor, weariness, suffering, and death for Jesus Christ.

Mary is the great apostle who brings Jesus to the world. An apostle is a person who bears such a great love for God that his heart cannot contain it and thus he feels the need of diffusing it and implanting it in others. The apostle is animated by the spirit of Jesus Christ, and he wants to conquer every soul for Him.

Mary, Mother, Teacher and Queen of the Apostles, presented her Jesus not only to the Hebrews but also to the pagans.

THE FLIGHT INTO EGYPT

Perhaps the Magi had informed Mary how Herod had advised them to go to Bethlehem to seek the Infant and then return to tell him where they had found Him that he, too, might pay homage to the newborn Child. Mary probably knew Herod, but she reassured herself with the word of God:

> The Lord is my light and my salvation;
> whom shall I fear?
> The Lord is the stronghold of my life;
> of whom shall I be afraid? (Ps. 27:1)

And God intervened to thwart Herod's wicked plans. He warned the Magi, in a marvelous manner, during their sleep, not to return to Herod. They obeyed and went back to their country without passing through Jerusalem again.

The Infant Jesus would have to be taken to Egypt for safety. The Gospel narrates the event clearly and briefly, as follows:

> Now when they had departed, behold, an angel of the Lord appeared to Joseph in a dream and said, 'Rise, take the child and his mother, and flee to Egypt, and remain there till I tell you; for Herod is about to search for the child, to destroy him.' And he rose and took the child and his mother by night, and departed to Egypt, and remained there until the death of Herod. This was to fulfill what the Lord had spoken by the prophet, 'Out of Egypt have I called my son' (Mt. 2:13-15).

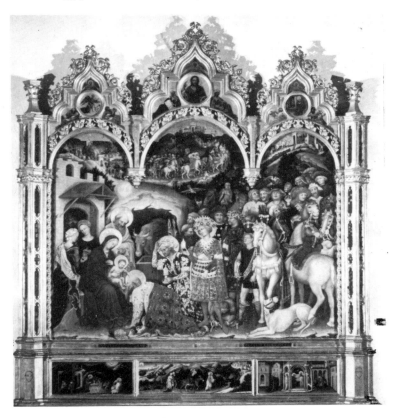

Gentile da Fabriano: *The Adoration of the Magi* (1423). Florence, Uffizi Gallery.

We can readily surmise that the holy fugitives undertook their journey in the direst poverty. Tradition has been pleased to picture Mary sitting on the donkey holding the Child Jesus in her arms, while St. Joseph walked along beside them.

During that long, weary journey, they spoke little, being absorbed in deep thought, and in prayer.

It was the triumph of tyranny over innocence, weakness, and sanctity. Herod abused his power; he employed deceit and cruelty—all because he jealously feared a future rival in the newborn Child.

The Holy Family humbly bowed to the will of the celestial Father. They submitted themselves to the grave difficulties of exile. Thus God's prophecies and designs were fulfilled.

> Then Herod, when he saw that he had been tricked by the wise men, was in a furious rage, and he sent and killed all the male children in Bethlehem and in all that region who were two years old or under, according to the time which he had ascertained from the wise men. Then was fulfilled what was spoken by the prophet Jeremiah:

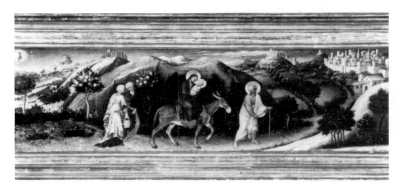

Gentile da Fabriano: *Flight into Egypt* (1423). Florence, Uffizi Gallery.

> 'A voice was heard in Ramah,
> wailing and loud lamentation,
> Rachel weeping for her children;
> she refused to be consoled,
> because they were no more' (Mt. 2:16-18).

Where did the Holy Family live during the stay in Egypt? The exact place is not known.

How long did this exile last? Certainly not many years, for it is known that their return took place immediately after the death of Herod, and it was only a few years after his heinous crime that Herod died, eaten by remorse and by worms.

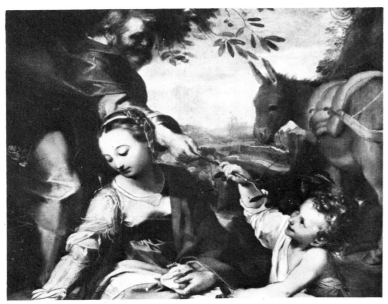

Barocci: *Rest During the Flight into Egypt* (1573). Rome, Vatican Gallery.

fortunate Mother! With her she had that Son whose boyhood was a wonder of beauty and goodness. Jesus worked with his foster-father and received a fitting education.

As soon as He reached the age of twelve, the boy Jesus was taken to Jerusalem for the feast of the Passover. At that age, in fact, a Hebrew boy became *a son of the Law*, responsible for his own acts. For the first time, on the sabbath, he was called before the sacred volumes of the Law to bless the Eternal God for having chosen the Hebrew people as the custodian of His Law. Therefore, Mary had the joy of witnessing this entrance of Jesus into the Temple of Jerusalem. A sorrowful episode occurred, however, which reminded her that her Son was destined for a mission that demanded painful separations.

But when Herod died, behold, an angel of the Lord appeared in a dream to Joseph in Egypt, saying, 'Rise, take the child and his mother, and go to the land of Israel, for those who sought the child's life are dead.' And he rose and took the child and his mother, and went to the land of Israel. But when he heard that Archelaus reigned over Judea in place of his father Herod, he was afraid to go there, and being warned in a dream he withdrew to the district of Galilee. And he went and dwelt in a city called Nazareth, that what was spoken by the prophets might be fulfilled. 'He shall be called a Nazarene' (Mt. 2:19-23).

Let us admire Mary's docile obedience to the divine will. In such a crushing trial Mary's faith did not falter in the least, nor was there any decrease in her total abandonment to God's will. Let us learn to trust in God. He abandons no one, and if He sometimes asks for sacrifices, it is always for our spiritual benefit.

A Thought from St. Thomas of Villanova: This faithful handmaid, Mary, never contradicted the Lord in deed or thought; she was obedient to the divine will always and in all things.

THE LOSING AND FINDING OF JESUS

The boy Jesus was advancing in grace before God and men, in the little home of Nazareth with Mary, His Mother and Joseph, His foster-father:

> The child grew in size and strength, filled with wisdom, and the grace of God was upon him (Lk. 2:40).*

Mary regarded with great delight this her Son, "beautiful above the sons of men" (cf. Ps. 44:3), the most modest, the best and most affectionate. Oh,

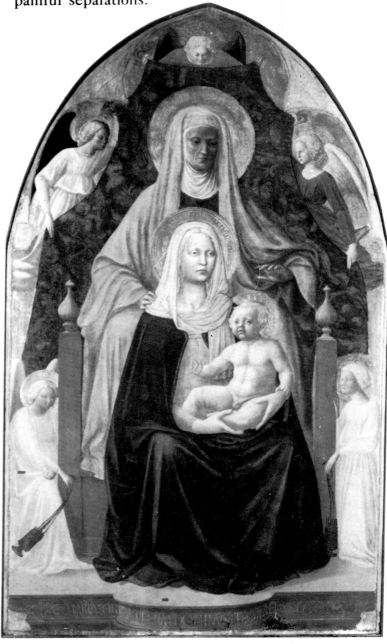

Masaccio: *St. Anne, Madonna and Child* (1424-25). Florence, Uffizi Gallery.

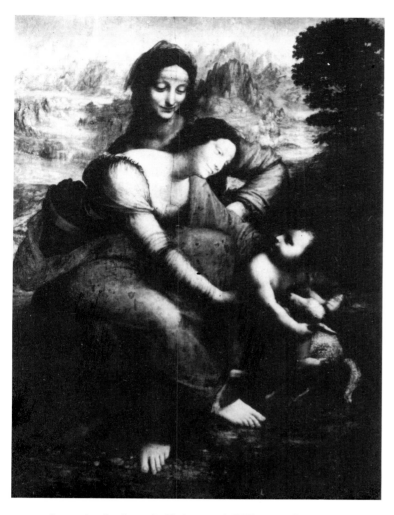

Leonardo: *St. Anne, the Madonna and Child* (1510). Paris, Louvre.

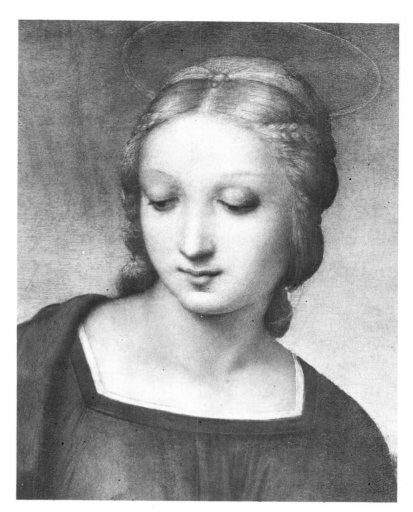

Raphael: *Madonna of the Goldfinch* (detail) (1507). Florence, Uffizi Gallery.

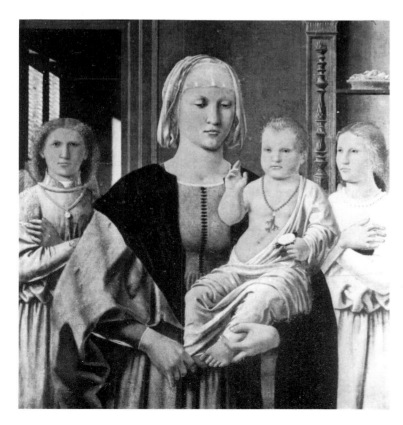

Piero della Francesca: *Madonna di Senigallia* (1470). Urbino, National Gallery of Marche.

Jan Mostaert: *The Repast of the Holy Family*. Cologne, Wallraf-Richartz Museum.

After the seven days of the feast were over, Mary and Joseph started out on their return trip, but Jesus remained in Jerusalem without their noticing it. On the day of departure all was a turmoil of shouting men, of guides rushing here and there, of caravans setting forth. With great difficulty groups banded together and set out on the journey. After a few miles, however, the first stop was made for needed rest. It was then that family members reunited, and Mary and Joseph succeeded in finding one another. As their glances met, their hearts began to beat fearfully; silence sealed their lips, and the same question shook them immediately: Where was Jesus? Anxiously they hurried from group to group. Neither relatives nor friends, however, had seen their Son. Perhaps Jesus was somewhere with friends met at the feast. He would appear at any moment.... But night fell and Jesus did not arrive! Trembling in anguish, Mary and Joseph returned to Jerusalem in search of their Treasure. They questioned the city guards, the women going to the fountain, the porters and beggars, but no one had seen their Son. Finally, after three days of searching, they found Him in the Temple seated among the doctors, listening to them and asking them questions, while "all who were listening to Him were amazed at His understanding and His answers" (cf. Lk. 2:47).

The Blessed Virgin stopped and so did Joseph. They would have liked to rush to Him, embrace Him, and kiss Him, but something mysterious restrained them. They had searched for Him in mortal anguish, believing that He too was searching for them. Instead, they found Him occupied with other matters, as though He had no need of them! He was seated among the doctors of the Law, listening to them and questioning them, filling them with wonder at His discerning questions and wise answers. The sorrowful Mary called out to Him, exclaiming:

'Son, why have you done this to us? You see that your father and I have been searching for you in sorrow' (Lk. 2:48).*

Calmly and serenely, Jesus replied:

'Why did you search for me? Did you not know I had to be in my Father's house?' (Lk. 2:49)*

Before Joseph, whom Mary called the father of Jesus, the heavenly Boy referred to His other Father, His true Father, and to His inscrutable rights. He had come into the world to do His Father's will and to save mankind:

'For I have come down from heaven, not to do my own will, but the will of him who sent me' (Jn. 6:38).

Not yet understanding the entire greatness of the mission entrusted to Jesus, Mary "kept all these things carefully in her heart" (cf. Lk. 2:51).

He went down with them then, and came to Nazareth, and was obedient to them (Lk. 2:51).*

There are many lessons which could be reaped from this episode: the choice of one's vocation, the search for Jesus when one loses Him through sin, and obedience to the heavenly Father. We shall mention, however, one thing only: in life there are many

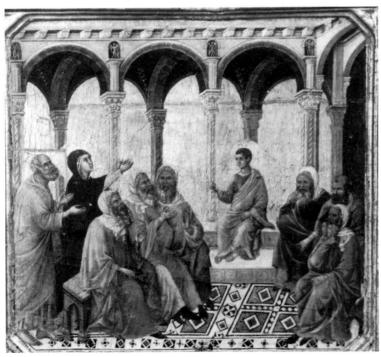

Duccio: *Jesus Among the Doctors* (1308-11). Siena, Cathedral Museum.

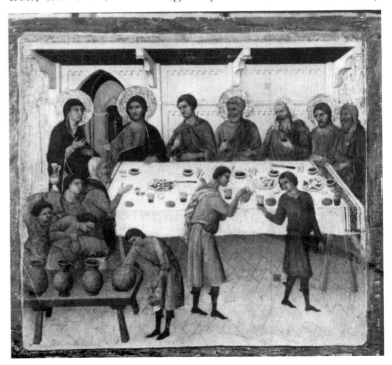

Duccio: *The Wedding at Cana* (1308-11). Siena, Cathedral Museum.

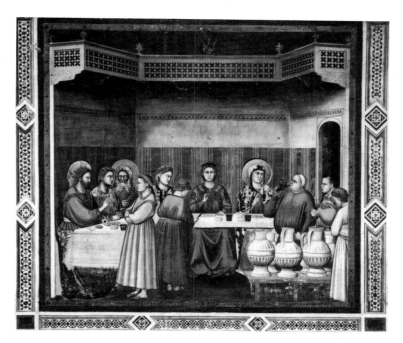

Giotto: *The Wedding at Cana* (1304-06). Padua, Scrovegni Chapel.

mysterious events—events that God permits for our good, for our spiritual progress. There are progress and retrogression, fervor and discouragement and even painful falls, because of which some souls exclaim, "But why, O Jesus, do You permit this?"— just as Mary said, "My Son, why have You done so to us?" In such circumstances we must love Jesus, love Him deeply and believe that what happens, happens because of a divine disposition, and that it is for our own good. Let us fear ourselves and confide in God, trusting in His divine grace. When Jesus enriches us with benefits and attracts us, let us think that it is grace working in us. When we are tempted, let us think that it is our own frailty. Let us humble ourselves for our part, and let us elevate ourselves on high through union with Jesus. We must not expect our reward upon this earth: God permits so much suffering so as to offer us opportunities for gaining merits.

THE WEDDING AT CANA

Left a widow by the death of St. Joseph, Mary changed her way of life very little. She tended to her home and went out only for errands of charity or religious duties.

It must not be believed, however, that Mary was negligent regarding her social duties such as visiting relatives and friends. Thus, as the Gospel narrates, she attended the marriage feast at Cana.

> On the third day there was a marriage at Cana in Galilee, and the mother of Jesus was there (Jn. 2:1).

It is a great joy for oriental women to participate in wedding preparations. Sisters, cousins and friends of the bride and groom assume the responsibility for the preparation of choice foods. They arrive at the home where the wedding is to take place on the eve of the feast, or even a few days before, and stay until the end, which is usually for about a week. The Evangelist has us suppose that Mary was already there with that family when her Son Jesus was invited. And Jesus went there with His disciples.

On that feast Mary proved the goodness of her heart toward the newlyweds by inducing her Son to work a delicate miracle so as not to spoil the sweet joy of the day.

At a certain point, Mary noticed that there was no more wine. With a few words she pointed out to Jesus the young couple's preoccupation, and tactfully, as only she knew how to do, begged Him to help them:

> When the wine failed, the mother of Jesus said to him, 'They have no wine' (Jn. 2:3).

Such a statement was obviously made to demand a miracle, and it reveals Mary's great confidence in her Jesus. She had always believed in her Son's divine power, and for thirty years she had experienced the goodness of His heart and His readiness to grant her least desire. She was, thus, certain of obtaining the miracle. Jesus, however, answered Mary in a way that emphasized the independence of His own action:

> 'O woman, what have you to do with me? My hour has not yet come' (Jn. 2:4).

Mary understood that He was postponing the miracle for a later time, but certain of being heeded, she told the servants: "Do whatever He tells you" (cf. Jn. 2:5). And Jesus, indeed, gave them orders to fill the jars with water. There were six large stone jars prepared in accordance with the Jewish manner of purification, each holding two or three measures.

The servants filled the jars to the brim. Then Jesus said to them, "Draw out now, and take to the chief steward" (cf. Jn. 2:8).

> So they took it. When the steward of the feast tasted the water now become wine, and did not know where it came from (though the servants who had drawn the water knew), the steward of the feast called the bridegroom and said to him, 'Every man serves the good wine first; and when men have drunk freely, then the poor wine; but you have kept the good wine until now' (Jn. 2:8-10).

Thus in Cana of Galilee, Jesus worked the first of His miracles, and manifested His glory, and His disciples believed in Him.

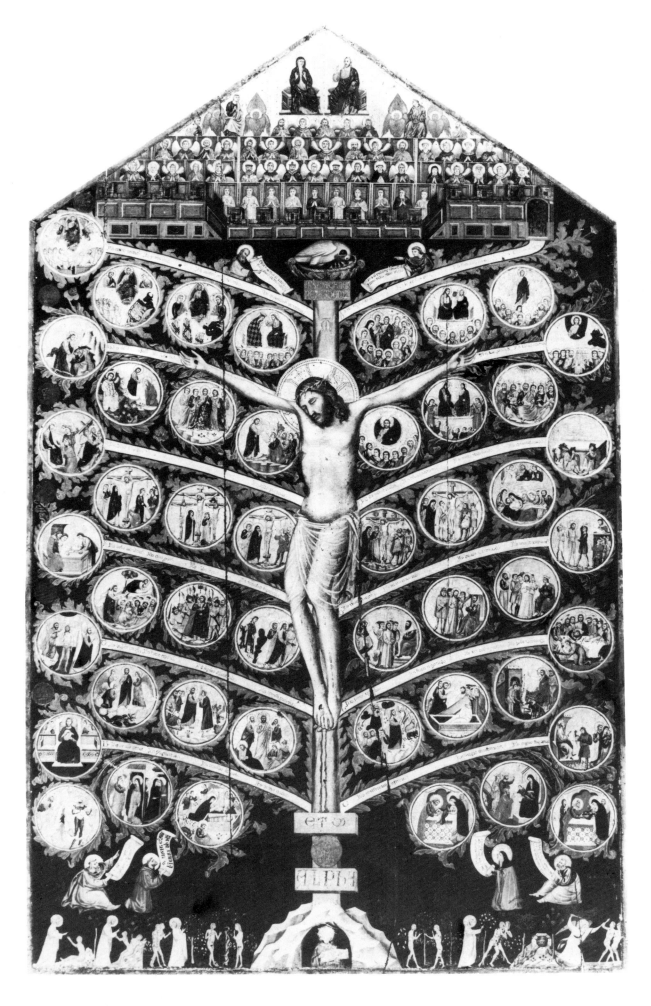

Pacino di Bonaguida: *The Tree of the Cross* (1310c.). Florence, Academic Gallery.

This episode teaches us a valuable lesson. Jesus willed to perform His first miracle at Mary's urging in order to teach us with what trust we should have recourse to this Mother of goodness to obtain the graces we need.

Mary is good; she thinks of us, sees and provides for our needs. Mary knows our wants. Assumed into heaven in soul and body, and admitted to the Beatific Vision, Mary sees in God all our thoughts, feelings, aspirations, difficulties, dangers, temptations and resolutions.

We are not excused by this fact from praying to her or enumerating the graces we need. Mary knows what is best for us, so let us tell her of our needs and trust in her. Let us abandon ourselves completely to her maternal heart.

Mary is powerful in her intercession. The power of saints to obtain graces is proportionate to their merit. Now, just as no one surpasses Mary in merits, likewise, no one has as much power of intercession. What God can do by commanding, you, O Virgin, can do by praying.

Mary's prayer is omnipotent because she has a mother's authority over her Son Jesus. Therefore, let us go to Mary without fearing to ask too much, as long as we seek graces that are useful for eternal life, and we pray with the proper dispositions.

Mary wants to provide for us. She is our Mother and a mother seeks the well-being of her children.

Mary wants us to be saints, similar to her, that we may reign with her in heaven.

A Thought from St. Bernard: Perhaps the Lord's reply may seem quite hard and severe, but He knew to whom He was speaking; and Mary knew whom it was who was speaking. And that you may know how she received His reply and how she trusted in the goodness of her Son, she said to the servants, "Do whatever He tells you."

MARY AND THE PUBLIC LIFE OF JESUS

When about thirty years of age, Jesus came out of His voluntary seclusion, and began to preach His heavenly doctrine. Before beginning His apostolic life, however, He went to His Mother to obtain her consent, or at least to inform her of His decision. Mary had foreseen this moment because she was well-acquainted with Sacred Scripture and the prophecies. For some time the banks of the Jordan had been resounding with the voice of John the Baptist preaching penance, giving baptism as a sign of it, and assuring the people that the kingdom of heaven was at hand. The time was ripe, and Jesus presented Himself to be baptized. As soon as John saw Jesus, he exclaimed, "Behold the Lamb of God, who takes away the sins of the world!" (cf. Jn. 1:29)

Afterwards Jesus retired into the desert for forty days, where, with fasting and prayer, He prepared Himself for His lofty mission. The name of Jesus, His miracles and His divine words soon became famous throughout Palestine. He made His home at Capernaum, and many authors maintain that Mary did likewise.

What did Mary do during the apostolate of Jesus? Three things: she prayed, she listened to His word, she followed Him and continued to serve Him.

a) **Mary prayed.** This is a most important mission, for prayer can do everything. Prayer is the base and the foundation of the apostolate, and without it we can do nothing. Fully aware of this, Mary prayed that her Son's apostolate might be full and fruitful.

b) **Mary listened to the word of Jesus.** Let us note Mary's unique position: on the one hand, she was superior to Jesus because she was His Mother; but on the other hand, she was inferior to Him because Jesus was the Son of God, sent by the Father! Mary became the humble and docile disciple of Jesus. She listened intently to all His words, and profoundly meditated them in her heart: "She kept all these things carefully in her heart" (cf. Lk. 2:51).

c) **Mary served Jesus humbly.** When St. John Bosco began his mission, he took his mother with him, so that she might assist in the care and education of his boys. Jesus and His Apostles, too, were served by Mary, by the august Mother of the Word Incarnate.

Oh, the humility of Mary! "Behold the handmaid of the Lord" (cf. Lk. 1:38).

The Gospel records two instances in which Jesus spoke of His Mother. Jesus was going about Palestine preaching the good tidings, curing the sick and freeing the possessed. From every side, He was assailed with so many supplications and petitions that He was often obliged to stop in the open country without being able to enter the towns. People followed Him about and welcomed Him as a great prophet and wonder-worker.

One day when Jesus was in the house of Simon Peter, intent on teaching the people, a messenger told Him, "Your Mother and brethren are outside seeking You." Jesus no longer had either mother or relatives; His family consisted of those souls who had come to Him to learn the glad tidings of the kingdom of God. And, resting His gaze upon His listeners, Jesus answered,

> 'Here are my mother and my brethren! For whoever does the will of my Father in heaven is my brother, and sister, and mother' (Mt. 12:49-50).

With this reply, Jesus did not intend to belittle His Mother's greatness. He simply wanted to give the world a splendid lesson. He wished to teach us that above love of our family and relatives stands the love of God, and that the true greatness of a soul consists in doing God's will:

> 'Not every one who says to me, "Lord, Lord," shall enter the kingdom of heaven, but he who does the will of my Father who is in heaven' (Mt. 7:21).

How great is the dignity of a soul that does the will of God! Without a doubt, according to nature, Mary's greatest dignity lies in being the Mother of Jesus, the God-Man. According to Faith, however, he is greater who does God's will. Mary was proclaimed Mother of Jesus in a twofold manner: physically and spiritually.

Spinello Aretino: *The Ascent to Calvary* (1365-70). Florence, S. Croce.

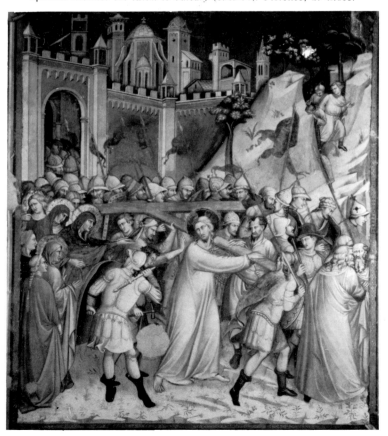

St. Luke narrates another episode in these words:

> While he was saying this a woman from the crowd called out, 'Blest is the womb that bore you and the breasts that nursed you!' 'Rather,' he replied, 'blest are they who hear the word of God and keep it' (Lk. 11:27-28).*

Again Jesus meant: Mary is blessed and is called thus not only because she is my Mother, but because she listened to the Word of God and put it into practice. Blessed is he who listens to God's Word and puts it into practice!

Mary was the first guardian of Jesus and His first listener. This fact teaches us to love the apostolate and to love the Word of God.

The apostle earns a twofold merit for having taught and acted well. Let us sanctify ourselves and do good to our neighbor.

THE SORROWFUL MARY

The public life of Jesus was drawing to a close, and the time was approaching in which Mary would have to make the greatest of sacrifices: the offering of Jesus as a victim for our salvation.

Jesus was hated by the leaders of the Jewish people, and Mary's heart suffered. She lived under the dread shadow of a sacrilegious crime, the victim of which was to be her own Son.

Her fears and anxieties seemed to vanish as if by magic with a new wonder, which was over in a short time: the triumphal entry of Jesus into Jerusalem. As He advanced, seated upon a donkey, the crowd spread their cloaks on the road before Him and, praising Him for His miracles, cried out: "Hosanna to the Son of David! Blessed is he who comes in the name of the Lord! Hosanna in the highest!" (cf. Mt. 21:9)

This episode inflamed the wrath of the Pharisees to a greater pitch, and they sought every means of condemning Jesus to death. Mary knew of their poorly concealed hate and she felt in her heart the stab of the sword predicted by Simeon.

Meanwhile Judas, an Apostle loved and taught by Jesus, had made an agreement with the Sanhedrin to betray his Master into the hands of His enemies.

The Divine Redeemer knew all this. The hour of His enemies had come, the hour of the powers of darkness, and so He bade Mary His last farewell.

How describe the Blessed Virgin's sorrow at that last embrace? "May the Lord's will be done," she must have said, thereby consenting to Jesus' laying down His

Michelangelo: *Pietà* (detail) (1497-99). Vatican, St. Peter's Basilica.

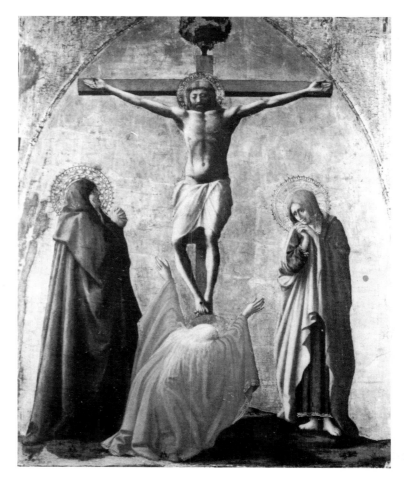

Masaccio: *The Crucifixion* (1426). Naples, National Galleries of Capodimonte.

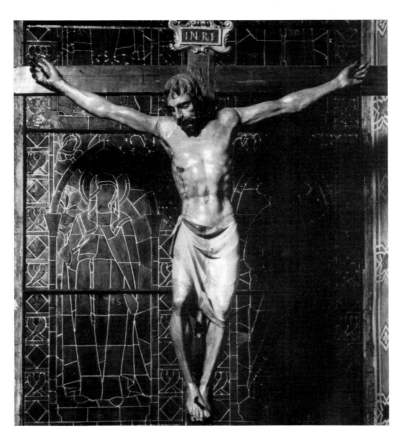

Donatello: *Wooden Crucifix* (1410-15). Florence, S. Croce.

life for the salvation of souls. Did she follow Him to the Last Supper? Was she there when He instituted the Most Holy Eucharist and gave His last sermon to His Apostles? Did she witness His agony in the Garden of Gethsemane? Did she see the kiss of Judas? The Gospel is silent on these points. And the many opinions vary, but we may surmise that if Mary was not actually present, she knew everything and kept herself informed of everything.

After the news of the horrible tortures inflicted upon her Son and the death sentence pronounced by the Roman governor, Mary resolved to walk beside the Divine Victim. During the public life of Jesus there are moments when we would wish to see Mary beside Him glorying in His triumphs, but we do not find her. Instead, she is beside the suffering Jesus.

The figure of Mary on Calvary stands out unique, grandiose, awesome. Mary ranked second to Jesus by virtue of the sublime mission she was fulfilling at that moment and the sorrows that were lacerating her soul.

Mary had ascended Calvary to put the seal on her mission as Co-redemptrix. There the woman concurred in crushing the head of the infernal serpent. Near the tree of the cross, Mary repaired what Eve had

foolishly ruined one day beneath the seductive foliage of a very different tree. On Calvary Mary was proclaimed the universal Mother of all men, and losing her only Son, she acquired us all as adopted children.

> When Jesus saw his mother, and the disciple whom he loved standing near, he said to his mother, 'Woman, behold, your son!' Then he said to the disciple, 'Behold, your mother!' And from that hour the disciple took her to his own home (Jn. 19:26-27).

Mary at the foot of the cross is the most moving picture of the whole Gospel story. No one can contemplate her without feeling his heart pervaded by a deep, ineffable sentiment of compassion.

The Church Fathers and ecclesiastical writers have found great difficulty in expressing the full bitterness into which the Blessed Virgin's heart was immersed. St. Bernard terms her more than a martyr. Eadmer expresses the same concept in the following terms: "Your heart was truly pierced, O Mary, by the sword of suffering more intense than the bodily sufferings of all the martyrs. In fact, the most cruel tortures inflicted upon the martyrs' bodies were nothing in comparison to your passion, which in its immensity, lacerated every part of your soul and the most intimate affections of your all-loving heart."

Blessed Amedo wrote that Mary suffered more than any man of the most robust constitution could ever suffer. She suffered more than human nature can naturally suffer.

The Church compares the immensity of Mary's sorrow to the vastness of the sea and places these words on her lips: "O all who pass by, look and see if there is any sorrow like my sorrow" (cf. Lam. 1:12).

To the mind of the Church, the sorrows of Mary surpass every limit of comparison: Mary is the *Queen of martyrs*. Mary is the Queen of martyrs because she is the Co-redemptrix. In union with Jesus, she willed to make reparation for our sins.

How many times we ourselves have pierced Mary's heart with the sharp sword of offense to God! Let us resolve to avoid every sin and, as much as possible, to make reparation for the offenses given to the hearts of Jesus and Mary.

MARY AND THE RESURRECTION OF JESUS

After the bloody drama of the cross, Mary withdrew in expectation of her Son's glorious resurrection. While the small group of friends who had remained faithful to Christ doubted their Master's promise to rise from the dead, Mary preserved unaltered her tranquillity of soul, for she was certain of the triumph.

Those who approached her felt their hope confirmed, their faith renewed. The holy women, no doubt, drew near to Mary in those days. Among them

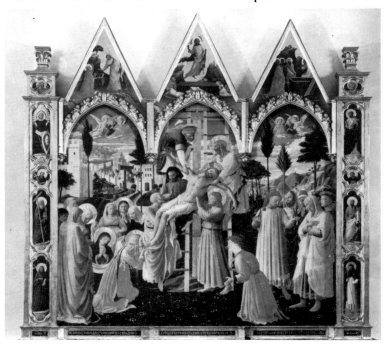

Fra Angelico: *The Deposition from the Cross* (1437-40). Florence, Museum of S. Marco.

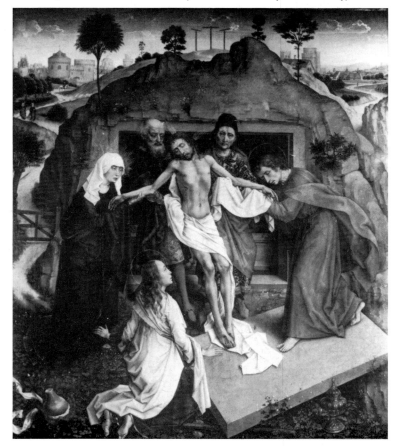

Rogier Van der Weyden: *The Entombment of Jesus* (1450). Florence Gallery.

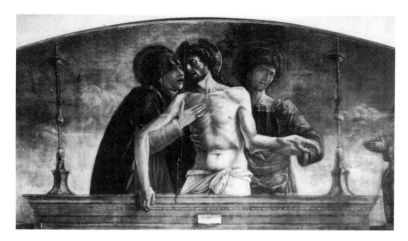

Giovanni Bellini: *Sorrow over the Death of Christ* (1472). Venice, Ducal Palace.

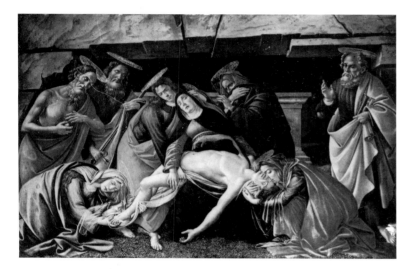

Botticelli: *Sorrow over the Death of Christ* (1495). Milan, Poldi-Pezzoli Museum.

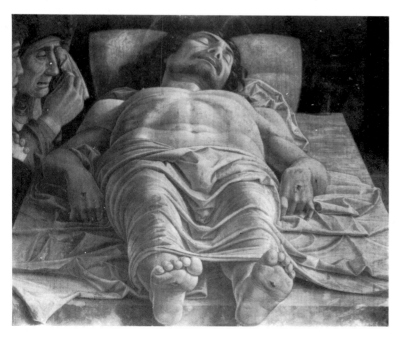

Andrea Mantegna: *The Dead Christ* (1480). Milan, Brera Gallery.

there was a complete exchange of confidences, and Mary certainly inspired them to greater faith in the words of the Master which promised His triumph over death.

In speaking of the apparitions of the risen Jesus, the Gospel first mentions the apparition to Mary Magdalene. It is common belief, however, that the honor and consolation of Christ's first apparition upon His return to life was granted to Mary. She was the first to behold the Savior's glory, just as she had been the first to share His sorrows.

Christ's love for His Mother and particularly His manner towards her when He hung from the cross convince us that when He arose from the dead, He appeared first to Mary, before all others.

Cardinal Capecelatro wrote: "When Jesus arose from the dead, Mary was the first to reap the benefits of the great mystery. She was the first to embrace her Divine Son and she was the first to delight in beholding the new and heavenly youthfulness gracing that Body which she, most blessed among women, had given Him. She saw and felt her own body glorified in the glorified Body of her most holy Son. She kissed the wounds which were to be the happiness of heaven and she rejoiced to the fullest in Him who constituted her paradise—Jesus, conqueror of sin and death, the restorer of mankind in God. Out of gratitude, love and His duty as a Son, Jesus came to fill His Mother with His glorified self. Reverently adoring and embracing her Son, Mary found her delight in that most blissful visit and her heart was set on fire with a new and most strong love. From that moment there began for Mary, already holier than the angels, a new life of perfection. Whoever would wish to describe it fully would have to have the mind and heart of Mary. And even she herself would not be able to do so fully, for human words would never be capable of expressing that which transcends everything human.

"The dignity of the Mother of God has a certain infinity, and from the moment when she embraced the risen Jesus, her life was gradually consumed by two most noble loves, which together possess the strength of maternity, and which have this maternity's perfection, sweetness, incentives. From that moment, she became ever more desirous of being united with her Son and with her glorified children. And in this desire, as in a living flame, she slowly consumed herself until the day of her glorification."

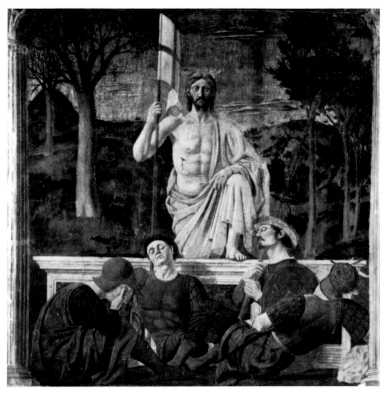

Piero della Francesca: *The Resurrection of Christ* (1463-65). Sansepolcro, Communal Gallery.

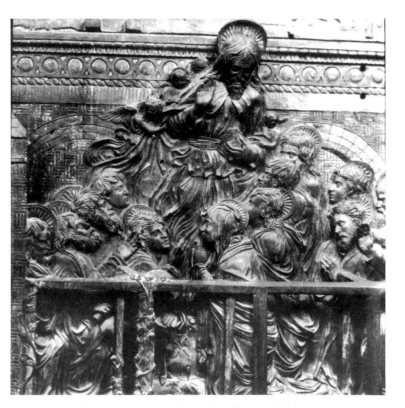

Donatello: *Ascension* (1465-66). Florence, S. Lorenzo.

Why is it that the Evangelists are silent about such an important event? Perhaps because Mary, ever faithful to her way of humility and reserve, kept even this favor buried in her heart so as to make of it a new subject for her silent meditations.

It must also be held that during the forty days He spent on earth after His resurrection, Jesus conversed with His Mother many times, and that she was present at the moving scene of His ascension into heaven.

From the Acts of the Apostles, we know for certain that Mary was present in the Cenacle at the descent of the Holy Spirit on Pentecost. For ten days, about one hundred twenty persons had been assembled there, according to St. Luke's narration:

> Then they returned to Jerusalem from the mount called Olivet, which is near Jerusalem, a sabbath day's journey away; and when they had entered, they went up to the upper room, where they were staying, Peter and John and James and Andrew, Philip and Thomas, Bartholomew and Matthew, James the son of Alphaeus and Simon the Zealot and Judas the son of James. All these with one accord devoted themselves to prayer, together with the women and Mary the mother of Jesus, and with his brethren (Acts 1:12-14).

It was, therefore, a prayer meeting, a holy retreat, in which Mary surpassed everyone in fervor of prayer and depth of recollection. And the Holy Spirit infused in her a grace as superior to that received by the others as her dispositions were superior to theirs.

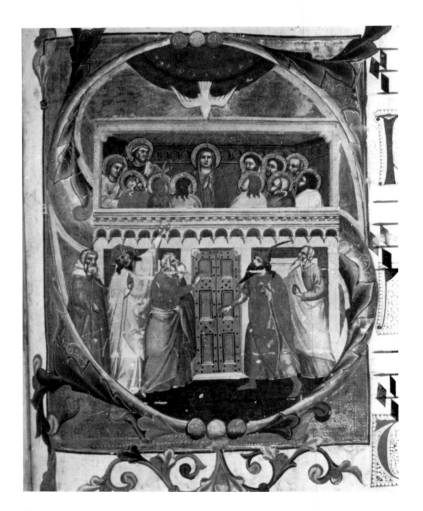

Pentecost, Miniature of the Gradule P. (end of the 14th Century). Florence, S. Croce.

Let us reflect: Mary was the first to share in the glory of Jesus, because she had been the most closely united with Him in sorrow.

St. Paul's expression is always true: "We suffer with Him that we may also be glorified with Him" (cf. Rom. 8:17).

If we know how to suffer with Jesus as Mary did, we shall share eternal glory with her.

A Thought from St. Cyprian: What can enrich us more with merit in this life and glory in the next than suffering patiently?

MARY AND THE APOSTLES

Mary was made the Mother of God to be the apostle, that is, to give Jesus to the world. We have received all from Mary in Jesus Christ.

The title, "Queen of Apostles," is the most glorious after the title of "Mother of God." By her divine motherhood, Mary became Queen of heaven and earth, of angels and of men, and among the latter, particularly of the Apostles: "The queen stood on your right hand, (O King of Heaven), in gilded clothing; surrounded with variety" (cf. Ps. 44:10).

We read in the Acts of the Apostles that after Jesus ascended into heaven, the Apostles descended the Mount of Olives and gathered in the Cenacle with Mary and the other holy women in expectation of the Holy Spirit.

The Divine Paraclete, promised by Jesus, descended upon them, bringing light, grace and comfort.

Mary was an example to the Apostles. When she was immersed in a sea of sorrow and love at the foot of the cross on Calvary, Mary's faith did not fail. Stronger than Abraham, she offered her only Son to the Father, with the intention of offering everything for the redemption of the world. When Jesus was laid in the sepulcher, the Apostles doubted His resurrection; Mary alone kept the light of faith burning, and strengthened the Apostles in this virtue. It may very well be said that the faith of the primitive Church was entirely gathered in Mary!

Furthermore, Mary was an example of fervor, zeal, strength and temperance. When the first persecutions broke out, Mary consoled, comforted, and sustained the Apostles and the faithful with her example, her words, and especially with her prayers.

Titian: *Descent of the Holy Spirit* (1539-41). Venice, Madonna della Salute.

Mary was the counselor and light of the Apostles. After the ascension of Jesus, Mary did not abandon the Apostles but was often with them. She loved them as an affectionate mother and instructed them as a competent teacher. What a sublime picture it is to contemplate Mary in the midst of the Apostles! With what ardor and dedication did she speak to them of Jesus! It was Mary who told the Apostles of those little incidents, now sorrowful and now joyful, concerning Christ's infancy and adolescence. And from whom did St. Luke learn the facts he relates in the first pages of his Gospel if not from Mary? Rightly then did St. Anselm exclaim: "Notwithstanding the descent of the Holy Spirit, many great mysteries were made known to the Apostles by Mary."

Protected by Mary we shall labor for the coming of Jesus Christ's kingdom with greater efficacy, and the greater devotion we have to her, the more souls we shall save. *To Jesus through Mary.*

A Thought from St. Anthony: Jesus wanted His Mother Mary to remain in the world for a certain period of time after His ascension, that she might be the Mistress and Guide of the Apostles.

Massys: *The Virgin Praying to Her Son.* Antwerp Museum.

MARY'S LAST DAYS ON EARTH

Many writers affirm that after the descent of the Holy Spirit Mary lived for a time in Jerusalem and then in Ephesus, *the city of Mary.*

The dying Jesus had entrusted His Mother to His beloved disciple, John, who testified that he had at once taken her into his home (cf. Jn. 19:27).

During this period of waiting for heaven, Mary presented to Jesus, now glorious in heaven, the needs of the infant Church and its Apostles. She prayed for the neophytes, she prayed for the conversion of idolators and sinners. Her heart grew ever more inflamed with the desire to be reunited to her Son.

After the ascension of Jesus into heaven, the following words can very well be attributed to Mary:

> As a doe longs
> for running streams,
> so longs my soul
> for you, my God (Ps. 42:1).**

It was her ardent desire for heaven which led her to exclaim,

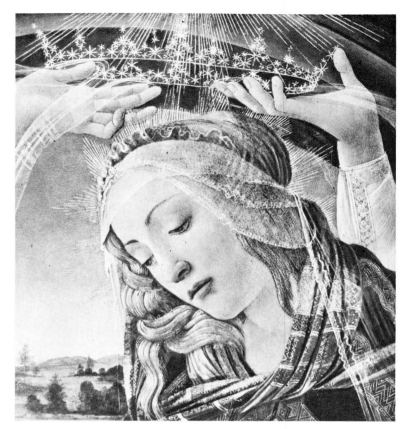

Botticelli: *The Madonna of the Magnificat* (detail) (1483-85). Florence, Uffizi Gallery.

> My soul thirsts for God,
> the God of life;
> when shall I go to see
> the face of God? (Ps. 42:2)**

The desire for heaven is fundamental, for faith in our rewarding God is one of the principal and essential dogmas. When a person is convinced of this truth and has faith, he establishes his life upon God alone and is indifferent to all else. To him, the important thing is to win heaven. Hope in this great reward must gladden us: "I was glad when they said to me, 'Let us go to the house of the Lord!'" (Ps. 122:1)

It should make us exclaim with St. Francis: "The good that awaits me is so great that every pain is a delight to me."

Mary's life on earth drew to a close. Her eyes were fixed on heaven; her heart beat with affection for God; her face shone and a smile was ever on her lips. All at once her heart gave a start, and Mary flew to heaven, to the embrace of her Beloved.

Mary was consoled in her last days on earth by the great number of her merits. Life passes rapidly, time flies and we continually add merits or demerits to the book of life. Every thought, sentiment and action is a merit or demerit according to whether it is good or bad, and whether or not it was accomplished with the right intention.

What was Mary's condition at the end of her earthly life? She had merits only, no sin—neither original, nor mortal, nor venial. Nor was there any voluntary imperfection in her actions, but all was perfect and meritorious. Mary, moreover, did not begin from nothing as we do, but rather from the point where the merits of the greatest saints reached, since she was superior to all the angels and saints from her Immaculate Conception.

This grace continued to increase in Mary until the last moment of her earthly life. How, then, is it possible for the human mind to calculate the treasure of grace accumulated by her?

Struck with admiration at the sight of the great merits adorning Mary at her entrance into heaven, the angels asked, "Who is this coming up from the desert leaning on her Beloved?" (Song 8:5)**

Are all our thoughts, sentiments and actions holy? Great vigilance is necessary. Let us try to sanctify all our days living with faith, hope and charity.

At the thought of her continuous progress in virtue, Mary experienced great consolation during her last days on earth. He who draws near to God and converses with Him is holy. Sanctity increases according to the progress man makes in his union with God. No one was ever more closely united to God than Mary.

If sanctity consists in fleeing from sin and practicing virtue, where can one find a person who avoided offending God and faithfully practiced virtue more than Mary?

MARY ASSUMED INTO HEAVEN

There is a vast difference between saints and followers of the world. Although the latter have some small successes, some rare satisfactions amid the trials of life, everything ends for them with death. Saints, instead, bear the inevitable sorrows of exile with resignation, *"for the yoke of Jesus is easy, and His burden light"* (cf. Mt. 11:30), but in the end, they will receive the eternal reward which the Lord prepares for those who love Him. Saints will have a more tranquil death and a happy eternity, whereas worldlings, after a life often full of misery, will have an unhappy eternity, too. People who detach themselves from the goods of the earth while they live will not have to do so at the point of death. At that hour, instead of leaving behind they will gather the fruit of their virtue: "And everyone who has left houses, brothers, sisters, father, mother,

children or land for the sake of my name will be repaid a hundred times over, and also inherit eternal life" (Mt. 19:29).**

If this is the lot of the saints, what was the lot of Mary, the most excellent of creatures? Having entered the world through a series of graces and privileges, Mary ended her earthly pilgrimage with a new prodigy: God, who had created her immaculate, willed that she be assumed into heaven in soul and body. She who was conceived without sin was not to see the corruption of the grave. The Co-redemptrix was to reign in heaven with the Redeemer; she was to take her place near the throne of God to intercede for all mankind.

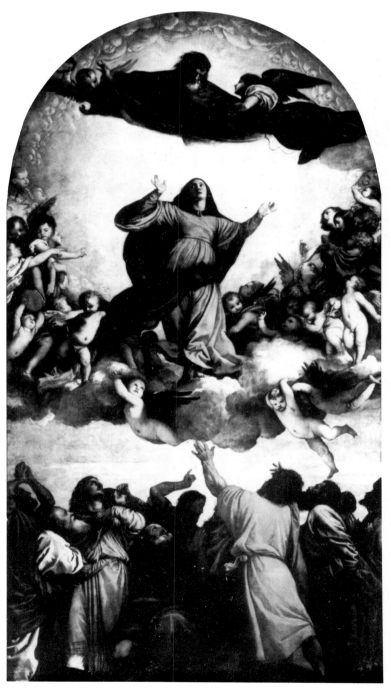

Titian: *The Assumption* (1516-18). Venice, S. Maria Gloriosa dei Frari.

Mary is in heaven in body also. Mary was exempt from original sin and her body was justly glorified immediately after her earthly life. She enjoys all the prerogatives of risen and glorious bodies: impassibility, clarity, agility and subtlety.

"Mary," says St. Bernard, "is presented to us clothed with the sun. She, in fact, who is immersed in God's inaccessible light, has penetrated the infinite abyss of divine wisdom much more deeply than man can imagine."

Mary is the noble star of Jacob whose rays brighten the entire world, shine in the heavens, encircle the earth, warm souls, quicken virtue and reduce vice to ashes.

Mary's body is now glorious, like the Body of Jesus. It can fly with the speed of thought from place to place; it can pass through locked doors; it no longer is

Andrea Bonaiuti: *The Coronation of the Virgin* (1365). Florence, S. Maria Novella.

subject to the weaknesses of human nature because it is spiritualized. Why was Mary's body so privileged? Because in life it was most docile to her soul, submissive in everything to reason. Mary progressed from good to better; in her there was no rebellion of body against spirit. It was just, therefore, that her body, which had shared her soul's merits, should also share its glory immediately.

Every merit has a corresponding glory in heaven.

Mary was exalted above the choirs of angels and the saints. Thus sings the Church in the liturgy of the Assumption. Behold the triumph of her who professed herself to be the humble handmaid of the Lord. There is no earthly comparison we can make to have an idea of the welcome given to Mary in heaven. For her, all the choirs of angels were moved to action, and even God Himself displayed His magnificence to receive her. At her entrance into heaven innumerable bands of angels accompanied her and called to those who came to meet them, "Hasten, O Princes of heaven; arise, open the portals, for the Queen of glory must enter in."

When she entered heaven, Mary was welcomed by the Blessed Trinity, before whom she prostrated herself in humble adoration, while the angels and saints came to pay homage to her as their Queen. To her was given a throne of glory superior to that of the angels themselves as the liturgy attests.

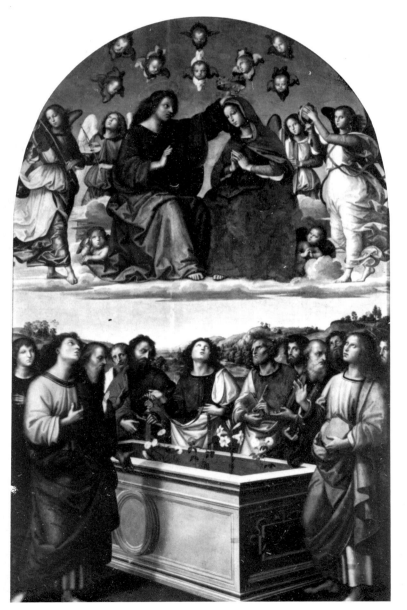

Raphael: *The Coronation of the Madonna* (1502-03). Rome, Vatican Gallery.

DEVOTION TO MARY

The Blessed Virgin leads the entire heavenly court in singing praise to the Blessed Trinity. As St. Francis de Sales expresses it: "Her voice rises above all others, rendering more praise to God than does any other creature."

For this reason, the celestial King invites her in a special way to sing:

'Let me see you,
 let me hear your voice,
For your voice is sweet,
 and you are lovely' (Sg. 2:14).*

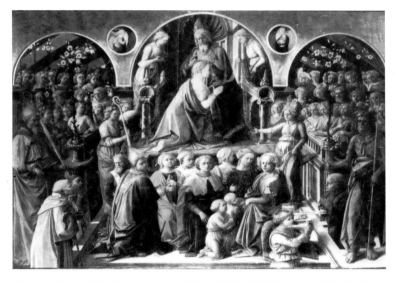

Filippo Lippi: *The Coronation of the Virgin* (1441-47). Florence, Uffizi Gallery.

Mary was thus exalted because she had so deeply humiliated herself. Her throne was placed close to Christ's, for in life she was always close to Him.

Let us learn from Mary to live in humility: only he who knows how to humble himself will be exalted by God.

Mary was crowned Mediatrix and Dispenser of graces. Seated on her radiant throne, the Blessed Virgin was proclaimed by the Blessed Trinity Queen of heaven and earth, Mediatrix and Dispenser of every grace. Mary's throne is the throne of mercy, and her mission in heaven is continually to ask that the merits of Jesus be applied to us, that our sins be pardoned and that all necessary graces for eternal life be granted to us. In heaven Mary is the good and powerful Queen who showers endless blessings upon earth.

St. Bernard says: "Take away the sun, which warms, illumines and makes everything fruitful, and what would remain on earth but dense fog and a deathly chill to sadden all nature? Likewise, if the shower of graces poured upon us by God's Mother were to cease, what would remain for men but anguish, sorrow and death?"

About herself Mary gathers choirs of angels and saints and intones the *Magnificat*, the most sublime hymn of thanksgiving.

However, Mary does not live in heaven only; she continues to live in the Church and in the heart of every one of the faithful who venerates her with a special and affectionate devotion.

Veneration of the Blessed Virgin began when she was still on earth. The Archangel Gabriel appeared to her and greeted her with words of the highest praise: "The Lord is with you. Blessed are you among women" (Lk. 1:28).* St. Elizabeth honored her with the inspired praise: "Blest is the fruit of your womb" (Lk. 1:42).* And what can be said of the great reverence that St. Joseph, Mary's most chaste spouse, had for her? But more than anyone, her divine Son, Jesus, esteemed and venerated her. He loved, obeyed and respected her; He gave Himself completely to her and willed to depend on her for everything. All the Apostles rendered homage to Mary, especially St. John, the privileged one who took her into his home after the death of Jesus. The Magi, the shepherds, and all who were so fortunate as to make her acquaintance, venerated Mary.

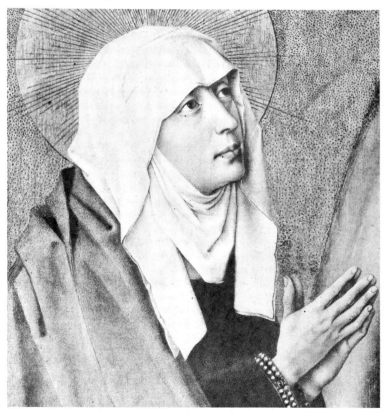

Rogier van der Weyden: *The Virgin as Intercessor* (detail). Beaune Hospice.

In the meetings of the early Christians, Mary always held a place of honor, as the Acts of the Apostles reveals. The account of the disciples assembled in the Cenacle after Jesus' ascension into heaven records Mary's presence, and she alone, of all the faithful, is mentioned by name.

Through the Gospel, devotion to Mary became widespread among Christians, and we have the first manifestations of Marian devotion.

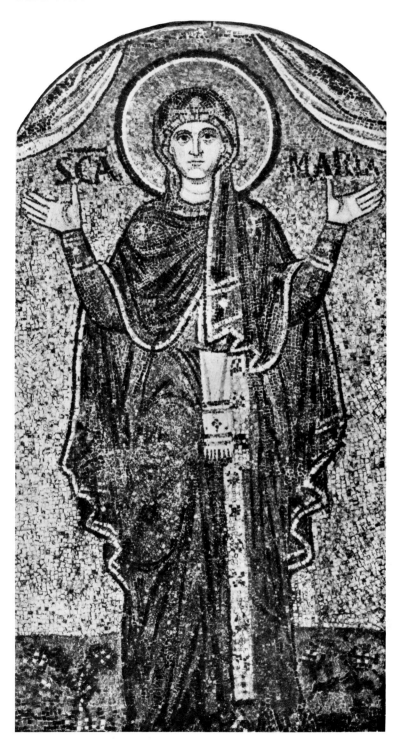

5th Century Mosaic: *Praying Virgin*. Ravenna, Archiepiscopal Palace.

After the Council of Ephesus, love and veneration for the Mother of God grew considerably by reason of the abundance of literature defending, explaining, illustrating the dogma of Mary's motherhood. It was during the eleventh century, however, that devotion to Mary assumed an eminent position. St. Anselm, St. Bernard and other holy Doctors wrote much about Mary, propagating her devotion in a wonderful manner. Mary came to be honored, exalted and invoked because of her privileged relationship with the Son of God made man.

Marian devotion is scriptural, evangelical and ecclesiastical.

The holy Bible presents to us a woman foretold by prophets and represented by types indicating aspects of the beauty which would be hers. This woman is praised and sought after.

The Gospel also speaks of this exalted Virgin. The Archangel Gabriel inaugurates this with his most gracious and magnificent homage. Elizabeth adds her voice to the voice of the angel, proclaiming Mary blessed. The shepherds and the Magi bow to her. Jesus Himself honors His Mother by living in obedient and devoted subjection to her.

Devotion to Mary, proclaimed Mother of all mankind by the dying Jesus, is deeply rooted in the Catholic Church. It was passed down from the Apostles to the first disciples; from the first disciples to the martyrs, to the virgins, and to the confessors. It has grown in century after century, in generation after generation, to become a vital, important part of Christian, Catholic cult.

Let us make every effort to guard this devotion as a precious treasure inherited from our fathers, that we may be able to hand it down to posterity.

Who can describe the benefits of devotion to Mary? She not only listens to her devotees, she anticipates their petitions and grants them beyond all expectations.

Let us take Mary for our Mother, and let us have recourse to her every morning and evening and in life's difficult trials: Mary will comfort and save us.

Let us remember that we have a Mother in heaven. *"Behold your Mother!"*

THE MADONNA
IN THE WORDS
OF VATICAN II *

*Chapter 8 of the **Dogmatic Constitution on the Church,** from *Vatican Council II: The Conciliar and Post Conciliar Documents*, translated by Austin Flannery, O.P. Used by permission of the publisher, Costello Publishing Co., Inc., Northport, N.Y.

I. INTRODUCTION

52. Wishing in his supreme goodness and wisdom to effect the redemption of the world, "when the fullness of time came, God sent his Son, born of a woman...that we might receive the adoption of sons" (Gal. 4:4). "He for us men, and for our salvation, came down from heaven, and was incarnated by the Holy Spirit from the Virgin Mary."[1] This divine mystery of salvation is revealed to us and continued in the Church, which the Lord established as his body. Joined to Christ the head and in communion with all his saints, the faithful must in the first place reverence the memory "of the glorious ever Virgin Mary, Mother of God and of our Lord Jesus Christ."[2]

53. The Virgin Mary, who at the message of the angel received the Word of God in her heart and in her body and gave Life to the world, is acknowledged and honored as being truly the Mother of God and of the Redeemer. Redeemed, in a more exalted fashion, by reason of the merits of her Son and united to him by a close and indissoluble tie, she is endowed with the high office and dignity of the Mother of the Son of God, and therefore she is also the beloved daughter of the Father and the temple of the Holy Spirit. Because of this gift of sublime grace she far surpasses all creatures, both in heaven and on earth. But, being of the race of Adam, she is at the same time also united to all those who are to be saved; indeed, "she is clearly the mother of the members of Christ...since she has by her charity joined in bringing about the birth of believers in the Church, who are members of its head."[3] Wherefore she is hailed as pre-eminent and as a wholly unique member of the Church, and as its type and outstanding model in faith and charity. The Catholic Church taught by the Holy Spirit honors charity. The Catholic Church taught by the Holy Spirit honors her with filial affection and devotion as a most beloved mother.

54. Wherefore this sacred synod, while expounding the doctrine on the Church, in which the divine Redeemer brings about our salvation, intends to set forth painstakingly both the role of the Blessed Virgin in the mystery of the Incarnate Word and the Mystical Body, and the duties of the redeemed towards the Mother of God, who is mother of Christ and mother of men, and most of all those who believe. It does not, however, intend to give a complete doctrine on Mary, nor does it wish to decide those questions which the work of theologians has not yet fully clarified. Those opinions therefore may be lawfully retained which are propounded in Catholic schools concerning her, who occupies a place in the Church which is the highest after Christ and also closest to us.[4]

II. THE FUNCTION OF THE BLESSED VIRGIN IN THE PLAN OF SALVATION

55. The sacred writings of the Old and New Testaments, as well as venerable tradition, show the role of the Mother of the Savior in the plan of salvation in an ever clearer light and call our attention to it. The books of the Old Testament describe the history of salvation, by which the coming of Christ into the world was slowly prepared. The earliest documents, as they are read in the Church and are understood in the light of a further and full revelation, bring the figure of a woman, Mother of the Redeemer, into a gradually clearer light. Considered in this light, she is already prophetically foreshadowed in the promise of victory over the serpent which was given to our first parents after their fall into sin (cf. Gen. 3:15). Likewise she is the virgin who shall conceive and bear a son, whose name shall be called Emmanuel (cf. Is. 8:14; Mic. 5:2-3; Mt. 1:22-23). She stands out among the poor and humble of the Lord, who confidently hope for and receive salvation from him. After a long period of waiting the times are fulfilled in her, the exalted

Daughter of Sion and the new plan of salvation is established, when the Son of God has taken human nature from her, that he might in the mysteries of his flesh free man from sin.

56. The Father of mercies willed that the Incarnation should be preceded by assent on the part of the predestined mother, so that just as a woman had a share in bringing about death, so also a woman should contribute to life. This is preeminently true of the Mother of Jesus, who gave to the world the Life that renews all things, and who was enriched by God with gifts appropriate to such a role. It is no wonder then that it was customary for the Fathers to refer to the Mother of God as all holy and free from every stain of sin, as though fashioned by the Holy Spirit and formed as a new creature.[5] Enriched from the first instant of her conception with the splendor of an entirely unique holiness, the virgin of Nazareth is hailed by the heralding angel, by divine command, as "full of grace" (cf. Lk. 1:28), and to the heavenly messenger she replies: "Behold the handmaid of the Lord, be it done unto me according to thy word" (Lk. 1:38). Thus the daughter of Adam, Mary, consenting to the word of God, became the Mother of Jesus. Committing herself wholeheartedly and impeded by no sin to God's saving will, she devoted herself totally, as a handmaid of the Lord, to the person and work of her Son, under and with him, serving the mystery of redemption, by the grace of Almighty God. Rightly, therefore, the Fathers see Mary not merely as passively engaged by God, but as freely cooperating in the work of man's salvation through faith and obedience. For, as St. Irenaeus says, she "being obedient, became the cause of salvation for herself and for the whole human race."[6] Hence not a few of the early Fathers gladly assert with him in their preaching: "the knot of Eve's disobedience was untied by Mary's obedience: what the virgin Eve bound through her disbelief, Mary loosened by her faith."[7] Comparing Mary with Eve, they call her "Mother of the living,"[8] and frequently claim: "death through Eve, life through Mary."[9]

57. This union of the mother with the Son in the work of salvation is made manifest from the time of Christ's virginal conception up to his death; first when Mary, arising in haste to go to visit Elizabeth, is greeted by her as blessed because of her belief in the promise of salvation and the precursor leaped with joy in the womb of his mother (cf. Lk. 1:41-45); then also at the birth of Our Lord, who did not diminish his mother's virginal integrity but sanctified it,[10] the Mother of God joyfully showed her firstborn son to the shepherds and the Magi: when she presented him to the Lord in the temple, making the offering of the poor, she heard Simeon foretelling at the same time that her Son would be a sign of contradiction and that a sword would pierce the Mother's soul, that out of many hearts thoughts might be revealed (cf. Lk. 2:34-35); when the child Jesus was lost and they had sought him sorrowing, his parents found him in the temple, engaged in the things that were his Father's, and they did not understand the words of their Son. His mother, however, kept all these things to be pondered in her heart (cf. Lk. 2:41-51).

58. In the public life of Jesus Mary appears prominently; at the very beginning when at the marriage feast of Cana, moved with pity, she brought about by her intercession the beginning of miracles of Jesus the Messiah (cf. Jn. 2:1-11). In the course of her Son's preaching she received the words whereby, in extolling a kingdom beyond the concerns and ties of flesh and blood, he declared blessed those who heard and kept the word of God (cf. Mk. 3:35; par. Lk. 11:27) as she was faithfully doing (cf. Lk. 2:19, 51). Thus the Blessed Virgin advanced in her pilgrimage of faith, and faithfully persevered in her union with her Son unto the cross, where she stood, in keeping with the divine plan, enduring with her only begotten Son the intensity of his suffering, associated herself with his sacrifice in her Mother's heart, and lovingly consenting to the immolation of this Victim which was born of her. Finally, she was given by the same Christ Jesus dying on the cross as a mother to his disciple, with these words: "Woman, behold thy son" (Jn. 19:26-27).[11]

59. But since it had pleased God not to manifest solemnly the mystery of the salvation of the human race before he would pour forth the Spirit promised by Christ, we see the apostles before the day of Pentecost "persevering with one mind in prayer with the women and Mary the Mother of Jesus, and with his brethren" (Acts 1:14), and we also see Mary by her prayers imploring the gift of the Spirit, who had already overshadowed her in the Annunciation. Finally the Immaculate Virgin preserved free from all stain of original sin,[12] was taken up body and soul into heavenly glory,[13] when her earthly life was over, and exalted by the Lord as Queen over all things, that she might be the more fully conformed to her Son, the Lord of lords, (cf. Apoc. 19:16) and conqueror of sin and death.[14]

III. THE BLESSED VIRGIN AND THE CHURCH

60. In the words of the apostle there is but one mediator: "for there is but one God and one mediator of God and men, the man Christ Jesus, who gave himself a redemption for all" (1 Tim. 2:5-6). But Mary's function as mother of men in no way obscures or diminishes this unique mediation of Christ, but rather shows its power. But the Blessed Virgin's salutary influence on men originates not in any inner necessity but in the disposition of God. It flows forth from the superabundance of the merits of Christ, rests on his mediation, depends entirely on it and draws all its power from it. It does not hinder in any way the immediate union of the faithful with Christ but on the contrary fosters it.

61. The predestination of the Blessed Virgin as Mother of God was associated with the incarnation of the divine word: in the designs of divine Providence she was the gracious mother of the divine Redeemer here on earth, and above all others and in a singular way the generous associate and humble handmaid of the Lord. She conceived, brought forth, and nourished Christ, she presented him to the Father in the temple, shared her Son's sufferings as he died on the cross. Thus, in a wholly singular way she cooperated by her obedience, faith, hope and burning charity in the work of the Savior in restoring supernatural life to souls. For this reason she is a mother to us in the order of grace.

62. This motherhood of Mary in the order of grace continues uninterruptedly from the consent which she loyally gave at the Annunciation and which she sustained without wavering beneath the cross, until the eternal fulfillment of all the elect. Taken up to heaven she did not lay aside this saving office but by her manifold intercession continues to bring us the gifts of eternal salvation.[15] By her maternal charity, she cares for the brethren of her Son, who still journey on earth surrounded by dangers and difficulties, until they are led into their blessed home. Therefore the Blessed Virgin is invoked in the Church under the titles of Advocate, Helper, Benefactress, and Mediatrix.[16] This, however, is so understood that it neither takes away anything from nor adds anything to the dignity and efficacy of Christ the one Mediator.[17]

No creature could ever be counted along with the Incarnate Word and Redeemer; but just as the priesthood of Christ is shared in various ways both by his ministers and the faithful, and as the one goodness of God is radiated in different ways among his creatures, so also the unique mediation of the Redeemer does not exclude but rather gives rise to a manifold cooperation which is but a sharing in this one source.

The Church does not hesitate to profess this subordinate role of Mary, which it constantly experiences and recommends to the heartfelt attention of the faithful, so that encouraged by this maternal help they may the more closely adhere to the Mediator and Redeemer.

63. By reason of the gift and role of her divine motherhood, by which she is united with her Son, the Redeemer, and with her unique graces and functions, the Blessed Virgin is also intimately united to the Church. As St. Ambrose taught, the Mother of God is a type of the Church in the order of faith, charity, and perfect union with Christ.[18] For in the mystery of the Church, which is itself rightly called mother and virgin, the Blessed Virgin stands out in eminent and singular fashion as exemplar both of virgin and mother.[19] Through her faith and obedience she gave birth on earth to the very Son of the Father, not through the knowledge of man but by the overshadowing of the Holy Spirit, in the manner of a new Eve who placed her faith, not in the serpent of old but in God's messenger without wavering in doubt. The Son whom she brought forth is he whom God placed as the firstborn among many brethren (Rom. 8:29), that is, the faithful, in whose generation and formation she cooperates with a mother's love.

64. The Church indeed contemplating her hidden sanctity, imitating her charity and faithfully fulfilling the Father's will, by receiving the word of God in faith becomes herself a mother. By preaching and baptism she brings forth sons, who are conceived of the Holy Spirit and born of God, to a new and immortal life. She herself is a virgin, who keeps in its entirety and purity the faith she pledged to her spouse. Imitating the mother of her Lord, and by the power of the Holy Spirit, she keeps intact faith, firm hope and sincere charity.[20]

65. But while in the most Blessed Virgin the Church has already reached that perfection whereby she exists without spot or wrinkle (cf. Eph. 5:27), the faithful still strive to conquer sin and increase in holiness. And so they turn their eyes to Mary who shines forth to the whole community of the elect as the model of virtues. Devoutly meditating on her and contemplating her in the light of the Word made man,

the Church reverently penetrates more deeply into the great mystery of the Incarnation and becomes more and more like her spouse. Having entered deeply into the history of salvation, Mary, in a way, unites in her person and re-echoes the most important doctrines of the faith: and when she is the subject of preaching and worship she prompts the faithful to come to her Son, to his sacrifice and to the love of the Father. Seeking after the glory of Christ, the Church becomes more like her lofty type, and continually progresses in faith, hope and charity, seeking and doing the will of God in all things. The Church, therefore, in her apostolic work too, rightly looks to her who gave birth to Christ, who was thus conceived of the Holy Spirit and born of a virgin, in order that through the Church he could be born and increase in the hearts of the faithful. In her life the Virgin has been a model of that motherly love with which all who join in the Church's apostolic mission for the regeneration of mankind should be animated.

IV. THE CULT
OF THE BLESSED VIRGIN
IN THE CHURCH

66. Mary has by grace been exalted above all angels and men to a place second only to her Son, as the most holy Mother of God who was involved in the mysteries of Christ: she is rightly honored by a special cult in the Church. From the earliest times the Blessed Virgin is honored under the title of Mother of God, whose protection the faithful take refuge together in prayer in all their perils and needs.[21] Accordingly, following the Council of Ephesus, there was a remarkable growth in the cult of the People of God towards Mary, in veneration and love, in invocation and imitation, according to her own prophetic words: "all generations shall call me blessed, because he that is mighty hath done great things to me" (Lk. 1:48). This cult, as it has always existed in the Church, for all its uniqueness, differs essentially from the cult of adoration, which is offered equally to the Incarnate Word and to the Father and the Holy Spirit, and it is most favorable to it. The various forms of piety towards the Mother of God, which the Church has approved within the limits of sound and orthodox doctrine, according to the dispositions and understanding of the faithful, ensure that while the mother is honored, the Son through whom all things have their being (cf. Col.

1:15-16) and in whom it has pleased the Father that all fullness should dwell (cf. Col. 1:19) is rightly known, loved and glorified and his commandments are observed.

67. The sacred synod teaches this Catholic doctrine advisedly and at the same time admonishes all the sons of the Church that the cult, especially the liturgical cult, of the Blessed Virgin, be generously fostered, and that the practices and exercises of devotion towards her, recommended by the teaching authority of the Church in the course of centuries be highly esteemed, and that those decrees, which were given in the early days regarding the cult images of Christ, the Blessed Virgin and the saints, be religiously observed.[22] But it strongly urges theologians and preachers of the word of God to be careful to refrain as much from all false exaggeration as from too summary an attitude in considering the special dignity of the Mother of God.[23] Following the study of Sacred Scripture, the Fathers, the doctors and liturgy of the Church, and under the guidance of the Church's magisterium, let them rightly illustrate the duties and privileges of the Blessed Virgin which always refer to Christ, the source of all truth, sanctity, and devotion. Let them carefully refrain from whatever might by word or deed lead the separated brethren or any others whatsoever into error about the true doctrine of the Church. Let the faithful remember moreover that true devotion consists neither in sterile or transitory affection, nor in a certain vain credulity, but proceeds from true faith, by which we are led to recognize the excellence of the Mother of God, and we are moved to a filial love towards our mother and to the imitation of her virtues.

V. MARY, SIGN OF TRUE HOPE
AND COMFORT FOR THE PILGRIM
PEOPLE OF GOD

68. In the meantime the Mother of Jesus in the glory which she possesses in body and soul in heaven is the image and beginning of the Church as it is to be perfected in the world to come. Likewise she shines forth on earth, until the day of the Lord shall come (cf. 2 Pt. 3:10), a sign of certain hope and comfort to the pilgrim People of God.

69. It gives great joy and comfort to this sacred synod that among the separated brethren too there are

those who give due honor to the Mother of Our Lord and Savior, especially among the Easterns, who with devout mind and fervent impulse give honor to the Mother of God, ever virgin.[24] The entire body of the faithful pours forth urgent supplications to the Mother of God and of men that she, who aided the beginnings of the Church by her prayers, may now, exalted as she is above all the angels and saints, intercede before her Son in the fellowship of all the saints, until all families of people, whether they are honored with the title of Christian or whether they still do not know the Savior, may be happily gathered together in peace and harmony into one People of God, for the glory of the Most Holy and Undivided Trinity.

NOTES

1. Creed of the Roman Mass; Symbol of Constantinople: Mansi 3, 566. Cf. Council of Ephesus; *ibid.*, 4, 1130 *(et ibid.*, 2, 665 and 4, 1071); Council of Chalcedon, *ibid.*, 7, 111-116; Council of Constantinople II, *ibid.*, 9, 375-396.

2. Canon of the Roman Mass.

3. Cf. St. Augustine, *De S. Virginitate*, 6: *PL* 40, 399.

4. Cf. Paul VI, *Allocution to the Council*, Dec. 4, 1963: *AAS* 56 (1964), p. 37.

5. Cf. Germanus of Constantinople, *Hom. in Annunt. Deiparae: PG* 98, 328 A; *In Dorm.* 2, Col. 357. Anastasius of Antioch. *Serm. 2 de Annunt.* 2: *PG* 89, 1377 AB; *Serm.* 3. 2: Col. 1388 C. St. Andrew of Crete, *Can. in B.V. Nat.* 4: *PG* 97, 1321 B. *In B.V. Nat.* 1: Col. 812 A. *Hom. in Dorm.* 1: Col. 1068 C. St. Sophronius, *Or. 2 in Annunt.* 18: *PG* 87 (3), 3237 BD.

6. St. Irenaeus, *Adv. Haer.* III, 22, 4: *PG* 7, 959 A, Harvey, 2, 123.

7. St. Irenaeus, *ibid.*: Harvey, 2, 124.

8. St. Epiphanius, *Haer.* 78, 18: *PG* 42, 728 CD-729 AB.

9. St. Jerome, *Epist.* 22, 21: *PL* 22, 408. Cf. St. Augustine, *Serm.* 51, 2, 3: *PL* 38, 355; *Serm.* 232, 2: Col. 1108. St. Cyril, of Jerusalem, *Catech.* 12, 15: *PG* 33, 741 AB. St. John Chrysostom, *In Ps.* 44, 7: *PG* 55, 193. St. John Damascene, *Hom. 2 in dorm. B.M.V., 3: PG* 96, 728.

10. Cf. Council of Lateran A.D. 649, Can. 3: Mansi 10, 1151. St. Leo the Great, *Epist. ad Flav.: PL* 54, 759. Council of Chalcedon: Mansi 7, 462. St. Ambrose, *De instit. virg.: PL* 16, 320.

11. Cf. Pius XII, Encycl. *Mystici Corporis*, June 29, 1943: *AAS* 35 (1943), pp. 247-248.

12. Cf. Pius IX, Bull *Ineffabilis*, Dec. 8, 1854: *Acta Pii IX*, 1, 1, p. 616; *Denz.* 1641 (2803).

13. Cf. Pius XII, Const. Apost. *Munificentissimus*, Nov. 1, 1950: *AAS* 42 (1950): *Denz.* 2333 (3903). Cf. St. John Damascene, *Enc. in dorm. Dei Genitricis, Hom.* 2 and 3: *PG* 96, 722-762, esp. Col. 728 B. St. Germanus of Constantinople, *In S. Dei gen. dorm. Serm.* 1: *PG* 78 (6), 340-348; *Serm.* 3: Col. 362. St. Modestus of Jerusalem, *In dorm. SS. Deiparae: PG* 86 (2), 3277-3312.

14. Cf. Pius XII, Encycl. *Ad coeli Reginam*, Oct. 11, 1954: *AAS* 46 (1954), pp. 633-636: *Denz.* 3914 ff. Cf. St. Andrew of Crete, *Hom. 3 in dorm. SS Deiparae: PG* 97, 1090-1109. St. John Damascene, *De fide orth.*, IV, 14: *PG* 94, 1153-1168.

15. Cf. Kleutgen, corrected text *De mysterio verbi incarnati*, ch. IV: Mansi 53, 290. Cf. St. Andrew of Crete, *In nat. Mariae. Serm.* 4: *PG* 97, 865 A. St. Germanus of Constantinople, *In ann. Deiparae: PG* 93, 322 BC. *In Dorm. Deiparae* III: Col. 362 D. St. John Damascene, *In Dorm. B.V.M., Hom.* 1, 8: *PG* 96, 712 BC-713 A.

16. Cf. Leo XIII, Encycl. *Adjutricem populi*, Sept. 5, 1895: *AAS* 15 (1895-1896), p. 303. St. Pius X, Encycl. *Ad diem illum*, Feb. 2, 1904: *Acta* 1, p. 154; *Denz.* 1978a (3370). Pius XI, Encycl. *Miserentissimus*, May 8, 1928; *AAS* 20 (1928), p. 178. Pius XII, Radio Message, May 13, 1946: *AAS* 38 (1946), p. 268.

17. St. Ambrose, *Epist.* 63: *PL* 16, 1218.

18. St. Ambrose, *Expos. Lc. II.* 7: *PL* 15, 1555.

19. Cf. Pseudo Peter Damien, *Serm.* 63: *PL* 144, 861 AB. Geoffrey (de Breteuil) of St. Victor, *In nat. b.m.*, MS. Paris, Mazarine, 1002, fol. 109. Gerhoch of Reichersberg, *De gloria et honore Filii hominis* 10: *PL* 194, 1105 AB.

20. St. Ambrose, 1.c., and *Expos. Lc. X*, 24-25: *PL* 15, 1810. St. Augustine, *In Io. Tr.* 13. 12: *PL* 35, 1499. Cf. *Serm.* 191, 2, 3: *PL* 38, 1010, etc. Cf. also Ven. Bede, *In Lc. Expo.*, 1, ch. II: 92, 330. Isaac of Stella, *Serm.* 31: *PL* 194, 1863 A.

21. "*Sub tuum praesidium.*"

22. Council of Nicea II. A.D. 787: Mansi 13, 378-379; *Denz.* 302 (600-601). Council of Trent, Session 25: Mansi 33, 171-172.

23. Cf. Pius XII, Radio Message, Oct. 24, 1954: *AAS* 46 (1954), p. 679; Encycl. *Ad coeli Reginam*, Oct. 11, 1954. *AAS* 46 (1954), p. 637.

24. Cf. Pius XI, Encycl. *Ecclesiam Dei*, Nov. 12, 1923: *AAS* 15 (1923), p. 581; Pius XII, Encycl. *Fulgens corona*, Sept. 8, 1953: *AAS* 45 (1953), p. 590-591.

INDEX OF ILLUSTRATIONS